The Crossing of Innumerable Paths

Essays on Art

The Crossing of Innumerable Paths

Essays on Art

GUY BRETT

Ridinghouse

So life is greater than the rules

MÁRIO PEDROSA

Contents

Preface

GUY BRETT

You probably wonder what this book is about. But there is no reason to explain things. You don't need to have an answer. I think of the artist Len Lye and his 'feeling days', an idea he had as a youth. For instance, 'If you've just heard someone clanking a nice piece of metal outside your window, then it's a sound day', what Lye would call 'the sound aspect of things'.[1] Then there were taste days, weight days, distance days, anything you care to choose and concentrate on.

My intention is not just for you to see but to *feel* your way around this book.

Fourteen artists and their traces are brought together here. I ponder over their diversity and singularity, the uniqueness of each one.

A fair number of these artists make works which arise out of their response to the situation, or the environment, in which they find themselves – 'a metaphoric shift or poetic device placed *in life itself*, intervening in life to quicken it, to work on it'. This quote, taken from my text on Dias & Riedweg, characterises something that all these artists share.

The Crossing of Innumerable Paths is something quite complex. The title is derived from a phrase used in one of my essays on Jimmie Durham. I used it in the context of his travels and what he observed or came across, but it is also the hundreds and thousands of ways people connect, countless interactions. The crossed paths could be anywhere, in any medium, in any real or imaginary form. The same applies to all the titles. The essay titles aspire to that multitude of possibilities. The titles do the job of opening up vistas.

7

Len Lye, *Tusalava*, 1929
Gelatin silver photograph

This book can perhaps be thought of in several ways, representing a floating connection of art movements and the details of people's lives. One path centres around the art/life relationship which was so much discussed in the period around the mid-twentieth century. Its keynotes are 'the participation of the spectator' and 'performance art' in both collective and individual forms, teetering on a borderline between being oneself and acting a role.

Another intricate thing for me has been my long association with Kinetic art, and the kinetic philosophy in general, as a way of seeing and thinking, which for me was an acknowledgement of energy as the basis for everything. Everything and everybody. All energies.

A further keynote is 'the unity of opposites'. I gradually began to realise that the idea, or the notion, or the phenomenon of the unity of opposites was assuming a greater and greater part in my thinking. In fact it has charged my writing from the beginning, from childhood. It was constantly re-appearing whether I knew it or not. It was as present in the ancient Greek philosophy of Heraclitus – 'the way up and the way down are one and the same thing' – as it was of the philosophy of Oscar Wilde, who 'maintained the paradoxical inter-relatedness of opposites';[2] 'There is no such thing as universal truth. A truth in art is that whose contradictory is also true'[3] ... 'light and darkness could only be understood together',[4] and so on.

Values important to these creative figures make themselves known. The quality of wit is widespread in this gathering of artists and most welcome. It steps lightly into every corner of the works I love. For the time being I am carrying around the reciprocal statement by writer Jean Paul in the eighteenth century: 'Freedom begets wit and wit begets freedom.'[5]

Fourteen artists
and their traces

Ana Mendieta
One Energy

Ana Mendieta herself used the phrase 'I am between two cultures, you know?'[1] It was said in an interview at the time of her second visit to Cuba, when she was hesitating over whether to return there and create works as an artist. Uttered by her, the words have a particular resonance because of all we know about her brief life. The circumstances of her removal from Cuba to the United States at the age of 12, with her elder sister Raquelín – knowing no English, growing up in a succession of foster homes and boarding schools in a remote part of the United States known for its harsh winters – she experienced as a profound dislocation. 'I am overwhelmed by the feeling of having been cast from the womb (nature). My art is the way I re-establish the bonds that unite me to the universe. It is a return to the maternal source.'[2]

Her metaphor of loss here refers to Cuba, but Mendieta did subscribe to the more general notion of 'Latin America'. She considered that, despite great disparities between the individual countries, there were similarities between Latin American cultures that were collectively different to North American culture. The feeling was confirmed on her first journey outside the United States since her arrival from Cuba, when she travelled to Mexico to do archaeological fieldwork on a study trip sponsored by the University of Iowa in 1971 ('plugging into Mexico was like going back to the source, being able to get some magic just by being there'[3]). Even Italy, where she went in 1983 on a Prix de Rome fellowship awarded by the American Academy, elicited the same sense of belonging.

11

Ana Mendieta, *Untitled: Silueta Series, Iowa (From Silueta Series in Iowa)*, 1976–78
Photo documentation of an earth-body work in mixed media
Photograph, 50.8 × 40.6cm

No doubt her sense of Latin identity was amplified and clarified for her by contrast with the mores of Midwest America in a process, at first painful and then triumphant, of understanding her difference. Mendieta wrote of being seen as 'an erotic being (myth of the Hot Latin), aggressive, and sort of evil'.[4] 'It's a very sensuous, immediate kind of culture that I come from...', she said in answer to a question during her lecture at Alfred State University, New York, in 1981.[5] Characteristics that would be lived as the norm in one milieu, come to seem alien and threatening in another.

Are we, even by raising such issues, on the edge of an area 'where angels fear to tread', an area littered with reductive stereotypes? Can a cultural difference exist both as a cliché and a truth? The answer is, perhaps; but only as readily as cultural characteristics themselves exist in a play of contradictions and relativities. In defining differences between Latin American 'character' and Anglo-Saxon culture, Mendieta herself often borrowed from the formulations of the Mexican poet Octavio Paz in his famous book *The Labyrinth of Solitude* (1950). In one of his chapters Paz tellingly contrasts Mexican fiestas ('with their violent primary colours, their bizarre costumes and dances, their fireworks and ceremonies, and their inexhaustible welter of surprises') with North American/European social gatherings and vacations ('which do not entail any rites or ceremonies whatever and are as individualistic and sterile as the world that invented them').

We seem to arrive at a statement of polarised cultural values, an either/or. However, difference is not essential but rooted in time, history and in the evolution of social forms. Paz's description of fiesta is close to the Russian philosopher and critic Mikhail Bakhtin's writings on carnival; and carnival, after all, is a universal phenomenon that has lived and died at different moments in different countries. Doubtless, too, at each moment and in each place, contradictory emotions are at play. Paz contrasts the brief explosion of festivity with the 'silent and sombre' Mexican of the rest of the year. 'There is nothing so joyous as the Mexican fiesta, but there is also nothing so sorrowful.'[6]

Just for the reason that cultural polarisation fails to reflect the complexity of experience, the North American influence on Mendieta should not be seen only in censorious or repressive terms; it was also a liberation. Through the agency of artist Hans Breder (himself a cross-cultural traveller) and his pioneering Intermedia Program at the University of Iowa, which combined dance, theatre, writing and music with visual art, Mendieta came in close contact with the considerable interdisciplinarity of the early 1970s avant garde. Breder's workshops also attracted participants from the mathematics, psychology, comparative literature and anthropology departments. At the same time, Mendieta was exposed to the upsurge of the women's movement that swept into the art world around 1970, her third year at the University of Iowa.

In Iowa, in the midst of the exciting experimentation, one can identify the influence on her of an extremely pared-down aesthetic. There were a number of names going around to describe this tendency, including 'primary structures', 'ABC art' and 'Minimal art'. Its influence was pervasive, crossing the spectrum of what came to be labelled Conceptual, Land, Body, Installation and Performance art. It can be traced through the ground-hugging work of Carl Andre, the propped lead slabs and tubes of Richard Serra, the transformation of materials and natural processes of change explored in Hans Haacke's kinetics, interventions in the outdoors by artists such as Robert Smithson and Michael Heizer, the Happenings of Allan Kaprow, and the body works of Vito Acconci (Haacke and Kaprow had been visiting artists in Hans Breder's program). It is somewhat paradoxical that, in expanding the boundaries, sites and concept of art, these experiments did so within a set of severe restrictions: adherence to the physical actuality of present space, real time and the body, to the exclusion of composition, emotion and symbolism. Mendieta's art profited from this paradox. In the early works her stark, literal, descriptive terms used to describe the works act like a foil to their powerful emotional content.[7] One of the most compelling elements of her Silueta series

is the centrality and continuity of the 'primary structure' of her body outline against which to measure the extraordinary fluidity and nuance of nature's intervention. This body-cipher was always returning, to be washed away again, consumed, melted, crumbled into its surroundings. The Siluetas are 'a long series that will never end', the artist said.[8] It is tempting to wonder if she would ever have arrived at such a telling effect of simplicity and seriality if she had not been exposed to the minimalist aesthetic.

At about the same moment, Mendieta came in contact with what was then the most powerful women's art movement in the world. At a time when 'one does not call oneself a feminist in polite society in Europe unless one wants to be ridiculed or ignored', Lucy Lippard wrote in an early and important article on women's Body art, the United States already had 'a broad-based support and interpretative faculty provided by the women's movement'. In her wide-ranging article, Lippard pointedly compared Body art by women and men. 'There are exceptions on both sides', she wrote, 'but, whereas female unease is dealt with hopefully, in terms of gentle self-exploration, self-criticism, and transformation, anxiety about the masculine role tends to take a violent, even self-destructive form.' By contrast with the whole history of men's representation of women's bodies, 'when women use their bodies in their artwork, they are using their selves: a significant psychological factor converts their bodies or faces from object to subject'.[9] Lucy Lippard met Ana Mendieta at the University of Iowa in February 1975. 'I was struck then, as ever since, by her intensity', Lippard relates.[10] The relatively recent rediscovery and re-evaluation of Mendieta's early performances and body works – coinciding with her time at Iowa and the explosion of the women's art movement in the United States – cast Lippard's words in a revealing light. Compared with the 'magical' (Mendieta's own often-used word) aura and metaphorical suggestiveness of the Silueta series, the early works have a confrontational, fearless and sometimes brutal directness. After reading of the rape and murder of a fellow student at

the university, Mendieta staged two rape scenes with her own body, one outdoors and the other indoors. Indoors she used her darkened apartment, to which the invited faculty and students arrived unwarned to find her naked body, bound and bloody, bent over a table. As the work of a woman and an artist, we can gauge the effect of *Rape Scene* (1973) from Mendieta's own words: 'I really would get it, because I was working with blood and my body. The men were into conceptual art and doing things that were very clean.'[11]

Knowing that Mendieta was capable of such fearless factuality makes us only more keenly aware of the different kind of intensity present in the Siluetas. It is as if in the early works she confronts discrimination, violence, rage, suffering, division; and in the later she seeks harmony, regeneration. The first is cast uncompromisingly in the here-and-now, the second in a huge sweep of time that conflates a very long perspective on human history with the recurring cycles of nature. Yet in both their intensity is very much wrapped up in their physicality and their processes of material transformation. 'She was at her best when the working process became most physical', her friend the Puerto Rican artist Juan Sánchez remembered.[12]

One of the most moving aspects of the Siluetas – an aspect amplified by each new one added to the series – is that creation is shared. Every tiny detail of every site and its recumbent female effigy, whether it be a rock face, an earthen bank, gully or creek, a tree trunk, scree slope, river mudbank, beach sand, flotsam and jetsam, bog land, reed bed, grass or snow, becomes part of a process of making. The artist added to it her own idiosyncratic materials, sometimes a mixture (made by herself) of gunpowder and sugar that she set alight to create a complex alchemy. At the same time there is no separation between production and dissolution, no finality. Such is Mendieta's artistic concentration that all this registers intensely on the psyche, whether we were there in person, or we see a film, slide or a photograph, even a small reproduction in a catalogue (each may be inadequate in some way but all are forms of witnessing).

Ana Mendieta, *Untitled: Silueta Series, Iowa*, 1977
Photo documentation of an earth-body work in mixed media
Photograph, 25.4 × 20.3cm (GL6866)

Ana Mendieta, *Untitled (Silueta Series, Iowa)*, 1978
Photo documentation of an earth-body work in mixed media
Photograph, 25.5 × 20.5cm (GL4349-A)

In a sense her process of making is another aspect of her 'between' position. The artist sets in motion a process but does not control its outcome. She allows nature to take its course. She is acted on as much as she acts. If this is so, it would only extend the complexity of reciprocal influences upon her evolving practice as an artist, which Lucy Lippard, referring specifically to Ana Mendieta, prefers to call 'a cultural integration' rather than an estrangement.[13] At first sight Lippard's words may appear too harmonious for what was plainly, in life terms, an experience of conflict for the artist. But perhaps Lippard refers to the fuller or longer-term effects of Mendieta's art, its dissolution of boundaries. In the same spirit of integration, and since it is an aspect of her art that has rarely been explored, this essay proposes to make some links (plays of similarity and difference) between Mendieta's and other art practices and positions of Latin American artists, more or less concurrent with hers, whether or not she and these practitioners were aware of one another. Mine is not an attempt to trace influences, but rather affinities, parallels, simultaneities, resonances, ideas 'in the air' at given moments, whose significance, I believe, has not been sufficiently appreciated. I will concentrate on her Silueta series, which I think is her great contribution to art. Some of these links may be pursued through two themes that form the title of an early article on Mendieta's work, by John Perreault: 'Earth and Fire: Mendieta's Body of Work'.[14]

NAKED FLAME

'Fire has always been a magical thing for me … fusion … its transformation of materials', commented Ana Mendieta off-the-cuff during her lecture to slides of her work at Alfred State University in 1983. Fire (gunpowder) is used in the Silueta series in Iowa, and (candles) in the Ñáñigo *Burial* at 112 Greene Street in New York in 1976, and in *Anima, Silueta de Cohetes (Firework Piece)* in the same year. Fire is particularly impressive in the film records of her work because it

is fast energy that lives and dies rapidly, contrasting with much slower changes in the earth itself. Working on another register, the contemplation of fire opens up a very long timescale. As Gaston Bachelard wrote in his book-length meditation *The Flame of a Candle* (1961): 'Obeying one of the most consistent laws of this reverie that happens before a flame, the dreamer dwells in a past which is no longer his alone, the past of the world's first fires'.[15]

It is very striking the way that artists of Latin America have taken primordial categories, such as earth or fire, and worked their cosmic nature into metaphors for contemporary social struggle. It is not, of course, that these categories are peculiar to Latin America, but they seem to have retained there an emotional and symbolic charge, a capacity of referring to 'what really matters'. Often inseparably, too, these categories have been woven together with metaphors of the culture in which the artist is embedded, culture at a popular and/or indigenous level, which the artist knows nourishes his or her own work, own imagination, to a great degree. In one sense this process has been a particular version of a characteristic of twentieth-century art in general, the paradoxical way in which avant-garde experimentation has drawn on the most distant past: the remarkable link-up between the most modern and the most ancient. A close connection has been made between the lure of the primordial and the radicalisation of artistic language, but the Latin American version of this has remained only patchily known. It has been more common to speak of what links the work of Latin Americans with movements centred in European and North American metropolises than of what they have in common with one another. An artistic scene needs to be known well, to be valued in depth, for it to be possible to see the conscious and unconscious dialogues and creative rivalries that go on among the protagonists. If we take an element like fire or earth, we find that these reciprocities and resonances are not only extensive but go far beyond the literal into metaphorical and conceptual subtleties.

The theme of fire is announced in the mid 1960s, with just such a degree of sophistication, by Brazilian artist Hélio Oiticica's series Bólides (Fireballs). By a coincidence rather appropriate to this essay, I first saw his Bólides at exactly the same moment that I first saw American Minimal sculpture (works by Judd, Andre, etc.), at the São Paulo Biennale in 1965. The contrast was striking in many ways, in material, in scale and also in formal structure. Oiticica's Bólides – glass containers or compartmented and manipulable wood boxes containing liquid, or pigment, or earth, and paint-impregnated gauze are on the model of the nucleus (bólides means fireball or meteor in Portuguese). A quantity of material is separated from the planetary whole, concentrated in space, becoming a glowing mass of substance and colour to which the viewer is attracted ('like a fire', as the artist once said). Occasionally a piece of gauze resembles a flame, but more generally the Bólide is a concept of form as an 'energy centre'. This sort of nucleic form can then be traced through a whole variety of works by different artists emerging from different contexts and sensibilities. In particular, fire became a powerful metaphor during the military dictatorships that brutalised several Latin American countries during the 1960s and 1970s.[16]

For example, there was Victor Grippo's gentle event Construction of a Traditional Rural Oven for Making Bread (1972), a contribution to a group show in a public square in the centre of Buenos Aires, with bread baked and handed out to passers-by. The artist saw it partly as a way of drawing attention to the polarisation of city and countryside in Argentina, but the police thought it subversive enough to break up the exhibition and to smash it and other artworks. Two years later, Leopoldo Maler produced a work that became iconic in the climate of the times, Hommage (1974), a typewriter with flames leaping from its carriage (the flames came from a hidden gas jet). It was a homage by Maler to his uncle, a well-known liberal journalist who was abducted and later murdered during the political violence leading up to the seizure of power by the dictator General Videla. From its personal

origins, *Hommage* became a universal metaphor both for state terror
and for the resistance of democratic individuals (it is interesting that
Leopoldo Maler met Ana Mendieta at the University of Iowa in the
1970s, and they were delighted to find that they were both using fire
in their work: 'we were both greatly surprised by the coincidence of
our works, not having before heard of each other's pieces'). Mendieta's
Anima parallels Maler's iron figures emitting or haloed by flames
from gas jets, exhibited in London in the mid 1970s.

Another Buenos Aires artist, Marta Minujín, one of the international
pioneers of Happenings (she collaborated with Jean-Jacques Lebel,
Allan Kaprow and Wolf Vostell in the 1960s), in 1981 created a five-
storey-high blazing figure of the Tango singer Carlos Gardel, *Carlos
Gardel on Fire*, a piquant parallel to Mendieta's *Anima*. One could say
that a subtle reference to the popular fiesta tradition of carnival
giants and animated figures lies behind both. Gardel had died in
a fire accident ('he was so ephemeral, so controlled by emotion',
Minujín has said[17]). Beyond making a specific reference to Gardel,
this was one of a series of towering event-sculptures she produced
that satirised the patriarchal cult of monuments. One of her favourite
targets was the Buenos Aires *Obelisco* (Argentina's equivalent of the
Washington Monument): in 1977 she made a full-size replica out of
wood that she exhibited lying on its side ('everything is so straight
and rigid and perpendicular that I want to make it all lie down'[18]).

Actual flames or fire metaphors are present in at least four of
the Brazilian Cildo Meireles's works. One, which masterfully uses
the conceits of Minimalism and Conceptualism while pointing them
in another direction, is *Southern Cross* (1969–70). This work consists
of a tiny cube made of segments of oak and pine (woods sacred to
the indigenous Tupí of Brazil because of their capacity to produce
fire when rubbed together) to be exhibited alone in a space 220 yards
square! The object and its surrounding space are inseparable (again
like the nucleus of an atom in relation to the space of its orbiting
electrons). The huge disparity in scale can be read in at least two

ways, or two directions: as a metaphor of the catastrophic reduction of the indigenous populations of Brazil since the Portuguese conquest or/and as a metaphor of potential, since the tiny cube can be the beginning of a vast conflagration, or renewal.

The primordial/modern fusion is lucidly demonstrated by Lygia Pape's *Book of Creation* (1959–60), one of the jewels of the neo-Concrete movement in Brazil. Each page is a geometric-abstract construction condensing an episode of prehistory. With playful wit, Pape arranged for the pages of her book to be taken out and photographed in various sites and corners around Rio de Janeiro. The 'discovery of fire' page was placed on the little table of a roadside drink-seller next to some bottles of a popular strong drink known as Paulista Fire.[19]

Among Oiticica's Bólides were objects found by him in the everyday environment and then designated Bólides. He called them Appropriations. Among them were fire tins, cans with a burning rag used by people in Rio de Janeiro in those days as a light for night-time roads. He wrote: 'I singled it out for the anonymity of its origin – it exists around as a sort of communal property. Nothing could be more moving than these lonely tins lit up at night (the fire in it never goes out) – they are an illustration of life, the fire lasts and suddenly one day it goes out, but while it lasts it is eternal.'[20]

Surely it is the same feeling of the ephemeral and the eternal that permeates Mendieta's *Anima*. She had it made to the outline of her own body by a *cohetero* (a maker of fireworks for fiestas) in Oaxaca, Mexico. With Hans Breder she ignited it one evening at dusk and after 30 seconds her form had been consumed by fire.

CONTESTED EARTH

In Oiticica's work there is close material interchange between fire and earth. The 'fireball' often consists of earth and some of the Bólides invite the spectator to enact a ritual of burial. It is the same with Mendieta: fires are set within mounds or 'containers' of earth (some-

times volcano-shaped as well as bodyshaped) and her Siluetas have strong overtones of burial. Here her position 'between cultures' takes on some powerful contradictions. Several writers have specifically contrasted Mendieta's attitude to the earth with that of other artists, North American and European, who came to be labelled Earth or Land artists. The Cuban critic Gerardo Mosquera, in the course of an essay on Mendieta's *Esculturas Rupestres* (Rupestrian Sculptures, 1981), gives a geographically and culturally sensitive description of the site in Cuba, the grottoes of the Stairs of Jaruco, where they were carved. He depicts with great empathy Mendieta's psychological relationship with this wild, beautiful spot that was often used as a refuge by rebels during Cuba's fight for independence. Mendieta was its 'last refugee', Mosquera proposes. Citing Mendieta, he describes her work at Jaruco as 'an intimate act of communion with the earth ... an imaginary solution, through art, for the drama of the sensitive girl forced to abandon her country, her family, her customs, her friends ...' Mosquera then suggests 'the very structure of her art' distinguishes it from other Earth art:

> Usually [in Earth art] matter is claimed by the act of displacing it from an original context in order to place it in a different hierarchy ... something almost always done on a grand scale. It is earth placed at the service and desire of man. In Ana one finds a more modest attitude: here the human being opens toward the earth, integrates itself to the natural medium ... Ana's approach is not to ravish or rape, but rather to search for an intimate fusion.[21]

The artist Nancy Spero has written in similar terms. 'Ana did not rampage the earth to control or dominate or to create grandiose monuments of power or authority. She sought intimate, recessed spaces, protective habitats signalling a temporary respite of comfort and meditation.'[22] A number of feminist art historians have identified 'gestures of control and domination' specifically with male Earth artists.[23]

As well as the male/female divide, Mendieta's work may also embody a perception of the land that derives from differences between North American and Latin American history. At the risk of dealing schematically with complex issues, one can associate North American history with massive exploitation of the land and the natural resources below the surface. As the land is exhausted, people – or giant corporations – move on to fresh sites, leaving scenes of devastation and wastage. The work of the Land artists of the 1960s and 1970s in one sense reflects this activity (on the 'grand scale' Mosquera mentioned), but at the same time, in certain cases, contests it. Thus Robert Smithson, shortly before his premature death, was making proposals to United States mining corporations for schemes of land reclamation. For Smithson, these would also represent a new possibility for the social functioning of art:

> A dialectic between mining and land reclamation must be developed. Such devastated places as strip mines could be recycled in terms of earth art. The artist and the miner must become conscious of themselves as natural agents. When the miner loses consciousness of what he is doing through the abstractions of technology, he cannot cope with his own inherent nature or external nature. Art can become a physical resource that mediates between the ecologist and the industrialist. The Peabody Coal, Atlantic Richfield, Garland Coal and Mining, Pacific Power and Light, and Consolidated Coal companies must become aware of art and nature, or else they will leave pollution and ruin in their wake.[24]

Following in the same spirit was Agnes Denes's extraordinary public artwork *Wheatfield: A Confrontation* (1982), in which she planted and harvested a two-acre wheat field on a landfill site in Manhattan's financial district, a block from Wall Street and facing the Statue of Liberty across the Hudson River. In turn, her action prefigures the

recent citizens' movements to reclaim derelict land in deprived cities like Detroit and plant gardens to grow food.[25]

In Latin America land wastage has been of a different kind. The classic pattern has been the survival of a quasi-feudalism, with vast tracts of land in the hands of a few landowners and a mass of landless peasants forced to flee to the cities in search of work. One of the most powerful grassroots political movements in Brazil in recent years has been that of the landless, Sem Terra (Landless Workers' Movement),[26] a phenomenon unimaginable in the United States outside of the specific land struggles of Native Americans.[27] Set against the abundant but unobtainable land of the interior is the tiny patch the squatter manages to seize in the city and live upon in conditions of great insecurity.

The perception of earth in Oiticica's work was strongly influenced by these conditions, I believe. He once distinguished his work from that of North American Earth or Land artists, which he seemed to see as a latter-day expression of the landscape ethos, with its implication of the detached surveyor's eye that renders the land neutral and available. Two of the strongest connotations of earth for Oiticica were, I think, as something close to all vital energies (heat, colour, humidity), and as something scarce and precious, to be struggled for, as in his passionate defence of Rio's *favelas* (squatter settlements): 'I love every centimetre of Mangueira Hill with the same intensity I give to my creative work', he once said.

The *favela* of Mangueira for Oiticica (as an émigré from the bourgeois parts of Rio) was dangerous, but also a place of culture and human affectivity. He made many Bólides and *Parangolé* capes (wearable artworks) in homage to Mangueira dancers, artists and rebels. In one *Bólide*, dedicated to a young outlaw killed by police, the viewer lifts out a heavy box of earth to reveal a newspaper photograph of the body of the young man lying in water in an attitude uncannily similar to Mendieta's Siluetas. The analogy with burial is clear. The dialectic burial/rebirth also became for Oiticica a vehicle for challenging the

reduction of artistic insights to inert objects and expensive commodities. Two years before his death he enacted what he called the *Counter-Bólide: To Return Earth to the Earth* (1978). Along with some friends, he took a small rectangular frame of wood, filled it with rich black earth that he had brought with him, and lifted it off, leaving the square of earth resting on the earth. It was intended to be the burial of the *Bólide* as an object and its resurrection as a 'life-act'. The place he chose for this little ceremony was Caju, a forlorn piece of wasteland and rubbish dump near the port of Rio de Janeiro.

In all this we find a human scale, a close correlation of land and body, a set of values, an emphasis on treasuring rather than dominating, which in this respect has strong affinities with Ana Mendieta's art. And in some Latin American Earth art we find, even when the scale expands beyond human dimensions, that the earth/body link is maintained, as for example in the work *Sutura* (Suture, 1989), carried out on a beach at La Plata, Argentina, by the group Escombros. Accompanying this action, emblematic of healing wounds and divisions, was a statement that ran as follows: 'Put new heart into the depressed; unite the divided; eliminate all frontiers; replace the "I" with the "we"; retrieve the lost; revive the dead; make the abstract real; turn the irrational logical; liberate the conquered; make the impossible possible. This is the artist's role.'[28]

The metaphor of the wound and suture could take us away, in a rhizomic manner, into other pathways of Latin American art: to the sculpture of the Colombian Doris Salcedo, or the stitched graphic works made by the Chilean Catalina Parra during the Pinochet dictatorship. But this would lead us some distance from Ana Mendieta.

SELF, SELVES

In an interview conducted in 1984, the artist Linda Montano asked Ana Mendieta if she was using death/burial images consciously. Mendieta immediately replied: 'I don't think you can separate death

and life. All of my work is about two things … it's about Eros and life/death.'[29] The photographic images yielded by the Silueta series are deeply ambivalent (or sensitive to the context of publication). It is not difficult to imagine that one of these photographs, if there was no other information about it and it was printed in a newspaper rather than an art book, could be mistaken for the scene of an atrocity. The 'goddess' looks very like a corpse. But, knowing what we do, an image that would register as a scene of absolute abandonment, the callous obliteration of an individual's identity and place in the social fold (still preserved in most customs of burial), is here read as a statement of love and of belonging to a humanity united in its long history and identification with mother earth. The signs of the body's decomposition, reabsorption with the land, through the intermingling materiality of the body image with earth, mud, water, etc., which was so important to Mendieta, is transmuted as celebration.

Mendieta liked to work alone, it is attested by her friends. Nancy Spero has said: 'Alone with her special tools and gear, she would hike to a chosen site, lie down and mark her body on the ground, dig trenches, filling them with gun-powder and setting them alight to blaze madly'.[30] Gerardo Mosquera has elaborated on her solitary ritual. 'Art for Ana was a compensatory rite of her personal schism, an imaginary solution for her impossible longing for affirmation through the symbolisation of returning, simultaneously in cultural, psychological, and social terms … Most of her work consists in a single act: to fuse with nature.'[31] However, what Mosquera describes as 'a personal schism' is not projected as a merely individual neurosis by the works. Lucy Lippard called the Silueta figure 'an everywoman'.[32] Mendieta herself complained about interpretations of this figure as 'The Goddess'. As it evolved she removed hands and arms. She said she wanted her work to be 'open'.[33]

Revealingly, Lygia Clark, working in Paris and Rio de Janeiro in the same years as Mendieta was making the Siluetas but probably

without knowledge of Mendieta, also declared that she wished her work to be 'open'. Rather than projecting the personality of the artist and her 'problems of a subjective type', rather than turn her statement into a 'biopsy of herself', which leads to closure, the work should 'leave an opening' for the people who see or experience it.[34] Likewise, Lygia Clark imagined or aimed for a form of fusion with nature. Mendieta's statement, 'My art is grounded in the belief of one universal energy, which runs through everything: from insect to man, from man to spectre, from spectre to plant, from plant to galaxy',[35] is paralleled by many of Lygia Clark's. Clark wrote of experiencing 'the totality of the world as a unique, global rhythm, which extends from Mozart to the gestures of football players on the beach';[36] 'contemporary man … learns to float in the cosmic reality as in his own inner reality.'[37] One could also add phrases of Hélio Oiticica that are remarkably similar, about how he aimed in his work for 'a total embodiment of that which was previously seen as environmental'; 'a total body-ambience communion'.[38] But Lygia Clark's (and Oiticica's) way of conducting this quest was very different from Mendieta's.

The differences between them are made all the more striking by the remarkable resemblances between Mendieta's Silueta photographs and photographs of two key works of Lygia Clark, *Canibalismo* (Cannibalism) and *Baba Antropofágica* (Cannibalistic Drool, both 1973). It is first of all the prone figure that begins to generate comparisons, and then the interference in its solidity, its surface. In Mendieta's case it is the material processes of nature that interfere; in Clark's the actions of other people. These are mediated by Lygia Clark's Relational Objects, manipulable sculptures that she evolved over more than 20 years as analogies of the sensuous experiences of the body. In both, a process of dissolution takes place, but of different kinds. Essentially with Mendieta the scenario is of one individual self fused with nature, and with Lygia Clark it is a social scenario, a participatory ritual of the interaction of individual selves with one another.

Lygia Clark's two works came at a kind of midpoint in the evolution of the participatory structure that distinguishes her entire oeuvre. In her earlier period, she had proposed the 'manipulation of objects to the spectator', to anyone interested. *Canibalismo* and *Baba Antropofágica* were developed with a group of students that she worked with regularly while teaching at the Sorbonne in Paris in the 1970s. Later she returned to Brazil and initiated her unique form of 'therapeutic' practice, working, via the Relational Objects, one-on-one with individuals. Clark came to see her work more and more in a context of 'healing', an idea that appealed strongly to Mendieta too. Artwork may have been for Ana Mendieta the means of healing a 'personal schism', but her audiences surely see it in the cosmic terms in which it was formulated and take a corresponding sustenance from that.

The dissolution of the body image in the Siluetas, as an opening or abandonment to natural forces, carries a powerful therapeutic charge. The outside flows into the inside, and the inside flows out. This process is present in Lygia Clark's work too, but again in a different sense.

Canibalismo and *Baba Antropofágica* exemplify Clark's notion of the 'Collective Body'. In some cases this was explored by means of linking bodies, limbs, together in a structure of elastic bands (one person's movements affect all the others' movements). In *Canibalismo* and *Baba Antropofágica* it went much deeper. Clark described it as 'the exchange between people of their intimate psychology'.[39] In *Canibalismo*, blindfolded people take out and eat fruit that they have discovered by opening the 'stomach' of the prone participant (actually a large pocket in a specially made suit). In *Baba Antropofágica* the group continuously pulls thread of different colours from cotton reels inside their mouths, letting it fall lightly onto the body of one lying down, in a mass of spittle-covered thread: 'They realise they are pulling out their very insides', Clark wrote.[40] She further described the experience as 'like getting inside each other's bodies'; hence the cannibalism metaphor.[41]

The Brazilian psychoanalyst and writer Suely Rolnik, after taking part in *Baba* in São Paulo in 1994 as the person lying on the floor, was able to vividly describe the experience as dissolution of her own body image and sense of self. At first it was frightening, she recalled, but she gradually lost her fear as she began 'to be that slobber tangle'. She had experience of it, she wrote,

> on a totally different plane to that on which my form is usually figured, whether subjectively or objectively … I began to see that the body without organs of the flux-dribble is a sort of reservoir of worlds – of modes of existence, bodies, me's … It is an 'outside of me' that, strangely, inhabits me and at the same time distinguishes me from myself – as Lygia says, 'the inside is the outside …' From the 'outside' is produced a new 'inside' me.[42]

Rolnik suggests that, through the ministrations of other selves/bodies, the individual self becomes a multiple self.

The experience Suely Rolnik describes has little to do with the photographic or filmic records of *Baba*. It is an experience that cannot be photographed. Essentially there is no audience for *Baba*; you are either a participant or you are not really 'there'. The experience is not part of 'visual culture', but the photographs inevitably are. They become a form of information, as for any event at which one was not physically present. In Ana Mendieta's case there was often no one else present at the action. The photographic and filmic records therefore have potential to increase the action's magic, the spatio-temporal distance that creates what Gerardo Mosquera calls the sense of 'impossible longing' generated by Mendieta's work. Indeed Mosquera has speculated on the absurdity of 'restoring' Ana Mendieta's *Esculturas Rupestres* in the remote grottoes at Jaruco, Cuba: 'creating an "Ana Mendieta Garden" for tourists, charging dollars for entry and selling souvenirs', he remarks derisively. This would be directly contrary to the spirit of her work, which,

once created, is intended 'to follow the ecological processes of its site.'[43]

'Participation' and 'the photographic report' are characteristic and important modern genres that have emerged out of questions about the relation between art and its public. They surely reflect the two types of experience that the ordinary citizen today is constantly oscillating between: the real and the mediated. The first corresponds to the willing or inescapable immersion in lived experience; the second to the forms of observing or witnessing, of varying degrees of detachment. An artist's practice involves studying this oscillation deeply.

I realise that the artists whose work I have compared with Ana Mendieta's have been from Brazil and Argentina, rather than Cuba. I can only explain this as the desire to pursue certain affinities and differences among a potential multitude. Of course, close cultural connections between Brazil and Cuba can be pointed to: the parallels between the Afro-Cuban Santería and the Afro-Brazilian Candombé belief and value systems, for example.

Much has been made of Mendieta's interest in Santería, but it is surely one among a complex web of influences, as Afro-Brazil and Amerindian-Brazil were for Clark and Oiticica. The shared desire for 'fusion with the Universe' (and in the case of the Mendieta/Clark affinities, the interest in healing) might be connected with those belief systems, but equally it can be found in many other traditions too, among them the Indian and the Chinese. For example, 'It is pre-eminently our body, or more precisely our body image, that holds us back from the mystical goals of non-duality, non-separation, and the dissolution of individual identity in a larger, cosmic identity', as the psychologist and author Sudhir Kakar has commented.[44] The spiritual quest referred to in these traditions is surely a perennial dilemma, since it deals with the attraction and repulsion of opposites, a dynamic in which we all have to live. All this would tend to work in a direction against cultural exclusivity and monopoly, a further aspect of what Lucy Lippard called Ana Mendieta's 'cultural integration'.

Ana Mendieta, Earth Body Sculpture and Performance 1972–1985, Olga M Viso (ed), Hirshhorn Museum and Sculpture Garden, Smithsonian Institution and Hatje Cantz Publishers, Washington DC and Berlin, 2004

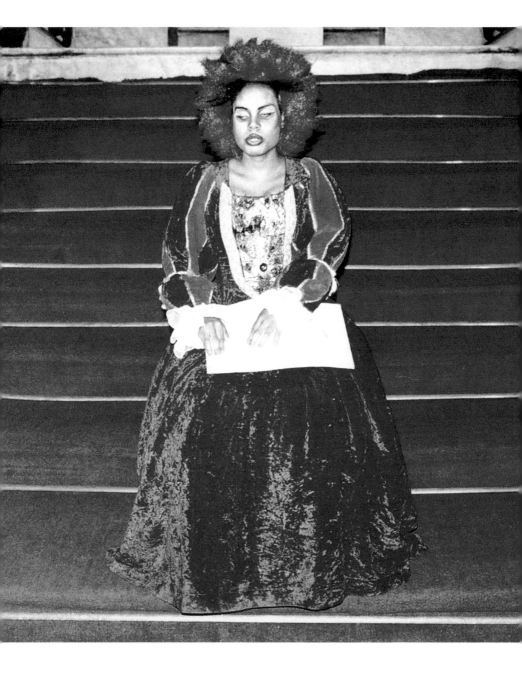

Dias & Riedweg
The Expanding Conversation

*'What I have in mind is something like the self spilling over –
over its boundaries into other selves, and in turn other selves
spilling over their boundaries into one's self.'*
ASHIS NANDY, *Dissenting Knowledges, Open Futures*

CAMERA EYE

In a frontispiece photograph for their publication *The Other Begins
Where Our Senses Meet the World* (2002), we see Maurício Dias & Walter
Riedweg crouching behind a video camera set on a small tripod. The
scene is shot from above. A microphone trailing a wire lies on the
floor. An assistant fixes one of the lights. Others come and go. The
camera is facing a woman wearing an exotic ultramarine dress and
a red wig sitting regally on the baroque staircase of Rio de Janeiro's
National Library. Her eyes are closed and she is reading, in Braille,
from the works of Homer and Borges, both blind writers.

 This image of the artists at work not only centres on the instru-
ment they have used to fabricate almost all their works to date – the
video camera but presents this extension of the eye, this latest tool
of visual representation, in the context of a work about blindness.
Beautiful is also that which is Unseen (2002) originated in a series of
'sensory workshops' Dias & Riedweg conducted with a group of 15
blind adults who attend the Benjamin Constant Institute in Rio de
Janeiro. They were asked to sample various smells, tactile materials
and sounds and to associate their perceptions with memories of
lived experience, or with the imagination. Their filmed responses
served to question that 'sight is an absolute path for perception …

33

Maurício Dias & Walter Riedweg, *Beautiful is also that which is Unseen*, 2001
Video installation, 25th São Paulo Biennale

and for the establishment of ethical and aesthetic values in our society'.[1] For us, as sighted spectators, the eye-catching costume of the blind reader acted as a kind of ironic foil to focus our thinking on what is *unseen*.

In *This Is Not Egypt* (1999), an installation which studiously avoids the clichés of tourism while admitting 'the cultural differences, controversies, criticisms, lack of understanding, impasses and pleasures' of two Western artists experiencing life in a modern Islamic metropolis, the camera again becomes a subject.[2] In one of the 11 'stories' that make up the work, the camera was left running on the sidewalk of a central street in Cairo. 'Nobody touches it. The pedestrians look curiously inside the camera while it is filming them. Fade out …'[3] Again, in *Throw* (2004), although unseen, the camera represents a powerful protagonist. Citizens, in the centre of Helsinki, were invited to throw anything they liked (within reason) at a sheet of glass behind which was the camera. Their slow motion run towards the camera (and towards us) and the launch of their chosen missile – soup, cake, a fish, and in one case a mobile phone – to smash or splatter against the glass, is intercut with rapid black-and-white flashbacks to previous political demonstrations in the streets of Finland. Against the backdrop of Helsinki's official buildings and monuments, these 'throws' might be 'the everyday rebellion of the little man';[4] but they could also be seen more specifically as a symbolic attack on the omnipresent eye of the media and of surveillance.

These three examples give clues to the ethic, aesthetic and world view behind Dias & Riedweg's handling of the camera. Working together as artists since 1993, they have established a practice of travelling the world, without prejudice, without agenda, and beginning dialogues with others, others both as individuals and as members of social groupings as they have come to be defined. Their desire is to be open. The role of art, in Maurício Dias's view, 'is not to educate, nor heal, nor organise, nor even change anything. Its role

is a little bit more abstract than that. I think it is to communicate, to reach people, to promote states of spirit, that redefine the state of things.'[5] 'I'm not interested in power but in conversation', Walter Riedweg says.[6] Both comment: 'Our studio is in the streets, our ideas pop up when we think we are in an interesting place.'[7]

Accordingly, the subjects and the collaborators of their work have covered an extraordinary range, both geographically and socially: street children in Rio de Janeiro, recently arrived immigrants and refugees in Switzerland, prisoners and juvenile offenders in the United States of America, janitors of São Paulo apartment buildings, inhabitants of Venice, dog-handlers patrolling the Mexico/US border, passers-by in Johannesburg Central Station, stall-holders in a São Paulo street market, bus passengers in Córdoba, Argentina, carnival revellers in Brazil, gay male prostitutes in Barcelona, children of asylum seekers in Liverpool, migrant artists, and, most recently, immigrant school-children and long-resident foreign workers in France. Of course, to make such a list is to group people together under collective and cursory names which may have been imposed on them to oppress, control or 'other' them in ways which Dias & Riedweg set out to contest. As a creative partnership, they themselves – a Brazilian and a Swiss – have forestalled any attempt to claim their work according to superficial nationalist reflexes. Although drawn to groupings of people outside or at the edge of so-called mainstream society (and being fascinated by the consequences of that gap), the artists like to question even such categories.

Sometimes a 'virtual' community can be formed by criteria which have nothing to do with the operations of power. In *My Name on Your Lips* (2000), a public art project which became a video installation, Dias & Riedweg asked Brazilian men and women to speak the name of their previous lovers, up until that moment. Their mouths were filmed in close-up, mouths 'both old and young, poor and wealthy, dull and thoughtful, gap-toothed and healthy, beautiful and ugly'.[8] We observe the tiniest tremors and hesitations as a

name is pronounced, 'small confessions are inscribed in a large format'.[9] The result is that the 'other' is brought so close to us as to be anyone, everyone, ourselves.

The use of close-up in *My Name on Your Lips* is an example of the poetic device, or the 'poetic field' as Dias & Riedweg have called it, which they have created for every work they have made. And in each work it has been different, arising out of their response to the situation or environment in which they find themselves – a metaphoric shift or poetic device placed in life itself, intervening in life to quicken it, to work on it. These imaginative elements are the core of the work, I believe. They enable one to speak of a hybrid which is both scientific enquiry and artistic transformation, both document and artifice, ethic and aesthetic, arriving in some experimental area where the objective and subjective can meet. This can be illustrated by comparing two works which arose out of very different situations.

Inside and Outside the Tube (1998) was developed in a Reception Centre for Political Refugees on the edge of Adliswil, a small town near Zurich. To this centre, and to 30 similar places in Switzerland, men, women and children arrive daily from countries in situations of conflict, which, at the time the work was made, included Angola, Algeria, Ethiopia, Zaire, Pakistan, Sri Lanka, Iraq and Eastern Europe. Detainees can wait up to a year while their cases for asylum are considered, housed in containers and denied the right to work or to mingle with the local population. 'These are true waiting rooms, where one finds totally adrift, almost mute and exhausted people', the artists write.[10] They worked intensively with 20 of the inhabitants, beginning with sensory workshops and then encouraging talks following each person's gruelling journey – a new type of journey for which there is no familiar model, no finished definition, no clear outcome:

Maurício Dias & Walter Riedweg, *Inside and Outside the Tube*, 1998
Public art project, Reception Centre for Political Refugees, Adliswil, Zurich

home … family … the moment when public life or war interfered in their private life … what happened then … the decision to leave … the flight … the farewell … the last thing they thought upon leaving … how the sky was at that time … the trip … the trip's length and the inner sensation of its length … the fear and hope for the future … the arrival at a new place … the first thing seen upon arrival … the first Swiss person seen … the smell of that time … the arrival at the Refugee Centre … the wait … the fear and hope for the future. The voyage was the theme connecting all these daily meetings.[11]

Stories were recorded and CDs made in which a chorus of testimonies in several languages gradually ceded to a German translation that could be understood by the Swiss general public. The CDs were mounted in sculptures, constructions of industrial tubing, designed by the refugees themselves and installed in public places around the town centre. Thus the citizens of Adliswil could put their ears to the tubing and hear the stories of the people in their midst about whom they knew nothing. The silver tubes have something of the quality of a magical industrial beanstalk sprouting among the tidy Swiss street furniture. It is the ad hoc exuberance and importunate directness of this completely unofficial and invented form of communication that constitute the poetic device.

> The installations polarised the population's pro and against arguments in relation to the most difficult issue of today's Switzerland. During a whole month, the tubes survived March's rough weather and several acts of vandalism carried out by right-wing extremists and neo-Nazi groups … On the one hand bruised by kicks and blows, on the other hand rewarded by an ample and consistent debate about the theme within several circles of society.[12]

If *Inside and Outside the Tube* focuses on displaced people and a sort of non-place generated out of the cruel vicissitudes of the global economy, *Tutti Veneziani* (1999), takes as a starting point a great cultural icon and the deeply rooted traditions and institutions which go with it. Venice has been a spectacle for so long that for Dias & Riedweg it has become a place where 'every gesture takes on a theatrical quality'.[13] As part of the Venice Biennale of 1999, they created a large projection installation in the hall of the Arsenale. In the central passageway Biennale strollers found themselves sharing the floor with the spectral walking images of people filmed and projected from directly above. In the cavernous spaces on either side, four suspended acrylic screens showed videos of a number of people getting dressed. It was surprising to hear these people on video speaking of their own deaths. What lay behind this strange scenario?

> During two months prior to the Biennale, we identified 36 Venetians of different neighbourhoods and social classes, and proposed to film them in their daily moment of changing clothes, whether inside their closets, homes or working spaces. To change clothes to enter the stage, to play his/her role on the city's stage.[14]

At the same time, the gondolier, the gynaecologist, the artist, the priest, the commander of the Navy Arsenal, the hotel porter, the personal trainer, and the others, were asked how they imagined they would finally die. We watched them with a poignant mixture of emotions: we saw their initial nakedness in the privacy of their rooms and their public masks, we saw the intense individuality of their death stories and their common humanity. Death as the great leveller. Death snatches away the king and the pauper. Perhaps Walter Riedweg had in mind the medieval tradition of the Dance of Death, as exemplified in the cycle of paintings on the Spreuerbrücke at Lucerne in his native Switzerland. A curious fact, though. Among

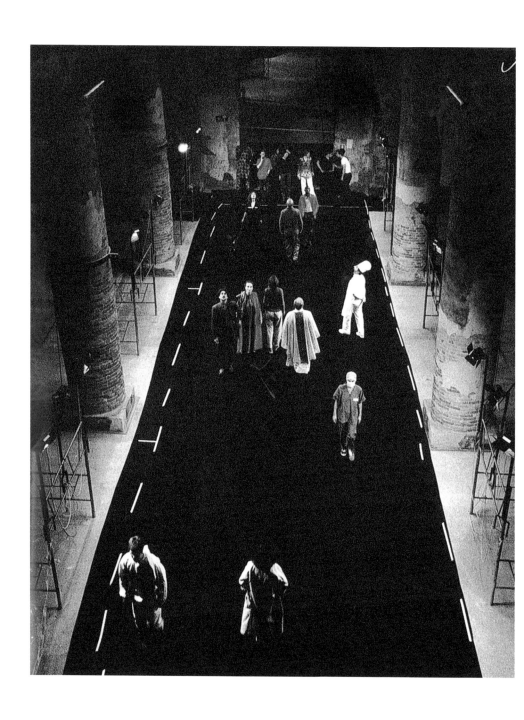

Maurício Dias & Walter Riedweg, *Tutti Veneziani*, 1999
Public art project and video installation 48th Venice Biennale

the Venetians interviewed was a Senegalese migrant who illegally sells purses at the Ponte dell'Accademia. The two works I've described seem strangely linked.

In their separate, brief, autobiographical statements included in catalogues, Maurício Dias & Walter Riedweg speak of their 'questionings'. Both resisted the future mapped out by their family background; Maurício, who was born in Rio de Janeiro, eventually went to study fine art in Switzerland but it was only when he took a job working with cows in the Alps that he understood 'what I wanted from art';[15] Walter, born in Lucerne, comes from a background of small mountain farmers. His mother and father made considerable sacrifices to enable all five children to study music and learn to play an instrument. This became the means for Walter to break away from 'everything that was programmed for me to be'.[16] He studied theatre and music in Europe and later went to New York where he acted and directed in theatre. In 1964, the year Maurício was born, Hélio Oiticica had begun to make his first Parangolé capes in Rio de Janeiro, and Lygia Clark was making her *Obra Mole* out of rubber. The experimentation of these two great questioners, indeed the general desire of the Brazilian avant garde of the 1950s to 1970s to re-think the relationship between art and life, and to fuse the corporeal with the mental, has been a crucial influence on the way Dias & Riedweg work. It has not been a superficial stylistic influence but one of deeper drives. The sensory workshops which the artists have often used in their public works as a starting point for dialogue have their origin in Lygia Clark's experiments of the 1960s. For example, in 1967 Lygia Clark made her Máscaras sensoriais (Sensorial Hoods), hoods of cloth which could be worn over the head with different substances sewn in front of the eyes, ears and nose. The experience of the eyes, normally the exclusive province of visual art, was woven in with

41

hearing and smell in a pluri-sensorial cluster. In the process the nature of the art object changed too:

> The old work, the object closed in upon itself, reflected an experience which was already in the past, lived out previously by the artist. While now the importance is in the act of doing, in the present. The artist is dissolved within the world … For the first time, instead of interpreting a fact which exists in the world, the same world is changed by direct action.[17]

Both Lygia Clark and Hélio Oiticica (as well as Lygia Pape in Rio and David Medalla in London at the same period) proposed models of 'individuality within collectivity', another conception which has proved structurally very fruitful for Dias & Riedweg and which they have rediscovered and extended in many forms and in many contexts. Lygia Clark experimented with *Collective Bodies* – groups of people linked together at their wrists and ankles by a web of elastic bands, or clothed in a single multi-cellular suit, in such a way that each individual's movement is affected by, and affects, every other's. Many small tensions and resolutions arise between individual will and the ensemble of others. Oiticica, paradoxically adopting a model of no-model from Brazilian popular culture – 'everyone creates their own samba, according to them, and doesn't follow models'[18] – made or planned complex, transformable environments which brought into relationship cabin-like spaces for solitary reverie and communal, usually circular 'jamming areas'. The public as co-author is basic to these artists' thinking. Oiticica imagined his propositions as a sort of template, or 'mother-cell', which could be taken up by others anywhere and mixed with local cultural possibilities.

There are many subtle references to the legacy of Oiticica and Clark in Dias & Riedweg's work, none of them imitative. For example, in *Voracidad Máxima*, the artists interviewed young male sex workers in Barcelona (known as *chaperos*), who wear rubber masks resembling

the artist who questions them. It is as if the artist was talking to himself. Originating on the one hand as a practical device to protect anonymity, the twinned mask also questions identity, and identification, the division of self and other, by deconstructing what would normally be assumed to be a confrontation. It is a remarkable transposition of Lygia Clark's *Dialogue: Goggles* (1968). In Lygia Clark's work, pairs of goggles joined together with small revolving mirrors between them are worn by two people facing each other. By turning the mirrors, they can either look into each other's eyes, or see fragmented views of the surroundings, or look back into their own eyes. The theme is continued in the careful staging of the *Voracidad Máxima* (Maximum Voracity) video installation. The artists and *chaperos* are dressed in identical white towelling dressing-gowns, lounging on a bed in a room with two parallel mirrors which continually displace back and front views of the speakers, confusing who is the addressor and who the addressee, the investigator and investigated. In the notes for the *Cosmococa* section of his *Quasi-Cinema* project of 1973, Oiticica had mused: 'mask ... to scramble roles ... situations ... the world of appearances ... psyche'.[19]

MIGRANT BIOGRAPHIES

We can in fact sense an identification between the artists and the *chaperos*. It is not merely that they share a sexual orientation, but that in their migrant lifestyle, and their 'voracidad máxmina' for new places and new facts or experiences they don't already know, the worlds of the artist and the sex worker become linked. The sense in which they do so is of course very different from the sometimes-heard condemnation of artists as 'prostitutes' servicing the art market and status-seeking clients. After making their interviews with the young men in Barcelona, the great majority of whom come originally from countries in the so-called developing world, Dias & Riedweg concluded that 'prostitution nowadays directly refers

to two main aspects of immigration worldwide: the individual desire to move and the economic condition. Sexuality and economics are understood here as the initial impulses for human movement'.[20] Prostitution becomes an instance, or a metaphor, for a desire and a need which is seen as both contemporary and widespread. Perhaps that is why the artists titled the show in which *Voracidad Máxima* was first shown, *Possibly Talking About the Same Thing*. The theme of immigration – as a many-levelled mixture between subjective desire and economic fact – has grown gradually within their work and they have made it the main focus of the present exhibition at Le Plateau.

Dias & Riedweg's desire for an enlarged idea of 'migration' comes at a moment when the phenomenon itself is revealing greater complexity than ever before. First, the scale of the figures. At the beginning of 2005, according to the International Organization for Migration, there were 185 million people in the world who were defined as international migrants. There were 19 million people defined as refugees, asylum seekers and internally displaced people, according to the United Nations High Commission on Refugees. Of course these statistics of movement conceal an enormous range of human experience, from utter wretchedness to something akin to pleasurable tourism, but this only adds to the difficulty of comprehending a process in which so many forces are at work. In his book *The Turbulence of Migration* (2000), Nikos Papastergiadis tells us that, today, 'the patterns of migration are ... so multiple and of such a complex nature that it is now impossible either to generalise about the logic which determines its causes, or to map its flows according to the binary co-ordinates of departure and destination'.[21] Papastergiadis questions whether, as is usually believed, economic survival is at the centre of migration, or if in fact the journey is 'the first step in the pursuit of a personal dream of cultural progress'.[22] A current map of global migration, he concludes one of his chapters, 'would have to be as complex as all the migrant biographies'.[23] It is exactly these biographies and their diversity that the two artists have

made the subject of their work, and which they devise imaginative procedures to reveal. Governments always stress national economic interests in deciding whether to accept or reject immigrants, rather than morality or justice, let alone the ancient rite of hospitality. If for a moment we see from the other perspective, the picture looks very different. In March 2002, when tens of thousands of people in Australia were protesting against the government's harsh policies towards 'asylum seekers', John Yu, a renowned paediatrician and vice-chancellor of the University of New South Wales, who as a child had been smuggled out of China before the country fell to Japan in the Second World War, said to the crowd: 'I cannot condone the systematic destruction of the hope and spirit of people who have suffered hardship and pain to reach our shores'.[24]

Where does the artist fit into all this? The nationalistic focus that, even today, defines almost all artistic institutions has obscured the complexity of artists' journeys in the modern period. The painter Lee Ufan, who was born in Korea in 1936 and went as a young person to live and work in Japan, describes his situation in this way: 'I am only a footloose man seeking after freedom. But one community makes a deserter of me, and the other an intruder. Both seem reluctant to accept me as an insider'.[25] At a certain point, Hélio Oiticica performed a kind of migration in reverse by leaving the prosperous parts of Rio de Janeiro and going to live in the *favela* of Mangueira. He went, not as a sociologist, reformer or dispenser of charity but as an artist in search of fellow artistic spirits there that he could collaborate with on the production of his Parangolé. Oiticica went to the margins and felt that he had found there the core of the social:

> In order to realise this vital experience, social preconceptions, group or class barriers, etc., had to be overturned, that was how I discovered the relationship between collectivity and individual expression […] I believe it was the very act of rejecting the so-called social layers that enabled me to see

the dynamics of social structures in all their crudeness … as if I were suddenly at a higher altitude seeing a map, a schema, as if I were 'outside' them. This sense of being marginal, which artists naturally have, has become fundamental to me: the total 'absence of social place' and at the same time the discovery of my 'individual place' as a man in the world, as a 'social being' in the fullest sense of the term …[26]

To make their single-channel video *David and Gustav* (2005), Dias & Riedweg interviewed two distinguished artists with a migrant background: Gustav Metzger, born into a Polish-Jewish family in Nürnberg, who escaped from Nazi Germany and came to London in 1939 as a stateless person; and David Medalla, who arrived in London from the Philippines in 1960 at the age of 18 and for whom the city became the base for a life of constant travels and art-making in destinations both far and near. Medalla has always been adamant that his experience has never been one of 'exile', that he feels at home anywhere in the world. Metzger speaks quietly but eloquently of contrary feelings – on the one hand he had the advantage over the settled national that being an outsider gave him: 'I could look at England in a cooler, more objective manner.' At the same time: 'As a migrant I'm in a state of trauma and I'll probably be in a state of trauma when I die. There are all sorts of negatives in being a migrant.'

Nikos Papastergiadis makes a point of including artists in his study of immigration. Artists 'are not only among the most mobile members of a community, but they are often outriders of the transformations between the local and the global'. And he goes on: 'Perhaps it is time for social scientists to face the more complex representation of reality that an artistic sensibility yields'.[27]

Flesh (2005) comprises two screens made of a special material that holds the images briefly before it fades – a little like a touch on the skin. On one screen we watch the gestures of five-year-old Mustafa, in the street outside the family house, as he mimes the actions of

his father killing the sacrificial lamb for the Bayram Festival in Cairo. Although the juxtaposition of the images of the child and the bloody lamb may hurt 'Western' sensibilities, Mustafa is perfectly at ease as he learns the rituals which enfold him into his culture. On the other screen we see sequences taken in a Swiss abattoir as serried ranks of animal bodies are slaughtered, decapitated, eviscerated, with the relentless precision and economy of industrial mass production, invisible to our daily lives. The two attitudes to 'flesh' may resonate with broader meanings. Rabindranath Tagore in India once commented sardonically on a British food product proudly labelled 'untouched by human hand'. For him it was not a recommendation but the opposite, and he could not resist taking it more widely as a metaphor for British rule in India. Tagore thought deeply about the impact of modernity on India in every department, from art and science to politics and daily life. He welcomed some aspects and criticised others (just as he did of India's own traditions), believing that modernity in India should be 'the outcome of [India's] own living'.[28] His critique has been taken up and extended recently by a writer like Ashis Nandy, in ways which can apply to every culture's struggle with the single dominant capitalist culture propelling globalisation.

The entrails of Mustafa's lamb exude from the body, plainly visible. Quite a number of Dias & Riedweg's works deal with a contradiction between the inner and the outer, according to several registers. *Flesh* itself is described by the artists as a 'chamber work', and in the Paris show it occupies a space between two larger pieces, *Labour* (2005) and *Sugar Seekers* (2004). The multiscreen *Sugar Seekers* was made for the Liverpool Biennial, in a complicated process whereby 12 young refugees spoke in response to a number of words (200 in all) which they associated with their situation. The artists filmed them and they filmed one another too. In addition, they made video collages of images from the internet illustrating the words they had chosen. The work's title is a play between the name of the exotic commodity on which Liverpool's prosperity was based, money made

47

by supplying slaves to plantations in the colonial Caribbean and importing the sugar, and the loaded epithet 'asylum seekers'. Among other things the work sets up a tension between the inner, personal experiences of the youths whose applications are being considered, and the outer, given words or available mass-circulation images they have to express themselves with:

> these people sit in their offices and listen to your story, because they ask you to tell your story, really your story, your background, your childhood, everything. You can't say it in one or two hours. You try to brief it. You try to make them understand, and when they go to decide they look at the papers, those few words you said …[29]

MEDIATION, PARTICIPATION

I believe the notion of an avant-garde art still holds true: an experimental space of sensitisation where 'futures not otherwise possible can begin to shape themselves', as Susan Hiller has put it.[30] Dias & Riedweg's extensive and powerfully staged use of the video camera makes it inevitable to see their work in terms of a challenge to the media, to the media's image of society. I mentioned this to Maurício and Walter one day when we were walking in Barcelona, and Maurício responded in an email: 'While the media tries to strip a context and rebuild it as one simple and singular message, to facilitate its absorption and consumption within the market, our work does the opposite: it inserts all levels of complexity and paradoxes'.[31] In this lies much of the 'humanising' effect which strongly marks their work. Thus they would stress and reveal the richness of individual subjectivity in the context of a group which has been coercively, conveniently, schematically or oppressively named (for example 'asylum seekers'). On the other hand, they might illuminate a context in which we are blinded by our individual pursuits from seeing the conditions we collectively share!

This latter was the case with their project *Recolectivo*, a collaboration with other artists, as well as the public, which took place in 2003 on the buses in the Argentinian city of Córdoba (buses there are called *colectivos* after a popular custom of sharing taxis). In a technique reminiscent of some 1960s guerrilla street theatre, a posse of collaborators would board the bus at a stop and unexpectedly, and sometimes hilariously, proceed to re-contextualise this mobile public space with private situations familiar to everyone. Thus passengers suddenly found their bus dripping with someone's weekly wash, or travellers were offered a manicure or a haircut, or a birthday cake was brought on board and a party took place …All this provoked much discussion in the bus.

It may be that there is no escape from mediation. Dias & Riedweg are mediators themselves in the sense that there are two sets of people with whom any piece of theirs is concerned: the people with whom they work and the audience which sees the final video installation. There is a meeting, in other words, between people in their guise as museum-goers, viewers of art, and people in some guise (they could be some of the same people) which represents a social category whose very rigidity and controlling power the artists want to question. In some works, there is a third set of people who experience the results of the original encounters before, or outside, the context of its exhibition as art, for example the citizens of Adliswil (*Inside and Outside the Tube*), who are drawn to listen to the migrants' narratives from the sonic sculptures in the town centre. All these meetings are critically, sensitively and imaginatively handled, and they make one wonder what further permutations of interaction are possible. The interaction by which museum viewers of *Voracidad Máxima* can 'choose a boy' by clicking on an image, or pick an abstract theme in the *Sugar Seekers* interviews by passing their hands over a word on a console, mimics the simple choices of consumer culture in a way which must be seen as ironic or satirical. But perhaps there are other forms of participation in which such estrangements can begin to be bridged and a wholly new kind of work appear.

Dias & Riedweg: Le Monde Inachevé, Le Plateau and
Frac Île-de-France, Paris, 2005

Javier Téllez
Worlds Real and Imagined

In the nature of things, it is a work of art I will write about here. My subject cannot be mental illness, which I have no direct experience of, which I have never lived. Anything I could say about 'madness' would be marked by this lack and would be monumentally irrelevant to any sufferer. Yet I can't ignore it since it is the subject, or point of departure, for almost all Javier Téllez's works, deriving from his personal history. He experienced the mental asylum in a very special way, not as an inmate, or a staff member, but as the child of psychiatrists. His father, Pedro J Téllez Carrasco, worked as a psychiatrist at Bárbula, the state mental hospital at Valencia in Venezuela. His mother, Teresa Pacheco Miranda, was also a psychiatrist. In the family living room, Téllez's and his brothers' play area doubled up as a space where his parents would see patients.[1] This combination of intimacy and distance became the grounding not for a medical but an artistic career. Such facts of biography have now become firmly attached to Téllez and appear in almost every verbal reference to his work, even the shortest. The last thing he would want, I'm sure, is to be simplistically branded, yet he has produced a body of work unique in recent art for its collaborations with psychiatric patients which result in complex mixed media works. These find their audience chiefly in the art milieu. What kind of collaboration is this?

In Téllez's own words: 'In a way I grew up next to the mentally ill, and this closeness from an early age served to confuse or to dissolve the borders between what's normal and what's pathological […].

51

Javier Téllez, *La Passion de Jeanne d'Arc* (The Passion of Joan of Arc), 2004
Video installation, Rozelle Hospital, Sydney

The mentally ill are the most marginalised individuals in society. I am interested in exploring the authoritarian control tactics exerted over these communities. My work attempts to bring one of society's peripheral subjects into one of its most central spaces, the museum institution.'[2]

Asked about the ethics of videotaping or photographing the mentally ill and displaying these images as artwork, Téllez replied:

> I think there is a moment of emergency when one faces a traumatic social situation. Then one has to choose – to paraphrase Hannah Arendt – the lesser of two evils. In my case I have chosen to represent something that has been condemned to invisibility. I do believe, however, that it is important to preserve human dignity within representation. I think many artists that have addressed social issues end up re-inscribing the same strategies of authority they set out to criticise.[3]

Expanding further on his position, Téllez relates:

> In my practice I try to create a flexible space where those represented can intervene in their own representation. According to [Emmanuel] Levinas, ethics is a devotion to the other: 'I have to forget myself to access the other'. Ethics has to be understood as a responsibility to difference. For me this responsibility is manifest in the inclusion of the other as an active participant in the work. This participation is capital in the production of the work: the patients are the main actors, they work on the scripts, choose the props, review the footage and comment on it. This inclusion obviously takes place within a framework that includes the conditions of distribution and reception of the art system. In the end it is about working in collaboration with other people. I never pretend not to be visible in the discourse,

but the work is articulated in the dialogue between my subjectivity and their subjectivities.[4]

Within this scenario of collaboration, rooted always in the local reality of a specific psychiatric institution, Téllez conducts an artistic practice that 'veers in myriad formal and philosophical directions'.[5] He plays with genres, he overlays discourses, visual disciplines and forms of mediation to make 'psychogeographic leaps' across space and time, opening up a scene of isolation and marginalisation to some of the greatest cultural and political questions that we face. Thus a contemporary psychiatric ward can be projected into medieval France, via the mediation of one of the masterpieces of early cinema, as Téllez and his collaborators – 12 women inmates of an Australian hospital – have done in *La Passion de Jeanne d'Arc (Rozelle Hospital, Sydney)* (The Passion of Joan of Arc, 2004). This subtle yet devastating video installation will be my main point of reference in this essay.

Erving Goffman, in his celebrated sociological study first published in 1961, *Asylums*,[6] described several forms of what he called 'total institutions': military establishments, prisons, monasteries, certain forms of school, and mental hospitals. Each total institution is a world in itself, cut off from the mainstream of society, with its own rules, customs, rewards and punishments. What they all have in common, however, is an almost primordial division between inmates and staff, rulers and ruled. Goffman's book is exhaustively concerned with the different realities and modes of behaviour of these two groups and the ways they may interact, without stepping out of their sanctioned roles. Total institutions are monumental instances of alterity. Each of the two groups is the other, of the other.

In his earlier work Javier Téllez was concerned to confront the psychiatric institution with the art institution, the museum, even if the museum could not be described as a total institution because it is open to society in general. Nevertheless, in Téllez's view the museum was certainly cut off from the asylum, even though the

issue of creativity was central to both. So, in his seminal early work *La Extracción de la Piedra de la Locura* (The Extraction of the Stone of Madness, 1996), he re-created a ward of Bárbula Hospital in the Museo de Bellas Artes in Caracas. Aside from this startling transposition, the hospital itself was represented at a key moment of its history. 'This public institution', in the words of author and critic Rubén Gallo, 'on the verge of being closed down, was founded in the 1950s and proposed an utopic treatment method of inserting mental patients in a vital and productive society, instead of incarcerating them in a small cell. More than a hospital, Bárbula was a real community, with chapels, theatres, artistic workshops and social clubs, attended and run exclusively by the insane.'[7]

Téllez's installation lamented the destruction of the creative atmosphere at the Bárbula and its replacement by treatments based on the heavy use of tranquilising drugs. He organised a children's party at the opening at which the children burst open hanging piñatas in the shape of pills. The debris of the party remained until the end of the show, sad traces of the end of something vital and euphoric. It was also clear that Téllez's metaphor extended beyond the example of the mental hospital to take in the museum as a social/cultural institution. Are museums places that celebrate the capacity of art to touch our deepest longings and conflicts, or are they places where culture is managed as a form of consumption and spoon-feeding? Though not locked into a structure of totality, museums are the location for the complex interaction and negotiation of two groups, artists and art professionals, over precisely this issue.

Tranquilisers and anti-depressants were a major visual feature of the excellent publication which accompanied Téllez's show. They were scattered in graphic form over a reproduction of the Hieronymus Bosch painting which gave the show its title on the front cover, and on the image of one of Franz Xaver Messerschmidt's portrait-sculptures of extreme human emotions on the back. Téllez also made a memorable installation in the Silverstein Gallery, New York, in the same year, in

which he occupied for the duration of the show a high-tech plastic cylindrical structure in the form of a gigantic Prozac capsule entitled *Jonac, 2001 mg* (1996). In modern hospitals, according to Michel Foucault's vivid phrase, quoted by curator Carmen Hernández in her insightful analysis of Téllez's *Piedra de la Locura*, 'pharmacology has already transformed the wards of the agitated into great lukewarm aquariums'.[8] By contrast, Hernández concludes, Téllez 'wants to restore madness to its ancient status as a mysterious and cosmic agent of destabilisation'.[9]

Destabilisation: it could invoke the link between madness and carnival which Téllez has often mentioned. He cites as a very powerful and formative experience in his youth, the sight of inmates and staff exchanging their uniforms amid laughter at one of the annual festivities held at Bárbula: a pure trope of the carnival reversal of consecrated roles and power relations. In Russian philosopher Mikhail Bakhtin's classic definition:

> Carnival is not a spectacle seen by the people; they live in it, and everyone participates because its very idea embraces all the people. While carnival lasts there is no other life outside it. During carnival time life is subject only to its laws, that is, the laws of its own freedom. It has a universal spirit; it is a special condition of the entire world, of the world's revival and renewal, in which all take part. Such is the essence of carnival, vividly felt by all its participants.[10]

Roberto DaMatta, writing of the Brazilian carnival – in its form of mass-participatory improvisation rather than the TV spectacular it has increasingly become – identifies it with the 'thousands of microscopic carnival dramas, these tiny plays of the people in which every citizen has the right to act and participate, once he or she is duly garbed in fancy dress and steps into the streets revealing what they may have liked to have been, or could have been […] this *fantasia* […] the equality and liberty of the individual in a profoundly controlled, authoritarian and hierarchical society'.[11]

55

It is interesting to note that English has two words – madness and folly – for what is denoted in Spanish by a single word: *locura*. In English usage, folly evokes something different from madness/insanity. It evokes the rich terrain of nonsense, jesting, truth saying and, of course, carnival laughter. Erasmus's famous book is titled in English *The Praise of Folly* (1511); if it were called *Praise of Madness* it would mean something quite different, even perverse. It seems the notion of folly is difficult to reconcile with the word *locura*, whose synonyms in Spanish stress a 'raving' condition: *demencia, furia, rabia*. In the end, of course, folly is a very ambiguous concept because of the reversibility of its values. Under differing conditions, what is conventionally or officially considered foolish, or wise, can be exchanged. William Blake was preoccupied with this paradox and expressed it unforgettably, playing with the reversals of meaning. In fact, if we consider Blake's celebrated text *The Proverbs of Hell*, a section of *The Marriage of Heaven and Hell* (1790), we see that in some 'proverbs' he equated folly with foolishness, and in others, with wisdom. He allowed full play to this ambiguity, with the equation folly = foolishness apparently predominating. 'If the fool would persist in his folly he would become wise'; but equally, 'The hours of folly are measured by the clock; but of wisdom, no clock can measure'.

The whole text of the *Proverbs* revolves round the desire to question and play with the absolutist notion of opposites. Erasmus wrote his *Praise of Folly* for his friend Thomas More, the author of *Utopia* (1516). More kept a Fool in his household, named Henry Pattenson, as did kings and aristocrats. The English Feast of Fools was a popular annual event which the Church tried for generations to suppress. As Carmen Hernández relates in her essay, Erasmus refers in his book to Saint Paul, who likened the notion of the Christian to that of the fool, knowing that 'fools had the privilege of being the only one who could say the truth without offending'.

The liberating aspect of carnival folly, and its capacity to produce endless subversive variations and upsets of the official order, often

in quite unexpected ways, was illustrated by an anecdote Javier Téllez told me once about his event *One Flew Over the Void*, which took place at Tijuana in 2005, on the frontier between Mexico and the United States, a border which Mexicans frequently risk their lives to cross in order to find jobs in the US. As part of the work, inmates of the Baja California Mental Health Center in Mexicali formed a parade, part circus, part carnival, part political demonstration, drawing a parallel between the geopolitical border and the demarcation confining them to the mental institution. As the noisy procession arrived at the border area, a human cannonball was about to be shot in a high arc across the frontier (certainly a novel form of immigration!) Presumably his papers had been exhaustively checked before he was allowed inside his cannon. While the large crowd that had gathered to witness the spectacle – local people, art world types, media crews, police and immigration officials – stared into the sky expectantly, a Mexican worker took the opportunity to slip through the fence and cross undetected to the US.

La Passion de Jeanne d'Arc was evolved with women patients of the Rozelle Hospital, Sydney, and was first shown at the 2004 Sydney Biennale, curated by Isabel Carlos. The set-up was as follows: in a dark grey carpeted room are two screens, on opposite walls. They cannot be watched simultaneously, although a soundtrack of voices from one of the two films which make up the installation, *Twelve and a Marionette* (2004), can be heard at all times. The screen for the other film, an altered version of Carl Dreyer's black-and-white silent classic, *The Passion of Joan of Arc* (1928), is smaller than that of *Twelve and a Marionette*, which is filmed in 16mm colour. There are in addition 12 chairs similar to those found in the waiting rooms of state hospitals. Three velvet curtains divide the space into an entry/exit corridor and the projection space proper. The curtain is red on the corridor side, evoking a movie-theatre, and on the other side it is made up of Rozelle Hospital bedsheets, on which the stamp of the institution can be seen. On one wall of the corridor is the blackboard used in

Javier Téllez, *One Flew Over the Void (Bala perdida)*, 2005
Production still

both the modified Dreyer film and in *Twelve and a Marionette*. It shows the work's title and the signatures of the 12 women collaborators.

The original inter-titles of Dreyer's film have been removed and substituted by inter-titles authored by the inmates. They appear as written by them on a blackboard, to be rubbed out and replaced by the next one as the film progresses. The removal of the original inter-titles hides references to history (for example the extraordinary achievements of the near-illiterate peasant girl who emerged, while still a teenager, to gain the confidence of the Dauphin, lead the army and reverse the fortunes of France in the Hundred Years War with Britain). And we miss the substance of Joan's trial after she was captured by the Burgundians in league with the British. What remains is the relentless, yet infinitely modulated, manifestation of power and authority to which Joan was exposed. It is this that has been recast by the Rozelle patients' inter-titles to become a conflict between inmates and staff in the mental hospital.

In a way this is completely consistent with the legend of Joan of Arc. As author Marina Warner writes in her masterly study of *La Pucelle*, 'Joan was already, in her lifetime, slipping away into a world of emblems, of personified abstractions.'[12] Warner traces the subsequent remodelling of the figure of Joan, often serving opposed ideological ends, up until recent times. The inmates studied the story of Joan, with the artist. The significance of Joan, and Joan's trial, for them is clear from their inter-titles. Early in the sequence a title asks: 'How old are you?' The answer comes: 'six hundred and twenty-five years old'. Some tiny details are matched: in the scene from Dreyer's film where Joan's ring is prised off her finger by soldiers, to her distress, and then returned to her by a kindly monk, the asylum institutional experience comes up: 'You can keep your belongings with you.'

Marina Warner writes that Joan of Arc 'transgressed against class, sex, social boundaries and feudal expectations'.[13] She was seen as on the margins between the categories of saint and witch. One feature of transgression, or heresy, which dominated her trial was the adoption

of male dress, which she defended vigorously. Warner comments: 'The many female saints who had lived as men […] do indeed present a powerful group, so numerous that they must signify more than mere curios of sexual history.'[14] And she observes: 'Shamans, in the rituals of many cultures, cross-dress in order to deepen their power.'[15] The other theme, which particularly interested the women of Rozelle Hospital, was the voices which Joan claimed she heard. They represented for her the word of God, conveyed to her by the saints Margaret and Catherine, and the archangel Michael. She was guided by the voices in all her actions. In Téllez's work this was directly transposed to the institutional treatment of mental illness. 'Are the voices inside or outside your head?', reads the blackboard. Many inter-titles are concerned with the coercions of the treatment process: 'Have you stopped taking your medication?'; 'You have to listen to the doctors'; 'We know what is better for you'; 'I agree to the terms and conditions', etc. Joan's refusal to submit to the Church authority (the Catholic Church on earth, known as the Church Militant, headed by the Pope), recognising only the authority of 'God my creator', i.e. her voices, 'who caused me to do what I have done',[16] rises to a crescendo in the film as it does in the inmates' inter-titles: 'You are un-cooperative'; 'You have to comply and sign the treatment form.'

In describing the dynamics of the asylum, Goffman speaks of the 'multitude of items of (the inmates') conduct […] that constantly come up for judgement'.[17] The atmosphere of relentless judgement is exactly what is conveyed by Dreyer's film technique. Dreyer's *Passion of Joan of Arc* is above all a study of faces. It is mainly shot in close-up, and pushes to a new intensity the clash of two apparently opposed tendencies of avant-garde cinema of its day: realism and expressionism. The film is the continuous parade of an expressionist repertoire of character types: physiognomies and emotions of the various kinds of judge that approach Joan and inspect her, conferring with each other while fixing her in their stares. In the trial itself 'sometimes more than seventy men attended a single session to listen to the

cross-questioning';[18] Joan's face shows none of this ready-made characterisation. In a way it is a blank sheet on which the tiniest inflections register her suffering, removing her to a different spiritual plane from her captors. Dreyer's work draws on the many variations of the Mocking of Christ and the Man of Sorrow themes that we know from medieval paintings – except that it is a Woman of Sorrows; except again that it is a woman who cut her hair like a man and dressed in male clothes.

Joan's monochrome monumentality also acts like a foil to, but also a kind of essence of, what we see on the other screen: the individual subjectivities and struggles of the 12 women participants. They are filmed in colour, not tidied up in any way. One, Carli Vinen, speaks in the form of a dialogue with a small puppet psychiatrist she holds on her knee. Even the mug-shot routine – front, side and back views, returning to full face – which introduces each speaker stresses the individual uniqueness of the sitters, not their entrapment by surveillance. The camera does not feel like a cold observer. Selves may be fragile, but each speaker is an active author, not always fitting the mould we might expect. One woman praises the electro-shock treatment, for example. As the critic Lilly Wei perceptively noted in a review, Téllez's work 'avoided all the usual bromides about the inmates of such institutions being saner than their keepers, instead providing an unsentimental, steadfast look at these women's essential humanity'.[19] Between each monologue there is a brief travelling shot of the hospital corridor, incongruously accompanied by the yearning, beautiful sounds of the *Erbarme dich* aria from Bach's *St. Matthew Passion* (1727).

For his part, Téllez provides a clearly aesthetic – and moving – finale to this film. As the speaker Lucy Giordano gives her credo, the music very gradually fades in, and then she is seen in close-up in another setting, playing the music for herself on a gramophone and going into a reverie, into another space. Because of the different lengths of the two films, which are projected continuously, the

synchronicity between the two scenes is always slightly changing. 'A sort of machine à la Ramon Llull', Téllez calls it, 'producing permanently new signifiers'.[20] It's not impossible that Lucy Giordano's reverie could coincide at some point with Dreyer's harrowing and anguished sequence of Joan's burning. 'It's not completely aleatory, since the women who are talking, or singing in one scene, studied Dreyer's film and the Joan of Arc trial for the making of the piece. I think it is in these emotional echoes and correspondences that the essence of the piece can be located.'[21]

Structurally, the screens of La Passion de Jeanne d'Arc are face-to-face, and in both films, as viewers, we face faces. In the philosophy of Emmanuel Levinas the face-to-face encounter with the other is taken as 'the primal moment from which all language and communication spring [...] The face of the other demands we care for others because it established a basic I-thou relationship.'[22] Levinas locates in the simplest expressions, the greeting 'Bonjour', or the reflex 'Après vous, Monsieur', recognition of 'the existence of the other as fellow, as another subjectivity to be welcomed and cared-for.'[23] A kind of micro-ethics. This interpretation would certainly seem to be borne out by an apparently trivial incident of inmate experience recorded by Goffman in Asylums: 'Even the canteen staff seemed to share the opinion that civility was wasted upon lunatics and would keep a patient waiting indefinitely, while they gossiped with their friends.'[24] However, while seeing exactly what Levinas and Goffman mean, and identifying with their ethical position, one cannot forget that many murderers and human monsters are capable of being perfectly civil and appearing to their neighbours to be ordinary and nice.

Of course, reality is mediated in both Levinas's writing and Téllez's installation: both are 'talking about', rather than directly constituting, a face-to-face encounter, based as they are on reflections upon lived experience. But is it ever possible to escape mediation? The Joan of the Australian work is not the real Joan (she can never be recovered), but a mediated Joan – by her biographers, by Dreyer,

by the inmates' inter-titles. In fact, there is a further mediation, more hidden: the whole scenario at Rozelle is supposed to be the story of a patient's delusion of grandeur that she is Joan of Arc (even Erasmus, in his book, wrote of folly in the guise of a fictitious speech by Folly herself to an audience of Fools).

One of the most complex structures of mediation in mid-twentieth-century theatre was Peter Weiss's play known as *Marat/Sade* (1963) which, interestingly enough, purports to be set in a mental institution. Its full title is: *The Persecution and Assassination of Jean-Paul Marat as Performed by the Inmates of the Asylum of Charenton Under the Direction of the Marquis de Sade*. What we have there is twentieth-century actors playing the inmates of an eighteenth-century asylum, who in turn are playing in a fictionalised version of revolutionary historical events which had taken place 15 years previously. The twentieth-century writer and director was trying to imagine what one of the most notorious thinkers in the history of philosophy might have come up with as a writer and director working, not with actors, but with asylum inmates, being himself one of them!

One of the dynamics of *Marat/Sade* was that the rational, scientific ideas of the Enlightenment, which were supposed to have inspired the treatment of patients at Charenton Asylum, who were 'constantly punctured by insurgent inmates who were clubbed to the floor when they got out of hand'.[25] Many theatre-goers at the time were appalled by the graphic violence on stage, by, in the words of one commentator, 'the writhings and meanings and ritual head-bangings of the impersonators of the insane'.[26] Certainly, Peter Brook's production of the play, influenced by Antonin Artaud and his ideas for a Theatre of Cruelty (another strange connection here: Artaud had acted the part of a monk in Dreyer's *Joan of Arc*), was designed to shake up the complacency and gentility of British theatre at the time.

Yet what strikes one, looking at photographs of the production today, is the overbearing theatricality of it all, a succession of set pieces almost like a demented Folies Bergère. As an image of the

mentally ill it could hardly be more different to Javier Téllez's partici-
patory and collaborative performances, which, however, are no less
fictions, no less works of imagination, well described by one reviewer
as 'unpremeditated stagings which surpass and overexpose the
routine "reality" of the psychiatric institution'.[27]

In other words, even if mediation is inescapable, artists will
continue to question its relationship to the real in the conditions
of their time and place. Indeed today, the closeness of the word
'mediation' to the word 'media' has sharpened the whole matter of
the authenticity of the image of the world which is presented to us.
In the Brazil of 1970, the artist Antonio Manuel made an action which
entailed his appearing totally naked at the opening of the National
Salon of Modern Art at the Museum of Modern Art of Rio de Janeiro –
exhibiting himself as the work of art. It was an act of great courage,
not only vis-à-vis the conservatism of the Brazilian art establishment,
but also of the general repression of art and artists under the military
regime. The critic and writer Mário Pedrosa interpreted Manuel's act in
even broader terms, as an attack on the society of mass consumption
and mass media. Only the artist 'frames issues in their ultimate
authenticity', he declared, in contrast to the inauthenticity of media
communication. 'It is not the media which communicates with
others but rather the fact in itself – the fundamental irreducible
unit of the person – that communicates with the other.'[28]

The connection between mediation and alienation was explored
with precision and wit in a work of Mona Hatoum, *Pull* (1995). It was
set up in Munich as a three-day event. The spectator was invited to
pull a hank of hair hanging down in a specially constructed niche
below a TV monitor. The artist's face on the screen registered a feeling
of pain or discomfort. When I saw slides of this work I thought the
image on the screen was a pre-recorded tape. I had no idea Hatoum
was physically present behind the wall, that it was her actual hair
hanging down (with an extra length platted in), and a real sensation
registering on her face. So conditioned was I to the distance of the

TV image, the media image, the lack of a direct connection with me, that my reaction seemed involuntary. The presumed process of this work would be the spectator's gradual realisation that there is a direct connection between his or her action, and the person whose electronic version appears before them. At a certain moment the spectacle suddenly ceases to be a spectacle. The response calls forth one's intimate psychology and Hatoum noticed that, on the whole, men yanked the hair without compunction, whereas women were more gentle, and even reluctant, through self-identification.

Téllez's work inserts itself here, with Antonio Manuel's and Mona Hatoum's, and many other examples one could give, within two movements, concepts or practices which have arisen in the visual arts in the last 50 years and challenged the ruling assumptions of the art institution: participation and performance. The many scenarios of participation have basically posited the spectator as an active agent in the realisation of the work, rather than a passive consumer. The equally diverse scenarios of performance have explored the ambiguous, fluid borderline between 'being oneself' and 'acting a role'. This borderline becomes particularly vivid and rich in the performance work of the ensembles Téllez has instigated.

At the beginning of this essay I quoted Javier Téllez's assertion that his youthful exposure to psychiatric institutions had 'served to confuse or to dissolve the borders between what's normal and what's pathological'. It has been his practice to bring this confusion as an active principle out into mainstream society, which is driven precisely by the anxiety to very clearly establish and vigorously defend the difference between normal and pathological, a state of affairs to be dissolved only by the Fool or by certain kinds of visionary.

The implications of Téllez's intervention are therefore far-reaching. At the present time, two opposite processes appear to be unfolding simultaneously, antagonistic to one another: one represented by initiatives such as Téllez's, and the other by the structures of power. The first is emancipatory in nature, the other authoritarian and

oppressive. For while Téllez provides creative models for bringing to light, and into the mainstream, what is excluded and rendered invisible, so-called normal society is beginning to look more and more like the 'total institution' Erving Goffman describes in his book. To a pathological degree indeed! Curator Okwui Enwezor has recently written of the increasing number of instances where forms of public speech are being stifled in the name of security: 'Everything is now subordinated to the vast apparatus of watching and keeping watch over, a pathology of surveillance that knows no end.'[29] Philosopher Giorgio Agamben has drawn similar conclusions: 'Today', he writes, 'one sees the beginning of a society in which one proposes to apply to every citizen the devices that had only been destined for delinquents [...] The normal relationship of the state to what Rousseau called "the members of the sovereign" will be biometric, that is to say, generalised suspicion.'[30]

In Téllez's model such generalised suspicion is replaced by reciprocal exchange, reciprocal borrowing between life-worlds that are considered to be totally estranged, unknown to each other. It would be erroneous to speak of such borrowing in terms of any intentions to offer a cure for psychiatric distress, but if one were to use such terms, it would again be to question the common assumption that it is the patient who needs therapy. 'The cure', Téllez has said, 'could perhaps be offered to those who go to the museum to see the work, those who consider themselves normal... If there's something to cure, it is undoubtedly society, not the patient.'[31]

Javier Téllez 4 ½, Hike Wagner (ed), exhibition catalogue, Kunstverein Braunschweig and Snoeck Verlag, Braunschweig and Cologne, 2009

Jimmie Durham
The Questioner, Material and Verbal Wit

The word 'wit' has a fascinating etymology. Like most words it has
changed over time, taking on and shedding meanings, evolving
in close proximity with life, organic, expanding and contracting in
its use. The modern definition of wit as 'amusing verbal cleverness'
has taken the place of a much broader meaning. In the Renaissance,
wit was associated with 'intellectual keenness and a capacity of
"invention" by which writers could discover [...] resemblances between
apparently dissimilar things'.[1] The French word for wit is the same
as that for spirit, *esprit*; it is possible to link intelligence, imagination,
humour, wisdom and spirituality in a single concept. The French
word continues to expand its links until it reaches something almost
cosmic in its scope: '*Esprit* n.m. spirit, ghost, soul, vital breath, vital
principle; mind, sense, understanding, intellect, wit, fancy, humour,
disposition, temper, character, meaning, spirits, spirituous liquour;
breathing, aspirate.'[2]

Even though it touches on all these interconnecting energies,
wit cannot be explained because it works by surprise. A revelatory
surprise – challenging the received, stereotypical, 'straight' wisdom –
can be found even within the conventional statement, simply by
reversing its terms, as Oscar Wilde so often did:

> Anyone can act. Most people in England do nothing else.
> To be conventional is to be a comedian.[3]

Explanations of wit, especially academic ones, lack the very energy
they celebrate, and writings about wit are rarely witty in themselves.

Jimmie Durham, *Arc de Triomphe for Personal Use (Yellow)*, 2007
Metal, 220 × 115 × 70cm
Dena Foundation for Contemporary Art, Paris

Nevertheless, wit is such an outstanding feature of Jimmie Durham's work both in sculpture, or object-making, and in writing that it is hard to resist the temptation to try to account for some of its workings, in particular the unique tone Durham gives it.

We could begin with Durham's own beginnings, the varying descriptions of the hesitancies and self-questionings involved in beginning a text or a speech.

> Originally this paper had three titles, by which device I'd intended to show my own hesitancy to attempt a clean statement.[4]

> I am going to speak about four areas of … well, four areas of something. But before I explain what those four areas are, I want to begin with a warning. I was asked to provide at least one outline of what I would say. I intended to do it but it became more and more problematic. I realised that these days I want to be pointless … I am trying to trust my confusion.[5]

And even on one occasion:

> Oh … someone is at this moment ringing my doorbell (!) and I'm going to answer it because it might be …[6]

There is an enormous variety of this kind of disclaimer at the beginning of his texts. It is as if he wanted to start off in the least authoritarian or presumptive way possible, to make an immediate empathy with the reader. Who else would title a book *A Certain Lack of Coherence* (1993), that was expounding the author's radical and often militantly activist ideas, and would begin the Author's Note in the first few pages in such modest and personal terms?

> Sometimes I think that remorse is the main element of my life; not for grand tragedies but for little everyday stupidities and unkindnesses. If only I could take back my words! If only I had spoken …![7]

Continuing with the motif of reversals (the modus operandi of Carnival the world over, the reversal of the established order) we can extend it to the device of self-deprecation: the use of the negative to arouse in the audience the opposite, to release their laughter and/or to empower them. We can see its workings in two wide-apart situations: the patter of the English comedian Frankie Howerd, and the Chinese writer Lu Xun, whose speeches in the 1920s sifted the reactionary from the progressive in Chinese life with humane intelligence. Frankie Howerd would appear on stage wondering what he was doing there. His subtle negation consisted in his jokes about having no material, no talent, that he has been hauled out again by popular demand without having anything prepared or anything to say. Naturally, it was all pretence. Lu Xun, surrounded by an audience of young people, would typically begin, 'First of all, I want to express my respectful appreciation to all of you who have come through this downpour to hear one of my empty and futile talks.'[8] Jimmie Durham's version might go:

> I expect that you are of two minds reading the 'conclusion' so quickly on: one of relief that there will not be more here, and one of frustration that you've invested time and intellect in something that really went nowhere.[9]

Such is Durham's attentiveness to words and their shades of meaning, that a word will suddenly trip him up in the midst of the text he is writing, or the speech he is giving, and lead to an aside. These asides actually take the form of a direct address to the reader or listener, involving them in the question being raised. For example, in the middle of an attempt to describe 'power relations' and their different 'physical…' *he is searching for the next word and digresses into parentheses*: '(not knowing another appropriate word, I suppose I must go ahead and use the word "manifestations" which is really ugly isn't it? The festival was infested with festering manifestations).'[10]

Here is another of many bracketed asides. He is telling a Cherokee story about a grandmother spider – in human form – who secreted food from her own body to give to the twin grandsons (who were the first humans).[11] When the boys discovered the secret of the source of their food, Durham writes,

> they were so horrified and nauseated that they could
> not contain themselves (isn't that the most incredible,
> and most English, English phrase? They couldn't contain
> themselves. Maybe if they had been English boys, they
> would even have lost themselves. 'I'm sorry, I forgot
> myself', Princess Di used to say when she could no
> longer contain herself).[12]

The scrupulous, alert, wide awake, wary yet wondering attention Durham pays to language is hinted at in a metaphor that can be traced all the way back to his childhood on Cherokee lands.

> I grew up in the woods and it was dangerous. There
> were five kinds of poisonous snakes. There were bugs
> that could kill you; all sorts of things that would bite or
> scratch you or make you sick if you breathed too close
> to this tree and so on. It made us careful, it made us
> move carefully.[13]

The Sioux writer Vine Deloria Jr devoted a chapter of his book *Custer Died for Your Sins: An Indian Manifesto* (1969) to 'Indian humour' and complained that 'the professed experts on Indian affairs never mentioned the humorous side of Indian life'. Rather, the image of the 'granite-faced grunting redskin' had been perpetuated by American mythology. 'The Indian people are exactly the opposite of the popular stereotype', Deloria writes. 'Indians have found a humorous side of nearly every problem and the experiences of life have generally been so well defined through jokes and stories that they have become a thing in themselves.'[14]

Jimmie Durham has cultivated a light touch and a conversational tone for dealing with problems, but at certain times his jokes are in deadly earnest. One of his most powerful writings, 'The Immortal State' (1991), uses his etymological erudition and a dark wit to mount a withering attack on the concept of the nation-state. It begins:

> When one is confronted by the State one might wish to
> kill oneself, yet a primary act of the State is a law against
> suicide. In a castle in Belgium there is a Museum of Justice.
> Amid the horrible implements of torture, a leather padded
> cap is on display. Its purpose was to prevent the torturee
> from killing herself by beating her head against the wall.[15]

Durham's attack on the nation-state in general represents a broadening out of his concern for the predicament of the Native American peoples in particular. His concern has expressed itself in a thousand different ways, from the stark facts of the treatment of 'Indians' in the nineteenth-century United States of America, to subtle speculations more recently on the notion of identity within historical processes. In 1988 Durham staged a play, *Columbus Day*, in collaboration with Natasha Drootin, which centred around a compilation of historical statements on 'Indians', and included a terrifying text by Durham in which he tried to imagine what it would have been like to stand in line to have a foot cut off in one of the early acts of organised brutality by Spanish Conquistadors at Acoma Pueblo in December 1598. A striking thing about many of these collected statements is the banal, but highly revealing, level at which the dominant culture imposed its values. A missionary wrote in 1896:

> To bring him out of savagery into citizenship we must
> make the Indian more intelligently selfish before we can
> make him unselfishly intelligent. *We need to awaken in him
> wants* […] the desire for property of his own may become
> an intense educating force. The wish for a home of his own

awakens him to new efforts. Discontent with the Tepee and the starving rations of the Indian camp in winter is needed to get the Indian out of his blanket and into trousers – and trousers with a pocket in them, and a pocket that *aches to be filled with dollars*.[16]

Such history leads Jimmie Durham, almost exactly a hundred years later, to ask the question:

> How can we think of ourselves and our history instead of someone else's given narrative? That sounds like just a little first step but over the past ten years we have been talking about 'who we might have been'. Who could we possibly have been before Columbus, before the Pilgrim Fathers and how would we be able to know who we were? We have now come to the conclusion that we were probably pretty much normal human beings, much like other human beings.[17]

> I so loved the dumps [on the edges of the towns of Durham's childhood] where one could find the products of civilisation, elegantly, surrealistically juxtaposed with pieces of wood, magic rocks, bones and wild flowers, that they have remained a metaphor by which I define myself.[18]

Elsewhere Durham asserts that his sculptures are made from 'everything people are trying to discard […] everything people are trying to hide, discard, or ignore. These are the things I want to reclaim'.[19] Just as strong as verbal wit, there runs in Durham's work what can only be described as a material wit. Sometimes the two overlap or combine in a piece, but at the same time they remain distinct and there is a kind of wit which resides in the material and has no need of verbalisation. It is not just the material as such or in itself, of course, but the way it is chosen and handled by the artist. Durham is constantly making juxtapositions of pieces of material which are unexpected and seem just right, drawing an immediate smile. But no

words. And he pays as much attention to those materials as he does to words. They are parallel universes. I have long thought that the artist's desire to reclaim 'everything people are trying to discard, to hide, to ignore' epitomised in the work of artists like Kurt Schwitters, Jean Tinguely or Robert Rauschenberg and many others, was one of the most powerful currents in modern art, a continually renewed antidote to the heedless waste and narrow imaginative possibilities of the consumer culture. At the same time, its radical reversal of prevailing and established values may go all the way back to philosopher Heraclitus and his famous statement, 'The fairest order in the world is a heap of random sweepings.'[20]

How perfect is the linking between humble sweepings and the cosmos! Durham is made happy whenever there is an interruption of the official line. We are suddenly released from what Russian philosopher Mikhail Bakhtin called 'the gloomy and false seriousness enveloping the world, and all its phenomena, [to lend it] a different look, to render it more material, closer to man and his body, more understandable, lighter in the bodily sense.'[21] Durham's sculpture is subversive of the official order in precisely this sense, as, for example, in his *Arc de Triomphe for Personal Use*, first realised in 1996, which mocks the pomposity of the monument, and any self-importance on the part of the artist, with a lightweight and spindly construction you can pass through.

In the video performance featuring a 'bureau for smashing things', which was realised as part of Durham's teaching residency at the Fondazione Antonio Ratti, Como, Italy, the artist is seated behind a desk on which lies a prehistoric stone tool. The camera stays focused on the artist and the desk as people enter from off-camera, one by one. As they lay their 'something' on the desktop in front of the artist he picks up his stone and smashes the object, sending fragments flying in all directions. If some small pieces escape he smashes them again. He clears the table after each 'submission' and issues a 'certificate of some sort' to the bringer. His expression throughout is

Jimmie Durham, *Smashing*, 2004
Video, 92min

impassive and distant, though he laughs at the end. The term 'bureau' immediately alerts one. Seeing the proposition with which one comes to the table crushed and smashed, casts the obstructive negativity of the Bureaucrat in stark terms. There is surely also here a reference to the Bureau of Indian Affairs, the official US body which oversaw the colonisation of the Native Americans' land and lives. In its rich associations, the performance evoked too the legal scenario of the judge with his gavel, and the art-world ritual of the auctioneer and his hammer (I once saw on television an auctioneer's hammer fall to pieces as he slammed it down to seal the sale of a fragile Chinese porcelain vase).

In relation to material wit, Jimmie Durham's work has changed over the years in ways which are typically paradoxical. In earlier days, when he was closely involved in the resistance struggles of the Cherokee and other Indian nations, he worked a lot with animal skulls, which would often crown a rudimentary wood substructure. Fierce but desiccated, the sculptures seemed to want to re-release the vital energy surviving latently in the wood and the bones, or, in the contradictory but tender way he put it, to try to understand 'what each particular animal (I mean the individual, not the generic) feels about being dead'.[22] Later, as his intellectual practice broadened and he launched his Eurasia project, he decided not to continue with the animal skulls, 'because the only place for such things in Europe is exotic anthropology'.[23] Instead he turned to stone.

In the book *Amoxohtli, Libro de Carretera, A Road Book* (2011), in a photo-sequence and a video, we see a huge, stony, obdurate mass lifted with a crane and slowly lowered on to a Dodge 'Spirit' limousine which it proceeds to crush. Later, by painting on to it two eyes and a mouth Durham turned it into an amorphous, unaggressive monster. Further recipients of a similar treatment have been an ailing mini-truck (with Durham crammed into the front seat), a boat and a light aircraft. All these images are comical, absurd, but disquieting, giving the overwhelming sensation of weight, a huge silent presence which is

both sculptural and social. Durham sees such heaviness in paradoxical terms, that its wit will be to give birth to is opposite, lightness. 'I want to do different things with stone, to make stone light, to make it free of its historical weight, its architectural weight, to make it light [...] free of monumentality', he writes.[24] Arguing against a certain mental rigidity, he observes that 'cities are as stony, for example, as are hills and plateaux, but the stones are usually ordered into buildings, streets, curbs, monuments. They, like us, must work. When undisciplined life happens, or chance, or a rabbit in the park, don't we feel liberated? I mean when "nature" happens in the city ...'[25] In the general workings of material wit he does not forget to mention that when we write with a pencil we use 'the stone called graphite, drawn across white paper'.[26] And yet, from the tiny to the vast, from the heavy to the light, how limited and relative are the terms we use! The rest is imagination, metaphors and similes. We are told by a scientist, for example, that the huge pressure achieved by the experimental laser fusion generator HiPER is 'equivalent to ten aircraft carriers resting on your thumb'![27]

Durham's continuous travels and sojourns in different countries and cities have led him to 'observe other movements and the crossing of innumerable paths'. I was entranced to come upon a small vitrine he made for the section of contemporary artists invited to make works in response to the exhibition of Hieronymus Bosch at Museum Boijmans van Beuningen, Rotterdam (2001). Crowded with invented monsters and strange plants, it was as if Durham had grown a Bosch landscape in one of the placid window boxes of a Flemish town. A perfect example of 'observing other movements and the crossing of paths' is a diary Durham kept between May 2000 and September 2001, in collaboration with artist Maria Thereza Alves; it was eventually published as *Nature in the City: A Diary*, a modest but exquisite little booklet, and part of an exhibition of free give-aways organised by Büro Friedrich in Berlin. Durham and Alves set themselves to notice and record evidences of nature which normally no one troubles to

heed or to mention but which exist within their own time patterns, within but detached from the time pattern of the city. A sample entry runs:

> We went to have lunch with Johannes Kahrs on his roof in Kreuzberg. I saw a bee, like a kind of bumblebee, who had its dwelling in a hole between bricks on the roof wall. An eastern crow landed on that wall as we ate, and cawed … we later stopped for coffee and a small black beetle landed on the table in front of me.[28]

If *Nature in the City* is attuned to another life, independent of the human, Durham has continued to produce works of strong social commitment, deriving from his response to specific places and circumstances. Such was his contribution to the 29th Biennale of São Paulo, Brazil (2010); he occupied a space which he called Bureau (again! and with the usual irony) for Research into Brazilian Normality. Jimmie Durham has long-held the view that Brazil is the only country in the world where the indigenous peoples are still not considered as fully human in the legal system of the country. Invited to participate in a biennale predominantly themed on the relationship between art and politics, Durham chose not to confront directly an issue which concerned him closely as 'an indigenous person of the Americas'[29] but to use the humorous device of a mock-anthropological investigation of Brazilian middle-class lifestyle.

This he conducted without special resources, wandering the city over several months picking up bits and pieces and noting this and that, eventually to create a room full of objects critically chosen whose homemade, car-boot-sale look made it stand out from the highly finished or neatly archived displays in most of the Biennale. Durham's list of exhibits ranged from family photographs to seeds, from pieces of furniture to a football whistle, from a BMW key ring (which, he notes, aspiring Paulistas use even if their car is humbler than a BMW) to the snobbish European or American names given

Jimmie Durham, *Prehistoric Stone Tool*, 2004
Wood, paint and stone, 75 × 85cm

to new apartment blocks. He counted at least 50, with names like California Dream, Central Park, Deauville, Villa Medici, Cambridge, Ville de France, Port de Marseille, King George V, Monte Carlo, Cap d'Antibes, etc.

Those who paid close attention would have realised that the male mannequin standing at one end of the room, wearing a suit, carrying a briefcase and wheeling golf clubs, had a gun tucked into his belt. He was a modern metaphor for the *bandeirantes* of Brazilian history, bands of adventurers who explored the hinterlands, enslaving the indigenous populations on a large scale and with great cruelty, and searching for precious minerals. They have been credited with opening up the interior of the country and are considered pioneer heroes. Their leaders were almost always Paulistas. Visitors to the Biennale would have passed every day the monument of homage to the *bandeirantes*, a vast mass of carved stone by the renowned early modernist sculptor Victor Brecheret.

In the event, the Research Bureau had a rough ride. There were intermittent acts of vandalism against Durham's display and thefts, which continued even when the installation was being dismantled. The tall vitrine protecting the *bandeirante* figure was broken into and his watch stolen. The hostility may have been partly provoked by the casual style of the ensemble, and partly by a perceived disrespect in criticising one's host. The main accusation against Durham was that he had not lived in São Paulo and barely visited Brazil. But all these 'interventions' only proved that Durham was effective in carrying out his role as Questioner.

The Bureau's scrappy materiality became effective in the fine-art context, proving that it is material plus context which creates the wit and the meaning. But more generally, drawing back from the specificity of the São Paulo installation, it seems to me that Durham, in the entirety of his work, has lived to the full a classic dilemma. On the one hand he exhorts himself, and the reader, viewer or listener, to what seems an impossible task, to 'take the time to ponder those

histories and qualities of every single thing you bump into, sit on, drink from, etc.'[30] On the other hand he entertains the cosmological speculation that everything is just the same and all things are one (or at least few). Words remain at the heart of this enigma.

(Not the point)

In the beginning, or perhaps,
Close to where something began,
There were probably only
Three or four or five
Things.

Possibly two or three or four of
Those were only words,
But words too heavy to remain in
Place.
We don't know
Who said what
First

+>")!!!:(?)=/ <<!?

(Is the world watching)[31]

Jimmie Durham: A Matter of Life and Death and Singing,
Anders Kreuger (ed), M HKA Museum of Contemporary
Art and JRP/Ringier, Antwerp and Zurich, 2012

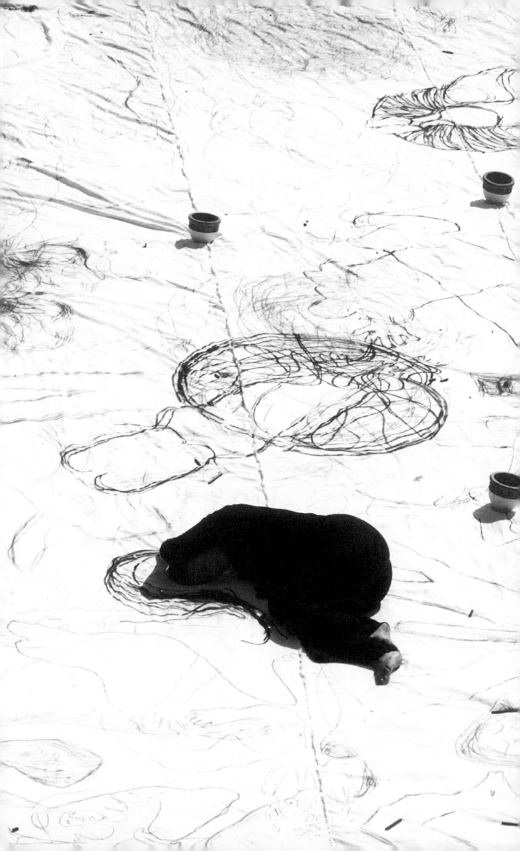

Monika Weiss
Time Being

Before it was named as such, and thereby threatened in its very
vitality, 'performance art', or 'live art', exhibited one of the great
creative desires of the twentieth century, the drive towards inter-
disciplinarity, or to use a more physical metaphor, towards the
crossbreeding of genres and expressive systems. This allowed, for
example, the dramatic action associated with theatre to mingle
with the contemplative time of the painting, sculpture or drawing.
Something new was created: each changed the other. The new work
could retain theatre's sense of witnessing a happening but dispense
with narrative and plot. It could retain painting and sculpture's silent
materiality while rendering it sentient and ephemeral. In Monika
Weiss's work there is a 'stage', but it is extraordinarily contained:
a chalice, a font, a concrete sarcophagus, layers of books, a portion
of the street. Action is minimal and everything works towards the
intensification of human presence.

Numerous statements of hers attest to this. 'During my actions
my eyes are closed … I am in a state of maximal concentration';
'Economy of motion emphasises act of composition – the isolation
of body;' 'I provide space for observation of delicate, small, and
often slow changes'. And finally, 'Everything is performative, in
a continuous state of becoming.'[1] In her work the body is not
ambulatory. It doesn't go anywhere. It moves only within its
own reach. It endures, laments, blooms. Its spatial element is
restricted to expand the experience of time.

85

Monika Weiss, *Drawing Lethe* (detail), 2006
World Financial Center Winter Garden, New York

As well as cultivating intensity within prescribed limits, her work muses philosophically on the nature of space in the most general terms. For example, the notions of the horizontal and the vertical. Their relationship is obvious but at the same time deeply mysterious. In several of Weiss's video/performance installations visitors take in the scene from their normal standing or sitting position. From a vertical viewpoint they see the horizontal body of the artist, lying in a concrete container or vessel, or on the floor [lying] on a layer of books. At the same time a camera films the artist from directly above, and this horizontal image is then projected vertically, sometimes in another room. To the spatial experience is added the cinematic, in which not only is the live action mediated by video but it may be manipulated in time according to whether the projection is a direct transmission or an edited version. The tension between live body and spectral image is beautifully suggested in *White Chalice* (*Ennoia*, 2004), by the projection of the naked, curled up body of the artist directly into the waters of the receptacle.

One has the impression that of all these spatial orientations it is the view from above which really engages Weiss's attention and resonates most strongly in her work. By a fertile paradox, the vertical view intensifies the act of lying down. It emphasises gravity, heaviness, attachment to the earth, while suggesting levitation and flight. And here perhaps, the image made possible by visual technology is one that connects with experiences reported in dreams since time immemorial of leaving the body and looking down on oneself from a great height. 'Images of flight and ascension are metaphors for transcendence and spiritual freedom. In this sense, the dream of flying, which implies a desire to abolish time and space and to unify matter and spirit, is a basic part of human nature, symbolising the need, and perhaps the possibility, of becoming free from all conditioned limitations.'[2]

Parallel with its dream connections, and strange as it may seem, the act of lying down is woven into political and cultural struggles

which are urgent and contemporary. Monika Weiss has said that for her lying down is an 'ethical stance'.[3] She refers to '"letting go" in a symbolic way ... as opposed to the physical posture of "marching soldiers"'. Again, in more personal terms, she says: 'I am interested in overcoming the idea of creativity as aggressive power, towards creativity which is close to melancholy, surrendering, humbleness and smallness.'[4]

A fascinating genealogy can be constructed of women artists who have valorised the act of lying down as a critique of patriarchy and as an apparently humble act that conceals a great strength. Examples come from many parts of the world, with many shades of metaphor. In Buenos Aires in the 1970s, Marta Minujín constructed a replica in wood of the Obelisco (Argentina's equivalent of the Washington Monument) lying on its side in a vast exhibition space. She said: 'Everything is so straight and rigid and perpendicular that I want to make it all lie down – [the Obelisk] represents the hard part of society.'[5] In the 1960s in Sweden, Niki de Saint Phalle (together with Jean Tinguely) constructed her *Hon – en Katedral* (She – a Cathedral, 1966), a huge joyful female effigy lying on its back which visitors could enter through the vagina. By identifying a woman's body with a cathedral, Niki de Saint Phalle found a way of expressing sacred space as a 'collective ideal'. Ana Mendieta's Silueta series (1973–78), recumbent female effigies made by bringing together, or taking away, natural elements particular to any outdoor site, an effigy left to disintegrate and return to the earth it was made from, exhibit a similar sense of slow-moving intensity as Monika Weiss's performances, a degree of artistic concentration which draws in every material nuance of the surroundings. In very different circumstances, women anti-war protesters, encamped around the US Cruise Missile base at Greenham Common in south-east England in the 1980s, lay on the ground and used string weighted down with stones to tie themselves to the site, which was in fact, according to ancient tradition, common land. The string looked frail but its symbolic charge was unmistakable.

Ana Mendieta's Siluetas were made in a solitary ritual and recorded by the artist or a photographer friend. This distancing may contribute to the power of the resulting image by the very fact of being removed from the event itself. The uniqueness of the chosen patch of ground is strongly communicated and at the same time generalised. Monika Weiss consciously explores this kind of ambiguity by playing live event against the video image. In *Phlegethon-Milczenie* (2005), there were two identical rooms. In one she performed several times, lying on a pallet of open books – philosophical and literary publications from pre-war Germany – and drawing around her body. In the other room a continuous video was projected, based on the performance, although the artist herself might no longer be physically present. Her videos are very minutely edited, an intervention in time flow she feels she can only do herself, in a hands-on process in front of the screen. 'I take specific fragments from the many hours of footage and then compose a new story, sometimes interrupting the chronology of events, mixing past and present with each other. Sometimes I incorporate visual commentaries (such as views of sky, river, fire and earth) [...] I edit instinctively with a deep focus and profound emotion – similar to the way I draw.'[6]

The linking of drawing with the editing of video is another particular characteristic of Monika Weiss's work. Both have a very personal touch, and, in both, the result is to create not so much a depiction as a presence. The video image is not 'of' her, but seems to arise from her own offering of herself, the result of some alchemy between the unmanned camera's 'surveying, cold, motionless eye'[7] and the emotion brought to the editing process. The bird's-eye view serves to create a site, a space, separated from the rest of the environment, a graphic world. On the horizontal plane the body's movement itself takes on a graphic quality: 'Outside the world and inside the drawing.'[8] In *Drawing the City* (2004), which took place on canvas spread on the pavement across from the Hudson Valley Center for Contemporary Art in Peekskill, New York, with traffic only a few

feet away but invisible, local children join the artist lying down and draw around their bodies. They enter and leave the arena as they wish, little bundles of energy which, thanks to the telescoping of time by the editing process, and the use of dissolve, can simply materialise in the scene, or fade away. They can appear ephemeral against the materiality of the drawing. Drawing is the connecting thread between the technological and the corporeal aspects of her work, the theatrical and the plastic, the communal and the intensely solitary. Indeed her sensibility may be present in its purest and darkest form in the fleeting phantoms of her large-scale charcoal drawings.

Sound joins the ensemble of the spatial, material and graphic worlds of her installations in a further complex process of editing. In her latest work, *Rivers of Lamentation* (2005), vocal lines from composers Gluck, Monteverdi, Purcell, Handel, Bach and Pärt, which she altered and combined and then mirrored with their own versions, contribute to the powerful evocation of mood which characterises all her work. How to describe this quality? The musical fragments in the new work are all forms of lament, and the visual associations enlarge the feeling of sorrow and loss: the fall of the body in the pietà, burial, immersion in a foreign medium, whose attraction she would universalise: 'We crave the coldness and wetness of the dark dirt and the earth – to lie down on or in it, to enshroud our tired body, to rest.'[9] When I visited Monika Weiss in her studio in New York something in her work compelled me to utter the name Grotowski (Jerzy), even though I knew very little about the work of the great Polish dramatist. The name struck her and later she went to read or re-read his writings, translating for me some passages from Polish which seem penetratingly apposite to her own art:

> An act of creation has nothing to do with either external comfort or conventional human civility. It demands maximum silence and a minimum of words, boundless sincerity, yet disciplined, i.e. articulated through signs.

Overleaf: Monika Weiss, *Drawing Lethe*, 2006
World Financial Center Winter Garden, New York
Ephemeral three-day public project: canvas,
charcoal, sound, the artist and passers-by

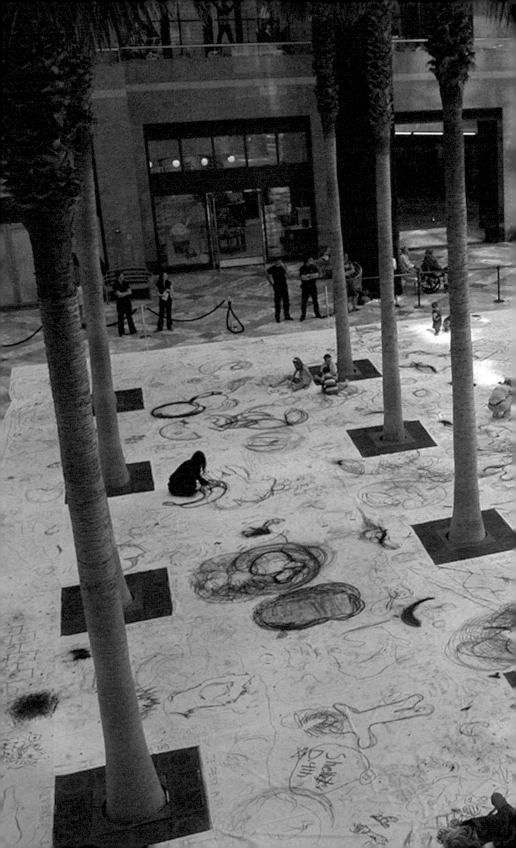

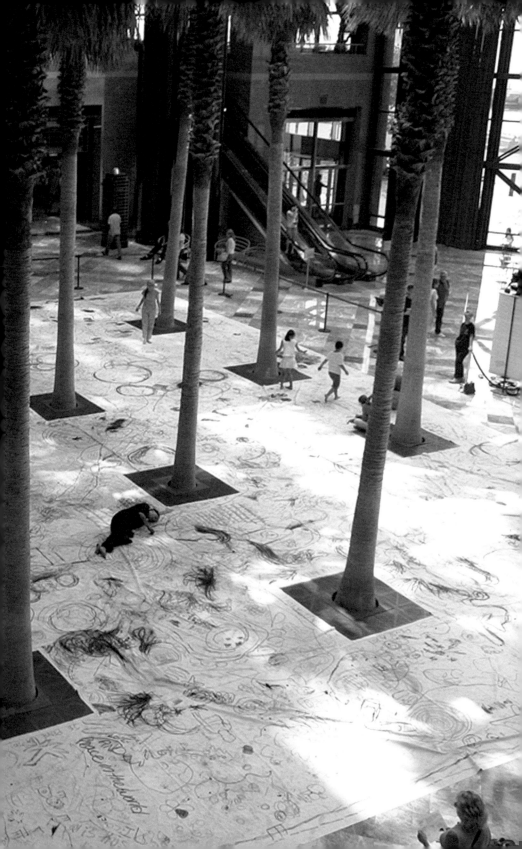

Making art is not a state but a process, a slow, difficult upheaval, where what is dark in us, becomes gradually light. [In *Towards a Poor Theatre* he wrote:] 'Human body, the breath, the internal impulses, all can be used to be uncovered, to surrender to something, which is infinitely difficult to name, but where Eros and Charitas live.'[10]

If these phrases indicate a form of thinking or sensibility which can be described as 'Polish', they also may be seen as particular inflections of states of dilemma and yearning which affect all of us. Artists and writers in the Chilean Avanzada movement in the 1970s developed forms of visual literary performance under the nose of the Pinochet dictatorship. Vulnerable to arrest and torture, the body was seen as the most real and honest site for expression, as 'the ultimate value', in the words of the artist and writer Diamela Eltit.[11] In less extreme circumstances the valuation of the body that Monika Weiss achieves in her unique fusion of media is similar, I believe. We realise that her 'slow time' always takes place within the 'hurry time' which increasingly moulds our daily rhythm. Weiss provides an alternative experience of space and time, which is not end-driven but steady and enduring, establishing and deepening a human presence in the Grotowskian sense, and seeking 'states of being outside time, where there is no beginning, middle or end, in an ongoing state of initiation'.[12]

Monika Weiss: Five Rivers, exhibition catalogue, Lehman College Art Gallery, City University of New York (CUNY) and Les Editions Samuel Lallouz, New York and Montreal, 2005

Len Lye
Force Field and Sonic Wave

It is customary to hear Len Lye described as a 'maverick' artist. Indeed Lye went one better than the popular cliché and called himself a 'maverick's maverick'![1]

The London artist Julian Trevelyan, who met Lye soon after Lye's arrival in the British capital in 1927, saw him as 'a man from Mars'.[2] And there were reasons for placing Lye outside the norm, even of the artistic avant garde: the perception of his origins in a remote country, his improvisatory, do-it-yourself approach to material making, which the writer and critic Roger Horrocks has identified with 'pioneer' cultures like that of New Zealand in the early twentieth century,[3] his ebullient individualism and down-to-earth way of talking about intellectual and aesthetic matters, and the polymathic range of his work: experimental film, batik work, painting, drawing and kinetic sculpture.

The Brazilian artist Hélio Oiticica once coined the phrase 'the experimentalised day-to-day' to describe his wanderings and encounters and inspirations in the streets of Rio de Janeiro. Lye was equally experimental in his daily life. Numerous anecdotes in Roger Horrocks's biography of Lye attest to this, proving, incidentally, how illuminating the biographical form, as practised with Horrocks's verve and perceptiveness, can be in charting the practice of someone for whom art and life were so interconnected. For example, Lye had the idea in his youth of 'feeling days'. If you woke up in the morning and you heard someone 'clanking a nice piece of metal outside your window', then it was a sound day: 'You pay attention to sound above

95

everything else, the sound aspect of things.' There could also be taste days, smell days, weight days, distance days and other variations.[4] The poet Alastair Reid remembers Len Lye in London around 1930, excited but impoverished: 'On a winter's night when Len would light a fire it would be like a huge celebration, it would be like the first fire anybody had ever lit, and we just had to watch it.'[5] Perhaps it was a combination of all these factors that led to this extraordinarily creative man being relegated to the margins of canonical histories of twentieth-century art, at least until recently.

Yet if we consider some of the great drives of twentieth-century art, Len Lye is right there in the centre. He is a brilliant example of the way in which innovation and experiment in the arts, a position of radical modernity, was so often allied in the work of the avant garde with a passionate identification with very ancient or ancestral forms of culture. Even in the technically experimental field that came to be called Kinetic art it is this tension between modern and ancient that underlies some of the best work, viz.: Takis's electromagnetic sculpture inspired by his admiration for archaic Greek and Egyptian statuary, Jean Tinguely's *Méta-Matic* machines hinting at carnival abandon and the Dance of Death, Jesús Rafael Soto's childhood memories of Venezuela: the way the Indians of the Orinoco river caught fish by shooting their arrows, not at the target, but in a large arc into the sky: 'In a flash you saw the fish pierced by the arrow…'[6] And in Lye's case, his personal exposure by book and by direct life experience to the Polynesian cultures of the Pacific. He lived for about a year, in 1924–25, when he was in his early 20s, in a Samoan village, where a house was built for him at a cost of five pounds. Samoa was at that time controlled under New Zealand mandate, and the British-born administrator objected to Lye mixing with Samoans. The threat of deportation for this kind of conduct, plus his own longing to live in one of the centres of modernism, eventually compelled him to leave Samoa and a little while later to head for London.

Another great drive Lye personifies is, indeed, kineticism – the reconceptualisation of the visual not in terms of static form but of 'figures of motion' – something that he embarked on completely off his own bat and held in front of him as a goal from his early days. He was searching for a quality of energy, the pulse of life, something he could not easily name. He experimented with animated film and he came to make machine-sculptures, but he insisted his experience of motion was rooted in his 'bodily sense of self', bringing us back again to the particular tenor of his modern-ancient consciousness:[7]

> Personally I have no aptitude for mechanics, no knowledge of motors, relay systems or servo devices. Perhaps I am for magic carpets over flying saucers, and would rather be heir to the Australian aboriginal with his boomerang and bull-roarer than an heir to constructivism and mechanics.[8]

That may be so, but Lye produced some extremely detailed, respectful and precise drawings of pieces of industrial equipment and machinery when he was a young artist (these are preserved in the Len Lye Archives in New Plymouth, New Zealand). And the remarkable fact is that he was drawing tribal artefacts from Africa and New Guinea at exactly the same period and with the same intensity and admiration. There is a third element in this synergetic fusion: the biological fantasies, amoebic improvisations, chromosomic diversions and proliferating nerve cells of what he called his 'doodles', drawings made over many years which are a fascinating and still largely unknown component of his work. All these graphic experiments seem to converge in the formation of a kind of energising matrix.

In the record of the twentieth-century-isms, the tendency known as Kinetic art has always suffered from being principally associated with the mechanical, with literal movement, whereas the word 'kinetic' should have been interpreted in a much broader sense, as a philosophical or even cosmological enquiry. The enquiry might have recourse to any medium, including the ostensibly 'static', like drawing. Such

an approach would also have allowed the links between Kinetic art and other contemporaneous movements to be made clear, and would have prevented the isolation of the phenomenon in a special category, as a sort of sideshow to the serious business of twentieth-century modernism.

Kineticism arises from an essential paradox of our perceptions. For what we perceive as in motion, or as static, tells us more about the bounded nature of our senses than about reality. It is not movement in itself which is important but the intensity with which a work can reveal space, time and energy. As artist Georges Vantongerloo wrote in 1957:

> When we believe we see something as existing, this thing, before being transformed into another state, corresponds to the speed of our senses. That is to say, its position at a given moment is maintained long enough to allow our senses to perceive it, or register its presence …Through our senses we are unable to perceive the infinite, for our senses are themselves limited. This does not affect the existence of the infinite, and we are subject to it.[9]

Indeed, far from a sideshow, taking this enlarged view of the phenomenon of kineticism enables us to reconsider or recast the general notion of the abstract in twentieth-century art. For Lye, the basic element of abstract expression in the twentieth century was the kinetic and this allows us to see abstraction not so much in terms of forms as of energies, replacing the traditional static idea of form with the dynamic model of a force field. The evolution of Vantongerloo's work, for example, which for a long time seemed so strange and unclassifiable led to his being underestimated in the history of twentieth-century art, shows exactly this process. Vantongerloo moved from geometric abstraction, with its confident application of spatial measurement and the rationalisation of form, to the pursuit of invisible and intangible energies. After the Second

World War he began to produce a series of modest little objects – wire nuclei, Plexiglas and prism models and paintings – seeking a sort of aesthetic equivalent of cosmic phenomena: radiation, radioactivity, fission, electromagnetism, attraction-repulsion, nebulosity. Such words were common in his titles. In his work from the 1940s to the mid 1960s, the physical and biological are reconciled in plasma-like fluxes which seem extraordinarily contemporary and in key with scientific knowledge of the cosmos.

In the exhibition *Force Fields: Phases of the Kinetic* an attempt was made to trace this expanded notion of the abstract, and the phenomenon of the representation of energy, through the art of the twentieth century. It was presented as an international tendency, embracing works by 44 artists with origins in 17 countries, and was broad in its treatment of media, including experimental film, drawing and etching, paintings, sculptures and many hybridised forms. On the one hand, there was a dissolution of the borders between media and genres in the creation of a particular kind of 'vibration', which seemed to run, with infinite inflections, throughout the exhibition; on the other hand, constant cross-references were made between a position of absolute contemporaneity and influences of the most remote past, expressed in the 'minute particulars' of the different cultural backgrounds and artistic journeys of each individual artist. *Force Fields* therefore gave an opportunity to compare Len Lye's relationship with Kineticism to that of other artists, and to enfold him in the multilayered pursuit of what Ana Mendieta called the 'One … energy which runs through everything from insect to man, from man to spectre, from spectre to plant, from plant to galaxy.'[10]

For example, Lye made his first animated film, *Tusalava* (1929), Roger Horrocks tells us, 'trying to imagine the kind of film that might have been conceived by an ancient [Australian] Aboriginal artist'.[11] The result was the release of a new kind of visual energy, which was both biological and astronomical, mythical and scientific, symbolic and real, microcosmic and macrocosmic, and was rounded

Len Lye, *Ribbon Snake*, 1965
Plastic, motor and metal armature, dimensions variable

Len Lye, *Tusalava*, 1929
Black-and-white film stills, 35mm

by a Polynesian philosophical concept expressed in the film's title, which means 'eventually everything is just the same'.

In *Tusalava*, as in Lye's static paintings, there is an almost seamless fusion of forms evoking Australian Aboriginal and Polynesian symbols and those evoking microscopic biological phenomena such as antibodies and viruses. It is as if both were born equally in Len Lye's lifelong habit of 'doodling'. What he called his 'Old Brain', borrowing a term used in biology for the area of the brain developed first in human evolution, 'must have communed with my innate self enough to have reached down into my body and come up with gene-carried information which I expressed visually'.[12] The old brain was a way of linking the ancestral past with the body living in the present moment.

An outstanding quality of Len Lye's kinetic sculptures is their attentiveness to sound (taking us right back to Lye's 'feeling days' and 'someone clanking a nice piece of metal outside your window'). The sonic aspect of a piece of metal is as important as its visual aspect, for Lye, making it possible to say that a work like *Universe* (1963–76) is as much a musical instrument as a sculpture. This sculpture/music interface was indeed a feature of Kinetic art, and one which is often forgotten, a facet of the pursuit of the 'vibration' – one thinks of the work of the Baschet brothers in France and of Phil Dadson's invented instruments in New Zealand. In *Force Fields* it was possible to compare the sound production of Lye's *Universe* and *Blade* (1959–76) with that of Takis's Sculptures Musicales series from the 1960s, for example. This went to show how, in two groups of works, apparently so pared down in their visual abstraction, a great range of different experiences could be felt to be concentrated there.

In *Universe*, when set in motion, the rigidity of the 6.7-metre circular polished steel band, suggesting the cosmos, is softened into figures of fluidity by the push and pull of electromagnets in the base, linking it with Lye's genetic doodles. At the same time the work is opened to chance, or to extremely complex patterns of interaction,

as the bounding steel misses or strikes the suspended satellite of the hardwood ball, emitting a clean metallic clang over the wavering resonance of the ring's contortions. It was impossible to forget the way, during the exhibition *Force Fields*, the sound of *Universe* carried through the crowded museum, travelling far beyond where the work itself was visible, yet, because of its sonic purity, making no distracting intrusion on the work of other artists. Somewhere too, in *Universe* and *Blade*, is the violence of Pacific storms, the din of factories, the singing saw of the woodsman, and the bullroarer of the Aboriginal Australian.

Far from the bounding and lurching motion of *Universe*, Takis's Musicales preserve an upright frontality and hieratic stillness which, despite the absence of any overt reference, make one think of the archaic Greek sculpture that Takis admires so much, especially the simplified human figures of the Cycladic culture. The *Musicale* is a relief, further emphasising the iconic stasis of the wall-hung work. At the core of this stasis is the single mobile element – the elegant needle which an on/off electromagnet causes to bounce against a stretched and amplified wire in a shivering and trembling motion caught between gravity and the magnetic pull. The sound is a single prolonged note which starts and stops again as the needle hits or drops away from the wire, a deep vibrato that could be heard as a sonic equivalent of universal electromagnetism.

Musing about his own work, Jean Tinguely once said: 'Perhaps we have the possibility of producing a joyful, that is to say a free, machine.'[13] Len Lye would surely identify with the effort to re-imagine our mechanical civilisation and complex social collective, with its essentially repetitive standardisation, under the sign of a liberated playfulness. In his upbeat way he advocated his theory of 'Individual Happiness Now'. His work proves how much that individuality would reflect difference and, what the Italian political philosopher Antonio Gramsci called 'the infinity of traces' that make up identity.

Len Lye, Tyler Cann and Wystan Curnow (eds),
Len Lye Foundation and Govett-Brewster Art Gallery,
New Plymouth, 2009

Gianni Colombo
The Eye and the Body

As a tendency in twentieth-century art, Kineticism has a number
of interesting and unusual features – one of which is its relative
obscurity. It was never accorded the centrality and influence given,
for example, to Minimalism, Conceptual art or even to Pop art. Indeed,
it was treated as something of a sideshow: entertaining, novel, but
short-lived, never attracting the gravitas that accompanied art-historical
or critical treatment of other tendencies. There have been signs recently
of a challenge to [the history of Kineticism's] historical marginalisation.
However, if the challenge is made in verbal arguments it runs into a
difficulty: the very fact that the work moves. Photographic reproduc-
tions, which would normally illustrate such texts, convey nothing of
the kinetic work's qualities, the language or the poetics of movement,
which can only be experienced live. Nevertheless, perhaps one can
evoke in the imagination what comes into existence with movement,
the transformation when movement begins, and the extraordinary
range of form and feeling it is capable of, by comparing works that
come from opposite ends of the kinetic spectrum: for example, a
Gerhard von Graevenitz motorised relief – so systematic, repetitive
and formal – and a Jean Tinguely *Baluba*, in curator Pontus Hultén's
words, 'the wildest and most extravagant works Tinguely ever produced'.

'At rest', Hultén goes on, '[the Balubas] are rather disappointing –
a few feathers, some scraps of cloth, some pieces of iron – so the
electric motor plays a decisive role … the melancholy engendered by
the assorted junk is transformed into gaiety as it suddenly springs
into life.'[1] While the motor in the *Baluba* is hilariously visible and

105

Gianni Colombo, *Spazio elastico* (Elastic Space), 1967–75
Installation view, Cesano Maderno, Milan

swept up in the contortions it brings about, in Von Graevenitz's relief it is hidden. It causes the small, evenly spaced, identical visible tabs to do no more than revolve. But since the relationships of these movements are random, their interconnections become extremely complex. Poverty of information, predictability, banal calculation, are all transformed into the incalculable.

Another striking feature of the tendency loosely called 'Kinetic art' in the 1950s and 1960s was its internationalism. Any list of major or minor figures in the movement would consist of people born at all points of the compass, with considerable emphasis on countries of the Third World. In relation to this phenomenon, it would be absurd to claim for North America the dominance that it is usually given in postwar art. Kinetic work expressed the notion that there is no one centre. It was a focus for the aspirations of diverse peoples to be absolutely modern, to speak in universal terms, and to evolve further the contemporary perceptions of space and time. This process often involved artists in a critical dialogue with both the dominant culture and their own intellectual, ethical and spiritual inheritance, in terms of ways of conceiving of a human relationship to the universe.

In fact, it was from Latin America, rather than North America, that a great portion of the innovatory energy of Kineticism came. The influx of Latin Americans to Paris in the 1950s and 1960s, to live, to work and to visit studios, actually altered the evolutionary history of twentieth-century art in a way that has not been sufficiently recognised. It injected into the postwar angst of Europe an optimism and a hope, forging a link with the utopianism of the pre-war avant garde, which was no longer fashionable in the Europe of the 1950s. The Venezuelans Jesús Rafael Soto and Alejandro Otero made visits to Holland to see Piet Mondrian's work. 'At that time [1950] no one in France was talking about Mondrian, still less might one see any of his work', Otero wrote.[2] The Brazilian Sérgio de Camargo visited Constantin Brâncuşi. Many Latin Americans, especially the Argentinians Gyula Kosice and Tomás Maldonado, called on Georges Vantongerloo – then working on his

cosmological Plexiglas and prism objects and his wire nuclei – visits that greatly cheered the Belgian pioneer, ignored as he was by the French and Belgian art worlds and living in Paris in poverty.

The origins of Kinetic art were broad, not only geographically but also conceptually. The names that become adopted for artistic movements are always provisional, and usually disguise links with other phenomena more difficult to name. In Europe, kinetic experiments had important links with the work and thought of artists who were not concerned with movement in a mechanical or literal sense, notably Yves Klein, Lucio Fontana and Piero Manzoni. The practice of the monochrome and its connection with the philosophical notion of the void forms another vector that unites artists of different geographical-cultural origins, practices and sensibilities. Besides Klein, Fontana and Manzoni, one could mention Camargo, John Cage, brothers Haroldo and Augusto de Campos (indicating the strong link between Kineticism and concrete poetry), Gianni Colombo, Lygia Clark, Dom Sylvester Houédard, Li Yuan-chia, David Medalla, Barnett Newman, Hélio Oiticica, Ad Reinhardt, Mira Schendel, Soto, Takis, Mark Tobey and others. Zero was the name of the group formed by German artists Otto Piene, Heinz Mack and Günther Uecker, and *Nul=0* the title of the review edited by Henk Peeters and herman de vries in Holland, which nurtured the sort of connections I have been describing. Clark's paradoxical characterisation of the void as the 'full emptiness' is perhaps one that most clearly unites the thinking of so many artists at that period, including the specific research of Colombo.

FROM THE PLANE

Any discussion of Kinetic art today has to reckon with the effects of the passage of time. Often, what seemed back then a radical rejection of the traditional material formats of art, can be seen now to have emerged from those traditions in ways that deepen one's appreciation of what was achieved. Indeed, the brilliance of some of the innovations

made, say, within the discourse of painting, become even clearer and have the effect of making much that is produced in painting today look obsolete and retrogressive. Colombo, Clark and Soto can be cited as three artists whose kinetic work emerged from a transformation of the historical 'plane' as a sensory experience and a philosophical notion.

The process can be seen with exceptional clarity in the early work (1954–60) of Lygia Clark. Starting with geometric abstraction akin to Mondrian's, and taking further Mondrian's attention to the problem of the painting's edges – where the fictive space of 'art' meets the rest of the world – Clark experimented with incorporating the frame as part of the painted surface. She then began to explore – within the strictest black/white geometric schema – modulations of the surface with incised lines and raised sections, tending to create a space within the thickness of the panel itself. A superb transitional work, *Casulo* (Cocoon, 1959), wraps together in a concise unity the broken surface plane and the inner three-dimensional space that the title characterises as organic and of latent potential. In the 1960s followed the Bichos (Creatures), structures of hinged aluminium planes to be manipulated and changed by the viewer according to a 'living' rhythm. With these participatory objects, Clark was launched on the path that eventually led to her unique hybrid of the aesthetic and the psycho-therapeutic, which threw into question the relationship of art and life and for which an adequate name has yet to be found. Clark's break with the convention of the plane is announced in philosophical, even cosmological, terms in her powerful text of 1960, 'The Death of the Plane':

> The plane is a concept created by man with a practical aim: to satisfy his need for balance … Arbitrarily marking out limits in space, the plane gives man a totally false and rational idea of his own reality. Thus appear opposing concepts such as high and low, the right and the inverse, which contribute towards destroying within man of the

sense of totality. This is also the reason for which man has projected his transcendental side and given it the name of God. Thus he then posed the problem of his own existence – inventing the mirror of his own spirituality.

[…] In becoming aware of the fact that this is a question of the poetics of himself projected onto the outside, he understood at the same time that there was a need to reintegrate his poetics as an indivisible part of himself.

It was this interjection which made the rectangle explode from the painting. We swallow this shattered rectangle, we absorb it.

[…] We dive into the totality of the cosmos: we are part of this cosmos, vulnerable on all sides: above and below, right and left, in short, good and evil – concepts which are transformed.

[…] [Contemporary man] learns to float in the cosmic reality as in his own inner reality.[3]

A world away, in Caracas, Soto was also inspired by Mondrian, believing that, in his Boogie-Woogie paintings, the latter was on the verge of 'a purely dynamic painting, realised through optical means'.[4] With this inspiration, Soto experimented with the repetition of identical elements and their possible permutations, and then discovered that by superimposing a transparent painted surface over the base, at a slight distance and a slight displacement, an indeterminate vibratory space was created, detached from both surfaces. Refining this structure to a lined screen as the baseboard, with wire, metallic squares, bars and other objects suspended in front of it, he produced subtly different visual experiences of the dissolution of solid matter into immaterial pulses. He had thus created a modern formulation of pictorial artifice, an illusion that says something about the actual nature of reality.

It becomes impossible to say which is more real: solid object or immaterial vibration. With irony and poise, however, Soto does not allow the energy to upset a pictorial equilibrium, a kinetic play that both respects and destabilises painting's traditionally iconic stasis. We may see this as an expression of Soto's particular search for harmony in conditions of uncertainty and instability that we now ascribe to the universe.

At the same time, he realised that he did not need the surface or plane to create his vibratory medium. His brilliant Penetrables, areas of densely hanging plastic cords into which one can plunge, made from non-precious and renewable materials, open on all sides, extend the contraction between the pictorial space and the world out into the public arena. Viewers can pass bodily from a state of solidity to a state of visual indeterminacy and dissolution and back again. The optical play sets up an easy communication between people both inside and outside the work, and so it becomes a social experience. I wrote at the time:

> Brushing through, there is an extraordinary feeling that one's physicality is diffused, and other people's also, so that people no longer abut upon one another like objects as they do in the street. In the modern street we are all eyes, staring, and our tightly defined bodies move along mechanically. In Soto's *Penetrable* the eyesight is scattered with all the delicacy of an object in one of his kinetic paintings. It is with our whole bodies that we experience the 'climate' of the work and welcome the illusion.[5]

Gianni Colombo's kinetic work clearly begins with a deformation of the surface (*Superficie in variazione* (Surface in Variation, 1959); *Superficie in divenire* (Surface in Becoming, 1959)), where bumps and depressions erupt its planar integrity. His belief in public participation is announced too, since in some works the spectator can change the surface by pulling on small tabs at the bottom edge of the canvas.

In fact, both these tendencies are present even earlier: when Colombo was working with ceramics and made a piece consisting of three elements of terracotta that the viewer could move to form a common surface, or to break it.

Colombo's first motorised work, *Strutturazione pulsante* (Pulsating Structure, 1959), both retains and disrupts the pictorial plane, and even the whole geometric tradition, in a way that is both poignant and witty. The movement of the massed polystyrene blocks is slow, intermittent and curiously subversive, as fissures are opened up in the surface and then closed again. *Strutturazione fluida* (Fluid Structure, 1960) is also a work conceived within but going beyond pictorial/graphic conventions. The fluid movements occur within a virtual plane, compressing the energy as a continuous steel band passes through the machine, creating one large cycle and several smaller ones.

Later, when he was working directly with environmental and architectural space, manipulating it in ways that affected the visitor's entire body and sense of self, he still liked to return to the wall-hung work and invite the intervention of the hand. With elegant economy of means, in his Spazio elastico (Elastic Space) works begun in 1968, a grid network of white elastic cords over black could be altered to read quite differently by stretching the cords in various directions and anchoring them to sets of pins at the periphery of the picture. It was Lucio Fontana, Colombo's teacher, who expressed most succinctly an ambition shared between himself and the three artists discussed here: 'As a painter … I do not wish to make a painting; I want to open up the space, to create a new dimension for Art, to tie it to the cosmos as if it was expanding beyond the restricted plane of the painting.'[6] Perhaps ironically, one thing that resulted from this ambition, this cosmological supersession of the plane in the years around 1960, was a wholesale enrichment of the physical surface of the work, of the most diverse kinds, beyond paint and brush.

It was a strong tendency among many artists associated with Kineticism, especially those who formed themselves into groups, to speak of their work in impersonal, 'scientific' terms. Thus Colombo, who was a founder member of Gruppo T in Milan, would say that 'the visual elements in my work are stripped of any kind of analogical or evocative function; their role is that of an indicator of rhythm.' 'Forms intended to seduce the imagination' of the spectator were to be resolutely avoided and replaced by a capacity to 'stimulate [in the viewer] psychological reflexes'.[7] Materials were chosen as the 'most measurable means for affecting the optical-perceptive apparatus of the observer'.[8] François Morellet, a member of GRAV (Groupe de reserche d'art visuel – Group for Research in Visual Art) in Paris, spoke of the 'unfailing affection' he had for 'systems and precision, in sum for everything that limited my subjective decisions'[9] (one may wonder if his 'unfailing affection' was not already a 'subjective decision'). Soto, who was not himself a member of any group, described his art as a matter of 'pure relations'. His words are very similar to Colombo's: 'I use anonymous elements to emphasise the purity and sufficiency of the rhythm that may be revealed between them.'[10] Soto, however, advised artists against an involvement in science. A field of scientific knowledge that is as complex as art is may 'swallow him up in its depths', he wrote.[11]

Whatever the case, I believe there is a tension in the work of Colombo that reaches deep into philosophy and cultural history. From the very beginning of his career, one feels a dialectical move-ment in his objects between rational structure and free-flowing fluidity. The rectilinear grid of the many versions of Spazio elastico, and the endless unwinding band of *Strutturazione fluida* can serve as an example of the two opposed principles at work – with the proviso that in fact they interpenetrate one another. The elastic material distorts the rigidity and uniformity of the grid structure, while in

the other work the word 'strutturazione' is deliberately inserted to accompany the 'fluida'.

A succinct way of evoking the two realms would be to place side-by-side two notable books that deal with the subject of art and the physical world: William M Ivins Jr's *On the Rationalisation of Sight: With an Examination of Three Renaissance Texts on Perspective* (1938), and Theodor Schwenk's *Sensitive Chaos: The Creation of Flowing Forms in Water and Air* (1965).[12] 'Rationalisation' in Ivins's book designates the Renaissance rediscovery of linear perspective, the geometric formulae for rendering vision in graphic terms. Sightlines and the conventions of perspectival space are now deeply ingrained in our psyches, and it is exactly on these habits that Colombo draws to destabilise perceptions and engineer his elasticisation of space. In this way, he works with, and critically assesses, his own Italian legacy, so that it is particularly poignant when he rigs up his elegant and minimal spatial networks in an ornate and vaulted marble church interior (Cesano Maderno, northern Italy, 1975). Theodor Schwenk's book is essentially an exposition of Rudolph Steiner's views on matter, on energy and form. The book contains many startling images of flows, currents, vortices, ripples, meanderings and suchlike. Colombo was interested in Steiner's ideas of space, and paid a visit to the Goetheanum in Dornach in Switzerland, designed by Steiner. The comparison of these two books, especially in their visual material, poses a stark contrast between the cerebral and the sensuous or organic, but we know that Colombo was concerned to go beyond this dichotomy.

EYE AND BODY

A notion shared by Colombo and Clark is elasticity – a challenge to the rigid. Both actually used elastic materials in their work. For both, elastic was a means of involving the body in the experience of the work. But the ways in which they did this were very different, the elastic serving two distinct visions.

113

Colombo's *Spazio elastico* (1967) is exactly what its title implies. The perceptual experiment is accomplished with the elegance of pure abstraction. A grid structure of fine thread is set up within a dark cube that can be entered by the viewer, who sees only the lines, picked out by black light. Motors mounted in the walls gently pull the grid into certain deformations, instantly changing our coordinates for reading the space we are in. Effectively, Colombo leads us back to an awareness of the body through an exclusive concentration on the visual sense and its ingrained habits, dependent on the conventions of linear perspective and sight lines. By contrast, many of Lygia Clark's works make us aware of our other senses and the totality of our bodies by blocking the visual sense, or by turning it inward and submerging it in the sensorium as a whole. Thus her Máscaras sensoriais (Sensorial Hoods, 1967), made of cloth and other materials, hold a cluster of sensations close to the eyes, ears and nose, and her Máscaras abismo (Abyss Masks, 1968), which hang from the head and cover part of the body, incorporate a blindfold, so that the participant feels a powerful sense of volume, space, weight, etc., not distanced by sight, but in close contact with, or even 'inside', the body.

When Lygia Clark did concentrate on the eye it was again to look inward, as in her work *Diálogo: Oculos* (Dialogue: Goggles, 1968). These goggles, adapted from rubber masks made for underwater swimmers, were extended by a system of hinged mirrors. The wearer could manipulate these to give a patchwork of partial views. By turning them flat, one looked past them to the 'real' world; by twisting them, one could produce reflected views up, down, or behind, or look back into one's own eyes. A double set of goggles allowed the heads of two people to be brought into intimate proximity, producing complex modulations of the experience of looking away or into the other's eyes. According to the way the mirrors were positioned, there could be a disturbing ambivalence between the experience of one's left and right eyes: one eye looking into the other person's and the other reflecting one's own eye.

Oliviero Toscani, *Gianni Colombo with Elastic Space Cube*, 1970

A third artist whose work can be related to this theme of the relationship of eye and body is Cildo Meireles, and especially his installation *Através* (Through, 1983–89). With this work, we move on twenty years from the 1960s propositions of Colombo and Clark, with a corresponding change in cultural attitudes. Whereas artists in the 1950s and 1960s – if this is not too much of a generalisation – pursued energy, contemplated space/time in a spirit of clearing away, starting from zero, from a tabula rasa (corresponding to the 'void' evoked by Klein and Clark, among others), Meireles presents such a search as enmeshed in culture, as inescapably mediated. *Através* is a penetrable maze made up of short, discrete sections of barriers of all kinds: garden fences, iron grilles, shower curtains, museum cordons, barbed-wire tangles, blinds, and even two aquaria (these last, obstacles even if made of glass, accommodated shoals of minute transparent fish). The barriers range from the benign to the aggressive, from forceful obstruction to delicate veiling, a combination of the minutiae of social experience with the generality of abstraction.

Beguiling in its visual densities when seen from outside, *Através* becomes a very different experience when entered, since the whole floor is covered with broken glass. It demands care to be walked upon. Multiple questions arise. Can we see through? Can we go through? Can we reconcile the eye-pleasure with prohibitions on our bodily movement? Is the eye and the body's experience divisible? *Através* is a double metaphor, cast in its labyrinthine form, posing the right-angled and perspectival 'order' of the screens against the nucleic energy and chaotic form of a great ball of crumpled cellophane that lies at its centre, lit by a single lamp. The great ball may be taken as an indication of infinity, which is found at the heart of all these devices of limitation.

In many ways, artists like Colombo adopted the language of physics and cosmology to get closer to the universe – the 'all'. They called themselves 'technicians' and 'researchers' and were prepared to sink their individuality in a group identity (at least temporarily). This position defined their attachment to and understanding of abstraction. They had a horror of anything figurative. Yet the figurative and the individual survive in Colombo's legacy in the most surprising way. Leafing through images and documents in the Archivio Gianni Colombo in Milan, under the kind supervision of curator Marco Scotini, I was amazed by the sheer number of portrait photographs of Colombo to be found among his things. In every photograph, with or without his work, he is dressed differently, and fashionably – a matter not only of clothes but of hair and moustache as well. He invited some of the foremost photographers of Italy to take the pictures: hence their sophisticated lighting and effective poses. Warming to the theme, Scotini suggested to me that Colombo was an actor and his work his stage. Certainly this fascinating cast of photographic characters – all, however, careful to project the *bella figura* – prove that the 'social' entered into Gianni Colombo's work in its own fashion.

This somewhat eccentric reference to the social, brings us back to a distinct characteristic of Colombo's kinetics, and to the kinetic conception of art in general, that is, the close relationship between material transformation and the invitation to the spectator to partici-pate actively in the work. The nature of authorship was profoundly questioned, and expanded, on two fronts. On the one hand artists opened their work to the physical world, allowing sources of energy in one form or another to take the work beyond the artist's absolute control; and on the other hand they opened it to the social world by providing models, moulds or templates that came to life through the input of each participant's subjectivity. The pervasive influence of both innovations needs to be fully recognised.

Gianni Colombo, Carolyn Christov-Bakargiev and Marcella Beccaria (eds), Castello di Rivoli Museum of Contemporary Art and Skira, Turin and Milan, 2009

Liliane Lijn
Wavering Line of Light

With this exhibition, Liliane Lijn returns to Paris after an absence of
some 20 years. Self-taught as an artist, she originally arrived in this
city in the autumn of 1958 from Geneva and immediately plunged
into the world of experiment and innovation of the Parisian avant
garde. In the first year she was in Paris, Yves Klein staged his epoch-
making exhibition *Le Vide* (the Void) at the Galerie Iris Clert, and,
in the following year, Takis made his first Telemagnetic sculpture.
Two years later, Liliane Lijn was making sculptures by drilling into
blocks of Perspex, producing empty spaces which paradoxically
behaved like solids in the transparent blocks, causing the light
falling on them to liquefy in the viewer's gaze.

Lijn embraced the Paris of artistic thinking, and also the Paris
of wild and orgiastic 'happenings' organised (if that is the right
word) by artist and poet Jean-Jacques Lebel at the end of the 1950s,
perhaps acting as a psychological release after the privations of
the Second World War.

It has often been assumed that when the 'grand narrative of
modern art' began to coalesce around the 'New York School' in
the 1950s, Paris lost its pre-eminence as the international centre of
modern art. Younger artists in Britain, for example, became increas-
ingly fixated on art movements in the United States, encompassing
Abstract Expressionism, Pop art, Minimalism and Conceptual art,
and gave little credence to events in Paris. But this judgement was
crude and simplistic. For one thing Paris and New York were not
polarised worlds. Robert Rauschenberg and John Cage had close

119

Liliane Lijn, *Linear Light Column*, 1969
Enamelled copper wire wound on perforated metal cylinder, mounted on
motorised turntable, chrome steel base, 73.6 x 15.2cm (base diameter)

contacts with Europe. Cage was associated with Fluxus, a transatlantic movement with its roots in Dada. North American writers James Baldwin, Brion Gysin, William Burroughs, Allen Ginsberg and Gregory Corso lived for periods in Paris. Lijn was inspired by Gysin's and Burroughs's 'cut-ups' as a liberating literary technique. (On seeing Lijn first exhibition, *Echo Lights and Vibrographes* at the Librairie Anglaise (1963), Burroughs suggested she use his cut-up text in her Poem Machines).

Far from declining, Paris gained a new cosmopolitanism in the late 1950s and early 1960s with the influx of young artists from Latin America, drawn by the desire to see first-hand the work of artists like Piet Mondrian, Constantin Brâncuși, Georges Vantongerloo and Klein. All this was no doubt below the radar of the French art establishment of the time, since the encounters between artists of different nationalities and cultural backgrounds were of a new and subtle kind, and they took place at levels which had been in no way institutionalised.

One way to look at the diverse nature of experiment in Paris at that time would be to see it as a multitude of different kinds of transformation of the traditional formats of painting and sculpture. Liliane Lijn's early works of around 1961 would exemplify this category, especially her *Double Drilling* and *Inner Space* (both 1961), transparent Perspex blocks into which she has drilled to create bubbles and cavities in the inaccessible interior. These works testify to a fascination with materials, their properties, and the possibility of a transformation that goes beyond a representation.

While prominent North American artists continued to adhere to the formats of painting and sculpture as the vehicles of their vanguard movements, European artists inherited a legacy of experimentation and the use of new materials from outside the sphere of art. This can be traced back to artists like László Moholy-Nagy and Vantongerloo – to Moholy-Nagy's *Light-Space Modulator* (1922–30), investigating the possibility of light and movement as a medium

Liliane Lijn, *Liquid Reflections*, 1966–68
Acrylic drum containing water, turntable and
projector lamp, acrylic balls, dimensions variable

of expression, and to Vantongerloo's use of a newly invented transparent material, Perspex or Plexiglas (1949–65). Vantongerloo imported it from the US to France and welcomed it in ecstatic terms: 'Plastic material!!!! What a marvel! It is both physics and chemistry. It's creation itself' (letter to artist Lillian Florsheim).

Liliane Lijn has always been identified with the tendency known as Kinetic art. It is of course a very broad term, encompassing expressions ranging from the exuberance of Jean Tinguely's machines to the austerity of, for example, the reliefs of identical small tabs in motion by kinetic artist Gerhard von Graevenitz. What they do share is the invention of a 'language of movement', something that can only be experienced directly and in real time. This leads to a further distinction: the difference between merely setting in motion an established formal structure such as geometric abstraction, and inventing a new kind of object which had not existed before. Lijn belongs to this latter tendency within Kinetic art, when one thinks of the originality of her Poem Machines, her illuminated Koans, her columnar lines of light. The Poem Machines are a brilliant contribution to the movement of concrete, or visual, poetry, where letters alternate with abstract pulses as the cylinder revolves. All have a fluid, fresh quality of going beyond a rigid adherence to a formal stylistic system. And yet the strange and fascinating thing about these works is that the geometric forms are not lost or superseded but retained in Lijn's personal and poetic treatments of the cylinder, the cone, the circle, the sphere. Also, the triangle and the prism first worked [with] in 1963. One has only to think of the beautiful interrelationship between circle and sphere in *Liquid Reflections* (1966–68) to appreciate the creativity of this inventiveness.

The Light Columns (beginning 1964) are another example, a wonderful re-invention of industrial materials, taking them from practical usages to create a new, poetic object. As the cylinder is tightly bound with fine copper wire and light is directed upon it, any imperfection or irregularity of the cylinder's surface is translated into

a wavering line of light, 'real' although it has no material existence. It's a 'vibration', an energy, which one can discover in the works of many of the artists of the twentieth century who have been interested in cosmic speculation: such as the 'vibration paintings' of Jesús Rafael Soto, the vibrating wire in Takis's Telemagnetic sculptural constructions, Hélio Oiticica's Bólides (Fireballs), Liliane Lijn's 'words accelerated' in the Poem Machines, or Sérgio de Camargo's white wood reliefs which respond so subtly to the nuances of ambient light. We reach a position, a confluence, superbly articulated by the architect Louis Kahn:

> All material is made of light which has been spent, and
> the crumpled mass called material casts a shadow, and the
> shadow belongs to light.[1]

Liliane Lijn: Early Work 1961–69, RCM Galerie, Paris, 2015

Gego
Art, Design and the Poetic Field

The trajectory of Gego [Gertrud Louise Goldschmidt] makes one
think again about the complexities and subtleties of the formation
of contemporary art. The crude category of the 'nation' obscures the
particularity of artist journeys in the twentieth century, with their
mixture of desire, accident, education, encounters, influences,
memories – the whole story of the individual's predilections and
possibilities vis-à-vis the great patterns of power that dominate
the world and the injustices they impose. Gego came to Venezuela
to escape Nazi persecution, unprepared, speaking no Spanish, at
27 years of age. Her art evolved within the Venezuelan context, yet
in many ways her journey was an inversion of the course of young
Venezuelan artists of the time. Venezuela was her refuge. She already
had a European formation and therefore was not drawn to Paris as
were aspiring artists of the two dominant modernist tendencies in
Caracas in the 1940s and 1950s: geometric or constructivist abstraction
and expressionist figuration.

In going to Paris many of these artists were driven by the desire
to place themselves at the forefront of modernity, to measure them-
selves against the 'best', to claim the right to speak in universal terms,
to challenge Venezuela's marginality. Gego did travel widely later:
her journeys were mainly for learning art techniques, attending her
exhibitions, or fact-finding missions connected with the teaching
methods of schools of architecture and design in various countries
that directly concerned her professional work as a teacher in Caracas.
In this connection poet and critic Luis Pérez-Oramas has pointed to

Gego, *Chorros* (detail), Museo de Barquisimeto, 1985
Aluminium, stainless steel, iron and rivets, dimensions variable

another inversion in Gego's life that went against the usual model of a constructivist artist: 'Instead of being first an artist, then a producer, Gego was first a producer – a technician, a designer – then an artist.'[1] I shall return in a moment to some of the fascinating questions this observation raises.

In Venezuela the unique situation developed in which avant-garde art – in this case what is broadly known as Kineticism – became the official, monumental art of a modernising nation (the ground had been prepared by the modernist architect Carlos Raúl Villanueva's invitation to international and Venezuelan artists, among them Alexander Calder, Fernand Léger, Sophie Taeuber, Jean (Hans) Arp, Alejandro Otero and Jesús Rafael Soto, to enhance with their works his designs for the university city of Caracas. Villanueva had assembled an outstanding personal collection of European and Venezuelan abstract art at its most experimental). Gego was not outside this movement (she made a number of installations for public buildings in Caracas) but her relationship to it was different from that of the triumvirate of kineticists, Otero, Soto and Carlos Cruz-Diez. The nature of that difference is deeply revealing. The mega-visibility of the kineticists may be contrasted with the modesty and secrecy of Gego, but the work of all four is connected at many levels. Gego admired Soto, and their researches were complementary. Both sought a dematerialisation of art, or rather a structure where matter and energy would be seen as interchangeable. In many ways Soto's later monumental work is completely at odds with the fragility, the instability, the delicate balance between the plastic and the vibratory that he brought into the pictorial tradition. Luis Pérez-Oramas reminds us of how Soto, 'as a child riding on the back of a donkey in Guyana, the Venezuelan region where he was born ... was impressed by the reverberation of light in space'.[2] Later in the same autobiographical statement that Oramas refers to, Soto muses: 'We pass so quickly in a world which is so vast.'[3] The fleeting was essential to his vision, evoked here as a lost landscape of childhood.

After the collaboration with Villanueva, which was carried out, according to his socialist humanist principles, very much in the public sector, the commissions for Soto, Otero and Cruz-Diez increased dramatically in both the public and private domains. It is hard to think of any European country which has given commissions to artists on the scale of Venezuela of the 1950s and 1960s; or of a single commission as gigantic as Otero's *Torre solar* (Solar Tower, 1986) and Cruz-Diez's *Ambiente Cromático* (Chromatic Environment), covering the turbines and walls of the powerhouse of the newly built Guri Dam and hydroelectric plant on the Caroní river (mid 1980s). However, this achievement is inescapably mixed with hubris. One has only to look at the essay by the project's instigator, Alfredo Boulton, in the souvenir book – a bizarre paean to power which manages, in a few short pages, to invoke the Parthenon, Abu Simbel temples, Teotihuacan, the Sphinx, Chartres Cathedral, Alexander the Great and Napoleon! Cruz-Diez's colour interferences, he writes, 'recall the splendour used to decorate the galleries, halls and sanctuaries of the homes of the most powerful men in the universe'.[4] It was left to the perspicacious art critic Marta Traba to remind of the other side of Venezuela's modernity, a landscape dominated by 'misery, chaos and irrationality even in the urban centres that try to mimic development'.[5] It is painfully ironic that many of Cruz-Diez's and Soto's public works in the urban centres are today looking shabby and neglected, with some of their parts looted for scrap metal.[6]

For all her contribution to Venezuelan modernism and her love of the country, Gego's relationship to the nation-state was very different. After all, Gego had to leave her country under threat of deportation and death, a country where her family, as assimilated Jews, had lived for generations. Questioned after the war by a German professor who was researching the lives of Jews in the Third Reich, Gego, who rarely talked about herself, was stung into celebrating her upbringing as a personal ethic:

127

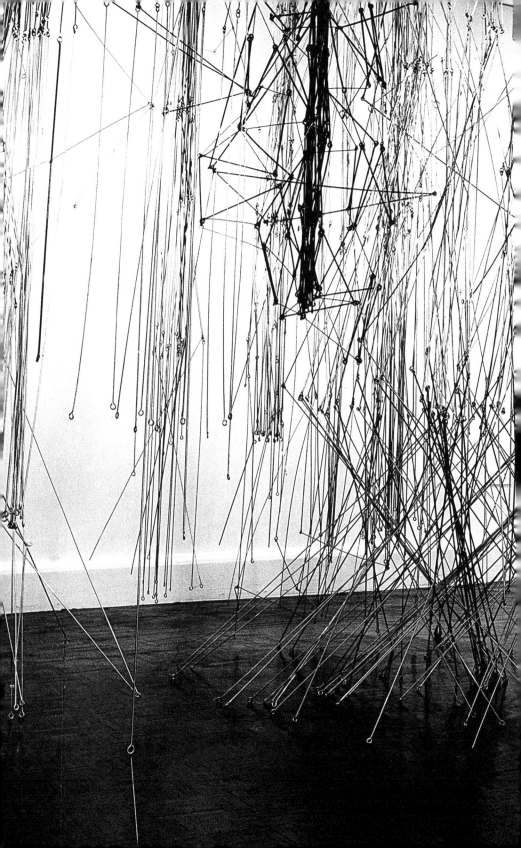

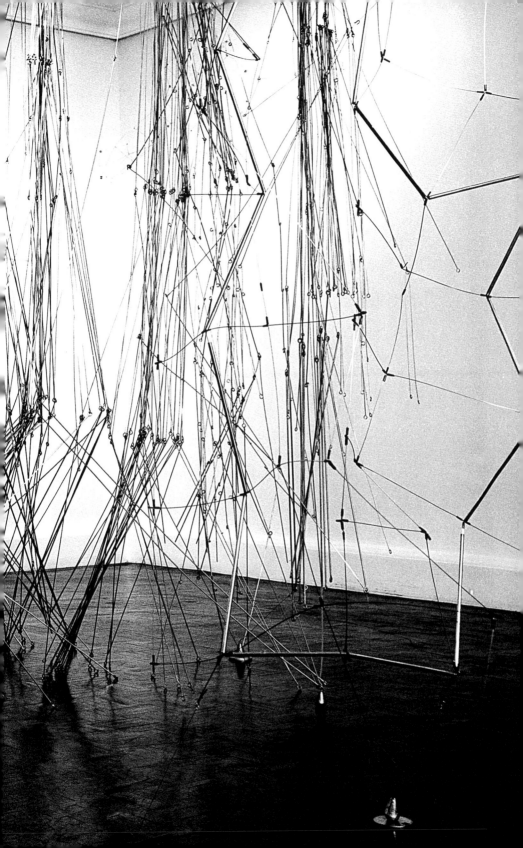

I never visited a synagogue or a temple in the Jewish community and it was much later that I learned the meaning of anti-Semitism. Perhaps one of the characteristics of my education was the respect for ideas, thoughts and cultures other than my own. Another important aspect was the demand to take the community into account, not to bother anyone and not be bothered, that is to say, to integrate oneself.[7]

The critic Iris Peruga, in one of her essays on Gego, expanded on this: '[from an early age] Gego demonstrated her rare ability to accept what life had in store for her: places, people or things';[8] and in the introduction to their compilation of the artist's spare, occasional writings, Maria Elena Huizi and Josefina Manrique speak of Gego's pleasure in 'hiding, or passing by unnoticed'.[9] It is a short step in fact from Gego's ethic to her aesthetic. The statements just quoted illuminate the spatial structures she created as much as they do her personality and life. 'I work without breaking or opposing architecture', she commented about her first public sculpture commission in 1962.[10] Iris Peruga's description of one of the finest of these commissions, *Flechas* (Arrows, 1968), a thrilling aerial web made of cables strung between buildings in a shopping centre, also rings true: 'This structure of vague, and of course centre-less boundaries … was held in suspension by the balance created by opposing forces: the compression of the work's own weight and the tension produced by the cables and nylon ropes fastening it to the walls.'[11]

Gego brought with her to Caracas a Germany different from the monstrosity of Nazism – the Germany of rigorous and precise technical education. She was trained at the Faculty of Architecture of the Technische Hochschule Stuttgart, a conservative institution which was on the point of turning towards the new interdisciplinary ideas associated with the Bauhaus. Some five years before Gego enrolled, [Ludwig] Mies van der Rohe, who later became director of the Bauhaus,

had completed a housing project in collaboration with the school for the Weissenhof quarter of Stuttgart which architect Philip Johnson considered 'the most important housing complex in the history of modern architecture'.[12] After the war, Bauhaus ideas spread more widely around the world, and Gego of course was one of the agents of that dissemination. Her first employment, after arriving in Caracas, was in an architect's office; a little later she set up a small business designing and making wooden furniture and lamps. In 1958 she began a teaching career which lasted until 1977. The critic and curator Ruth Auerbach, who was herself a student of Gego's, has written an invaluable study of Gego's teaching during these two decades, clarifying an aspect of Gego's life which 'few researchers have paid attention to, or acknowledged the importance of'.[13] 'Gego never separated her academic activities from her study of forms and their transformation in space, or from her artistic practice.'[14] Auerbach traces Gego's pre-eminent educational contribution to Venezuela's 'fragile academic arena'[15] from its early days to its culmination in the 'Spatial Relations Seminar' at the then recently founded Instituto de Diseño Fundación Neumann, a participatory workshop which Auerbach considers 'the freest and most singular undertaking of her whole teaching career':[16]

> A varied repertoire of models, drawings and calculations – first using the five platonic or regular volumes: tetrahedron, cube, octahedron, icosahedron, dodecahedron, and their interpenetration to obtain different sequences of semi-regular or Archimedean solids – were individually analysed until their essence was grasped. Cuboctahedron, dymaxion, icosidodecahedron, rhombicosidodecahedron, symmetry axes, face, vertex, arris, spheres, duals, projections, relations, truncations, stellations as well as many other terms were part of the routine vocabulary used by the group in this peculiar laboratory.[17]

131

Interestingly, as a fascinating sign of cross-cultural interaction of ideas at the time, a starting point for the work of the seminar was a book by the English scholar and artist Keith Critchlow, *Order in Space*. Published in 1969 in an elongated format with a plastic spiral binding – looking like a technical manual – and with a recommendation from Buckminster Fuller on the back cover, Critchlow's book illustrates scores of examples of space-defining geometries. Critchlow later went on to study Islamic patterns and ornamentation, interpreting them as cosmological/mystical models of infinity.

Just as Gego's teaching and her 'visual research' interlock with the evolution of her art, both together interlock with another outstanding, and unaccountably overlooked, aspect of the visual arts in Venezuela over the period in question: the highly sophisticated development of graphic design. In 1952 Gego met Gerd Leufert, who, like her, arrived as an immigrant from Europe, and who became her lifelong companion and supporter of her work. Leufert was a brilliant graphic designer, photographer and painter – by common consent the instigator of the design movement, one of the best in the world at the time, which succeeded in releasing a sort of tropical exuberance on the basis of rigorous constructive and technical methods. Perhaps this is what made it a quintessentially Venezuelan phenomenon. It was a close-knit association of people and a cluster of interrelated practices, including logo and book design, photography and printing. Each discipline stimulated and asked questions of the other. In fact, a great part of this exuberance lies in playful dismantling and re-assembly of the classic components of the book.

The productions of this modern tradition of design are not easy to access outside of Venezuela. An immediate and convenient way to appreciate their qualities is by means of the succession of catalogues of Gego's own work produced in Caracas. Leufert's layouts, and espe-cially the sequence of Gego publications designed by Alvaro Sotillo, show how structural invention and originality can be combined with great sensitivity to the nature of the artist's work. Sotlllo's designs

range from the first substantial publication on Gego in 1977,[18] with a fine text by poet and critic Hanni Ossott – a graphic record in which technical isotype-like drawing is combined with photography – to the recent tiny volume which concentrates exclusively on the joints and cross-points of Gego's constructions.[19] Paolo Gasparini, the photographer to whom we owe the finest – now iconic – images of Gego's *Reticulárea* installed in the Museo de Bellas Artes, Caracas, in 1969, is another example of these interacting talents. Later, in quite a different vein, Sotillo designed Gasparini's astonishing book of photographs *Retromundo* (1986), a fantasmagoric *flânerie* through First and Third World cities, by turns spectral and earthy, stretching to some sort of limit the resources of printing.[20]

But what is design? How and where does it overlap with and differentiate itself from art? What is the meaning of the strong desire for interdisciplinarity in the twentieth century, the possibilities released where categories and discourses meet? Such questions become rich and complex vis-à-vis the history of modern design if one considers a figure like the Italian artist and designer Bruno Munari.

Although there is no direct connection between Munari and Gego, it is revealing to compare them. Munari personifies the great reputation of Italian design in the mid-twentieth century. But he was more than that. He was continually inventive around a whole range of contemporary issues. Munari made Sculture da viaggio (Travel Sculptures, 1958) to fold down into a suitcase, Macchine inutili (Useless Machines) in the early 1930s, which are pioneering works of Kinetic art ('"useless" because they don't produce material consumer goods like the other machines, they don't dominate labour, they don't aid in the creation of capital'[21]), experiments with falling pieces of paper to 'make air visible' in the late 1960s, and much more. He also designed clocks, chairs (including, amusingly, a tall, slender, tilted chair 'for the briefest of visits'), ashtrays, advertisements and beautiful children's books. 'He turns restlessly in a world that bombards him with stimuli that assault him from all sides', as

Umberto Eco wrote.[22] Munari's mind is fascinating and his playful spirit deeply life enhancing, yet a certain quality of schematic neatness and containment which runs through all his work, seems to distinguish a designer's rather than an artist's mind.

But does the distinction really lie in schematism, and if so how does Gego escape it? The Venezuelan novelist Victoria de Stefano recalls a visit to Gego and Leufert's house during which, at a certain moment, she referred to Leufert as an artist and he retorted: 'Artist, me? There's only one artist in this house, and that artist is Gego.'[23] No doubt he was being modest. I know too little about his work to be able to judge myself, but Luis Pérez-Oramas considers that, after the painter and sculptor Armando Reverón's work of the first half of the twentieth century, there are only two moments in Venezuelan painting which reach a similar height: Otero's series of Lineas inclinadas (Inclined Lines, 1948–51), and Gerd Leufert's large white monochromatic paintings (1959–63).[24] At this point, however, I would like to take Leufert's protestation that Gego was an artist and he, by implication, a designer, to speculate on what it is that makes Gego's work 'art'; and where 'visual research' tips over into artistic expression.

In a note among the bundle of her *Sabiduras*, the folder of her writings and drawings, Gego wrote: 'Thirty years ago I was trained as an architect committed to draw lines that determine forms or spaces as symbols of limits, never with a life of their own.'[25] In this revealing statement Gego describes the discipline she left, and the space of freedom she sought, and she describes that transition in terms of drawing and lines. No observer of her work can miss the pre-eminent role drawing plays in it and to what extent her universe is graphic. Drawing, age-old, never exhausted (nobody ever claimed the 'end of drawing', as they did of painting), is an activity very near the creative core of the psyche. Gego's 'lines in space' play a continual game with the memory of the plain sheet of paper and the frame, dissolving both in her aerial Reticuláreas and re-invoking them in a subliminal

form in her late series of works, *Dibujos sin papel* (Drawings without Paper). And drawing, which had been the agent of delimiting form and space in her architectural and design work, became the agent of dissolving form in favour of ever-freer forms of energy in the evolution of her structures from the parallel lines sculptures of the late 1960s, to her Reticuláreas (1969–72) and *Chorros* (Streams, 1970–74), to the simultaneously sprouting and disintegrating wire grids of her late work. Constant through these changes was Gego's characteristic combination of a lucid constructive logic and a deep organic and emotional intuition.

Gego's work can be convincingly placed in an international development of avant-garde art during the twentieth century where the old idea of form was gradually, and in the most diverse guises, abandoned and replaced by the notion of a force field. In its application to art, Umberto Eco described this force field as a 'complex interplay of motive forces ... a configuration of possible events, a complete dynamism of structure'.[26] Artists came to this perception by different stylistic routes: put at its simplest, both from the geometrical or concrete and from the informal or gestural, expressionist, directions. In the conventional categorisation of modernist idioms, these were seen as opposite, even antagonistic, tendencies. But the notion of the force field enabled one to see deeper than style, towards some intuition about the nature of matter and energy which amounts to a shared desire to construct a model of the 'all', the universe. This question was certainly on Gego's mind in the early 1970s. After visiting an exhibition of the art of Indian Tantra (whose spiritual exercises have close links with Indian cosmology), Gego expressed the opinion that 'nuclear reality as perceived by science has not yet been updated convincingly in art.'[27] Among South American artists of her generation, Gego's trajectory can be plausibly compared with those of Lygia Clark and Hélio Oiticica. 'I began with geometry, but I was looking for an organic space where one could enter the painting', Lygia Clark has said about her earliest experiments.[28]

The *Reticulárea* (Gego), the cellular body architecture (Clark), the *Parangolé* (Oiticica), can, despite their differences, be seen as organic, elastic structures of interacting forces emerging from the plane, the geometric schema, into an active space. Looking back to an earlier generation we find an exemplary process of the same kind in the visionary but still under-appreciated work of Georges Vantongerloo. Vantongerloo certainly achieved an aesthetic equivalent for 'nuclear reality'.

Vantongerloo's journey from the geometrical and mathematical in his early work of the 1920s (incidentally, an 'all round' structural system which stretched to the design of furniture, houses and airports), through his 'curves' paintings of the 1930s, to the nucleic wire and Plexiglas models and 'radiation' paintings of the mid 1940s to the early 1960s, continues to exert a profound fascination. 'In creation, objects experienced through our senses are not inert; they are energies of which the whole of space is composed.'[29] It may be that Vantongerloo's vision of space was with him from childhood but his struggle to find the way to express it led him from abstraction to a sort of materialised equivalent to the real forces of creation. A mysteriously modest equivalent, it must be said, the only way, perhaps, for human beings to bear witness to what he called 'The Incommensurable'. Thus his few twists of wire around a solid core, his prisms drawing colour/light into a loop of Perspex, his delicate paintings of plasmic densities and fluxes, exist on the threshold of what cannot be visualised.

Towards the end of his life he liberated himself from any sort of schematism, as artist and designer Max Bill wrote.[30] Jane Livingston noted in the catalogue of the first, and only, substantial Vantongerloo exhibition in America in 1980: 'We can assume that [Vantongerloo] understood the implications for science and art of the shift in emphasis, even by theoretical physicists, towards organic life-forms and their sub-molecular genesis and evolutionary reformations. The later work of Vantongerloo unavoidably reminds one of plasma

…From the biological, we are brought abruptly to the mental.'[31] It is here that the apparently incongruous and impermissible connection can be made between Vantongerloo and an artist like Wols, who arrived at 'plasmic' cosmic models by the route of informal abstract painting and etching. Their meeting produces an endlessly ramifying force field between biology and physics.

However, we are not speaking in terms of science but of art, and in art the force field of the work must also be its poetic field. It may also be the creation of a poetic field which distinguishes art from design, although this matter is highly paradoxical since some work labelled 'design' may have a poetic field, may give lines 'a life of their own', and some labelled 'art' may not. A poetic field is that which transforms everything placed inside it, according to a very individual, personal magic which is rekindled for each work. At the same time the poetic field is the force field. The leftover scraps of metal and plastic Gego saved in her studio – wire, coils, sleeves, little tubes, balls, bolts – and later incorporated into her *Dibujos sin papel*: they enter the work and take on a delicate yet intense presence which they don't possess outside it. Everyone recognises and marvels at the role the joinings, hubs, and 'cross-over points',[32] as the artist herself called them, play in her art from the beginning. This would include the makers of the small photographic book mentioned earlier, *Gego: Anudamientos*, whose enjoyment in focusing on the incredible variety of Gego's 'articulated intersections' (again her own words)[33] is obvious. Yet for all this material diversity and imagination, it is remarkable and moving to see the way, in some of her drawings on paper (for example, untitled drawings on the triangular module at the time of the environmental *Reticulárea*, 1969), Gego could dissolve the point where the lines join into a void, a tiny empty space, a charged space, between lines that only meet in the imagination. This simple device makes clear that the void, space, is as much the material of her work as the ink, or the metal.

Rina Carvajal has written of the way Gego's art echoes the 'self-renewing continuity of life'. 'The forms resist closure, rather expressing

an infinite expansion of space.'[34] And Luis Pérez-Oramas has referred to 'the incessant prodigality of a centre-less structure, which generates from the edge'.[35] Pérez-Oramas has compared this structure with certain characteristics of ornament. These linkings are very interesting. Of course they depend on superseding the long-ingrained prejudice in Western art history which sees 'decoration' as low down on a constructed hierarchy of visual art forms. A counter claim, for example in the writings of Alois Riegl on the arabesque, Arthur Upham Pope on Persian carpets, and Keith Critchlow, as already mentioned, on Islamic patterns, has considerably weakened this prejudice. The arabesque is one of the great inventions in the history of visual culture, a beguiling fusion between the pulse of nature and the abstracting human mind, a metaphor for infinity. Describing it, Riegl writes of how 'the individual motifs vary only slightly and then repeat continuously, and yet they never become monotonous. The pattern as a whole seems infinitely richer than it actually is …' Riegl calls this quality of Islamic ornament 'infinite rapport'.[36] The phrase seems to bring us full circle back to Gego's personal scale of values as mentioned earlier, and, also, the comparison with decoration revives in a new light the role played in her life by design.

But not entirely, because Gego gradually pulled away from the immaculate, unfaltering character of the decorative and the constructive, her activity in the late *Dibujos sin papel* was an unweaving as much as a fabrication. Iris Peruga has spoken of 'grids that slowly and almost inadvertently shift towards the irregular, the torn, the wasted, the parodic',[37] and she has compared the structures of the *Dibujos sin papel* to the precarious and improvised dwellings of the Caracas *ranchos* or shantytowns, where people make what they can out of what is available (which, as we saw, could include, ironically, materials filched from the neglected and decayed utopian urban works of Soto and Cruz-Diez). Oramas interprets the *Dibujos sin papel* as working 'abject transmutations [of the] immaculate constructivist image'.[38] Elsewhere, making a correlation with the philosophy of

Gilles Deleuze and Félix Guattari, he explains the same quality as a form of freedom from a 'hegemonic signifier' and a 'final culmination'.[39]

Each of these readings is convincing. In my view, joy is never absent in Gego's handiwork and her trajectory showed a continuous growth in wisdom and awareness. To see a Gego exhibition is to be buoyed up by a sense of hope. We feel we are in the presence again of the early promise of abstraction, where it seemed a point of honour for the artists to accomplish their work with the greatest economy and wit.

Gego: Defying Structures, Museu de Arte Contemporânea de Serralves and MACBA Barcelona, Porto and Barcelona, 2006

Anne Bean
Within Living Memory

A *Short History of Performance: Part One*, Bernsteins, Whitechapel Art
Gallery, London, April 2002. What had originally come into being as
an experiment: seven artists – among them Anne Bean as the only
woman – sitting round a kitchen table and laughing together for
one hour with just a few friends attending, was now, 30 years later,
re-created in front of a much larger audience in a public gallery.
It was part of a curatorial attempt by the Whitechapel Art Gallery
(futile? misguided? audacious? long-overdue?) to restage some
artists' ephemeral events, sprung from living time, that had passed
naturally into memory. The original kitchen table was in an old
chemist's shop on the Mile End Road called 'Bernsteins' which gave
its name to this loose collaboration of artists, one of many that
Anne Bean has participated in. There was poignancy in the fact that
the work's title, *Death to Grumpy Grandads*, conveying youth's impish
criticism of the older generation, was now being acted out by people
fast approaching the grandad condition themselves. The second
time around they may well have been laughing at the oddity of their
own situation. After the event the audience remained in their places
and a discussion took place. Anne Bean assumed the role of a benign
hostess, coaxing from the men some account of their lives since the
early 1970s. These reminiscences were affective exchanges. They took
the form of lived experience rather than art history.

I attended *Death to Grumpy Grandads* with a friend and, arriving
late, we took up places near the edge of the crowd surrounding
the players. We were quite some way from the centre of energy.

141

Anne Bean, *Falling In Love With a Chair*, 2003
Performance/Installation, National Review of Live Art, Glasgow

It was fascinating to notice the way in which the laughter was most contagious among those nearest to the performers and that it spread a certain distance through the rings of people. Of course there were those who preferred to pay attention in silence, and the attendant photo and video cameras created further pools of solemnity and stasis. My friend noticed that Anne Bean particularly made eye contact with her fellow performers so the individual nuances of laughter would resonate between them. We fantasised about starting a little nucleus of mirth outside the main event, and wondered if that would be sabotage or be taking participation a step further.

Laughter spreading through the crowd could be taken as a metaphor for the way the ephemeral work spreads through time, in ever widening circles, increasingly remote from the original source. In the process it lights people up, it becomes something else and the 'original source' can never be returned to. A wonderful paradox is contained in the invention of the genre of Performance art, which epitomises a crucial dilemma of contemporary culture. On the one hand, performance rejects the means of reproduction, recording and mediating which technology has taken to such lengths. It is archaic in that sense. Performance exists in the moment, for those who were present in that place and time, and it entrusts itself to the vagaries of individual memory and subjectivity. No two people remember exactly alike. On the other hand, there is a persistent desire to record it, or even re-create it, as happened with *Death to Grumpy Grandads*. But this is never adequate, so these recordings submit to the same vagaries as human memory – and the same creative potential. Is it right or wrong to re-stage ephemeral events? This debate raged around the Whitechapel Art Gallery's *A Short History of Performance*. There can be no absolute judgement. There is something more like a gradual diminution of effect, or a place on a scale between the fiery core moment and complete extinction. Even a poor translation, even a faded photograph, gives some clue, and an approximation can itself set another creative cycle in motion. In some cases, the report of

something remote may itself carry the aesthetic charge. In the Silueta series of Ana Mendieta for example (which almost everyone who knows them knows through photographs), the photographs add something mechanical which passes beyond what one could have perceived if one had actually been present at her solitary ritual. This is due to the forensic nature of the camera's gaze which picks up every nuance and detail of the patch of land where Mendieta was working. Every leaf, every bubble in the sea wash, every trickle of mud then becomes implicated in the presence and decay of Mendieta's female effigy. At the same time, the Siluetas need to preserve the character of a 'report', which may explain why they are more suggestive when reproduced in a book or catalogue than as framed photographs hung on a wall.

Reading Anne Bean's CV is like following a continuous performance, a continuous response to the world (*Our Trespasses*, the title of a project of 1993 – for which she has not asked for forgiveness! – is a nice way of putting it), a 'magicification' of the world. The panoply of places she has worked, times of the day or night, interiors, exteriors, seasons, publics, materials, concepts, tools, is astonishing: all shifting but all attuned to unique situations. Many works have evolved collabora-tively, sometimes leading to the formation of groups (such as Moody and the Menstruators, Bernsteins, Bow Gamelan Ensemble) and sometimes not. Looking at this vibrant chronicle, the writer writing this looks for the points at which he entered the programme, what he witnessed, what he caught of it, small compared with many others, all with their individual memories.

The word 'performance' is actually too limited and contained to describe the multifarious and poetic manner of working that distinguishes Anne Bean's career, and is especially marked in the 30 actions from 1969 to 1974 which she has re-visited for the show [*Autobituary*] at Matt's Gallery, London and collectively renamed *Shadow Deeds*. For Anne Bean, to re-visit was to re-experiment with previous experiments. Were the years 1969 to 1974 any different

from other years? The answer will always be a mixture of personal experience, a particular point in the individual life story (Anne Bean's age was 18 to 24 at that time), and a consensus of meaning that emerges from the chaos of worldly events. For Anne Bean those years were a time when 'the inner landscape of the child met the zeitgeist'. The 'inner landscape' was conditioned by her birth and childhood in Zambia, which was then the British colony of Northern Rhodesia, her art education in Cape Town, South Africa, her travel, and her arrival in England, whose zeitgeist at that moment, it is generally agreed, was one of extraordinary ferment in society and in culture.

> The conjuncture, and its significance for many young artists, has been nicely summed up by art critic and writer Jean Fisher: 'To the accompanying beat of rock and soul, a new generation of politically radicalised artists emerged in the wake of the unprecedented threats to global survival posed by Western militarism and ecological disaster, decolonisation struggles and apartheid, and the black and women's rights movements, which in turn produced a new scepticism to existing structures of power and their forms of representation. The restless energy produced by this realignment with the status quo was fuelled by the rise in media culture and accessibility of its own reproductive technologies ... Time-based media [such as video and super-8 film] formed a natural alliance with emergent performance art, generating new aesthetic languages through which the relations between the subject and the social could be "re-narratised". Because the work was ideas – not market – driven, its often ephemeral nature was not immediately susceptible to existing means of documentation and exhibition; and it is perhaps not fully appreciated the extent to which it forced a revision of both curatorial practice and art school curricula.'[1]

It was just the number and diversity of these currents that excited Anne Bean. She wanted to embrace them all. She identified with the women's movement but the designation 'feminist artist' would seem like a restriction. Her groups might perform at a benefit for the feminist magazine *Spare Rib* one evening and at a working men's club the next. 'I felt so multi-levelled. Why does an artist need to assume a fixed identity, a career? Why such narrowing down?'[2] Her work could be construed politically but she felt a certain liberation from the burden of politics which so dominated the horrible situation in apartheid South Africa. Just before leaving, and just before the end of her time at the Michaelis School of Fine Art in the University of Cape Town, she had sat for a day on a park bench reserved for whites only with the palms of her hands painted black and facing outwards. 'I thought of it as a visual protest. Only in retrospect could I see it in terms of performance.'

The artist has described her project at Matt's Gallery, *Autobituary* (2006), as 'announcing one's obituary to be alive again'. As such it could be seen as a paradoxical stratagem in a body of actions, large but almost unremarked-upon as such, by which artists have endeavoured to rescue their work from the fossilising process of institutionalisation and acculturation. One example would be the Brazilian artist Hélio Oiticica who, two years before his death, carried out a little ceremony with a few friends he called *Counter-Bólide: To Return Earth to the Earth* (1978). Back in his 20s he had gathered earth, or pigment, or brick dust, in boxes and glass containers he called Bólides (Fireballs). But, feeling that these had come to be seen as art commodities rather than, as he intended them, as 'energy-centres', he took some rich earth and a small wood frame to a desolate patch of waste ground in the city of Rio de Janeiro, poured the earth into the frame and removed the frame to leave a dark square of earth on the earth. Clearly, it was intended to be a way of burying the *Bólide* as an object and resurrecting it as, in his phrase, a 'life-act'. Anne Bean's strategy has also been to return to a period of exceptional creative

145

Overleaf: Spread from Anne Bean, *Autobituary: Shadow Deeds*, Matt's Gallery, London, 2006

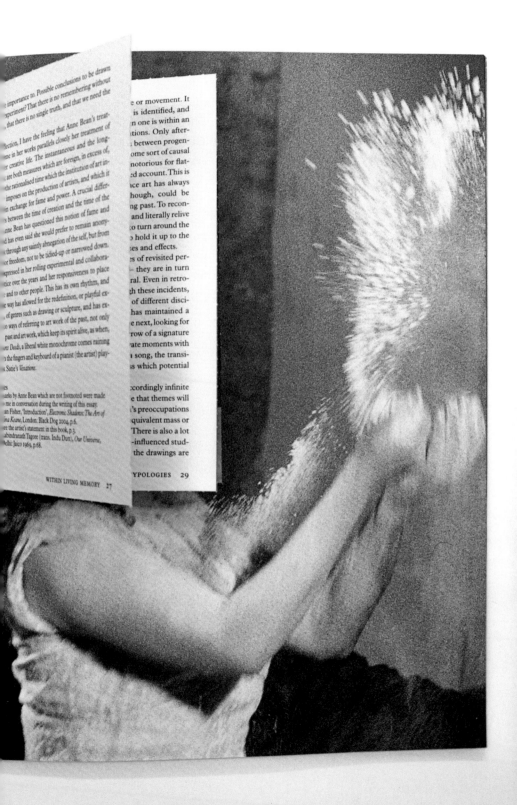

...importance to. Possible conclusions to be drawn
...experiment? That there is no single truth, and that we need the
...that there is no single truth, and that we need the

...ection, I have the feeling that Anne Bean's treat-
...ne in her works parallels closely her treatment of
...r creative life. The instantaneous and the long-
...are both measures which are foreign, in excess of,
...he rationalised time which the institution of art in-
...imposes on the production of artists, and which it
...in exchange for fame and power. A crucial differ-
...between the time of creation and the time of the
...nne Bean has questioned this notion of fame and
...has even said she would prefer to remain anony-
...through any saintly abnegation of the self, but from
...r freedom, not to be tidied-up or narrowed down.
...xpressed in her rolling experimental and collabora-
...tice over the years and her responsiveness to place
...and to other people. This has its own rhythm, and
...way has allowed for the redefinition, or playful ex-
...of genres such as drawing or sculpture, and has ex-
...to ways of referring to art work of the past, not only
...past and art work, which keep its spirit alive, as when,
...over Deeds, a liberal white monochrome comes raining
...the fingers and keyboard of a pianist (the artist) play-
...Satie's Vexations.

...es
...marks by Anne Bean which are not footnoted were made
...me in conversation during the writing of this essay.
...an Fisher, 'Introduction', *Electronic Shadows: The Art of*
...ina Keane, London, Black Dog 2004, p.6.
...ee the artist's statement in this book, p.3.
...abindranath Tagore (trans. Indu Dutt), *Our Universe*,
...elhi: Jaico 1969, p.68.

e or movement. It
is identified, and
n one is within an
tions. Only after-
between progen-
ome sort of causal
notorious for flat-
ed account. This is
ce art has always
hough, could be
ng past. To recon-
and literally relive
to turn around the
o hold it up to the
es and effects.
es of revisited per-
— they are in turn
ral. Even in retro-
h these incidents,
of different disci-
has maintained a
e next, looking for
row of a signature
ate moments with
song, the transi-
s which potential

cordingly infinite
e that themes will
's preoccupations
quivalent mass or
There is also a lot
-influenced stud-
the drawings are

and experimental energy, when 'literally hundreds of actions were produced', in diverse collaborations and 'ephemeral event structures which allowed and sustained this dynamic and spontaneous flow and generosity of spirit and … non-ego-driven process'.[3] One can speak of a 'creativity of the moment' in certain periods and contexts of the history of art which somehow sweeps artists up and emboldens their imaginations to go further than they would otherwise. Respecting the fluid nature and unfixed definition of what that creative moment really was, Anne Bean devised her own method of re-visiting it: to perform again some of those original actions in an attempt to activate that memory which is not the same as cerebral memory; memory which remains in the body-cells even though we change the cells themselves continuously during our lifetime.

This calling on the past from the present, therefore, joins other recent work of Anne Bean in being an experiment with time. One of the most striking features of her work is that it posits and celebrates two measures of time: one of great physicality and visceral immediacy, usually expressed through her body, and the other of slow change that takes place over a long period of time, and is by contrast almost impersonal. Both tendencies can be found within the 30 episodes of *Shadow Deeds*. To take two examples of the first: she pricks her finger and writes 'RAW' with her blood on a sheet of glass, then turns over the glass so it reads 'WAR' and smashes her head into it, breaking it; lying down, she pours honey into her mouth from a funnel and attempts to carry on singing through the sweet viscosity. Then two examples of the second: a white sheet is suspended in sunlight and a model aircraft fixed behind it, casting a shadow – she draws around the shadow at intervals during the day showing its movement across the sheet as an intricate line drawing; she returns 20lbs (9.07kg) of sea salt and several sacks of sand to the seashore to be gradually reclaimed by the sea. And one example of the humour of the unexpected which is so much part of such acts: at intervals during the *Shadow Deeds*

she appears in various public spaces shouting the word 'MORTALITY' at the top of her voice. It originated in the observation that having a dog enables you to shout a word, i.e. its name, very loudly in public. Staged amidst the completely ordinary, the cry of 'MORTALITY' seemed to echo in the vast emptiness of space and time, reminding me of a poem by Rabindranath Tagore in which he wrote about how the 'wailings of others' and the 'sighs of thousands and millions' went unheard in the howl and roar of the universe.[4]

In the event *Reap* (2004–05), in which she collaborated with, and which included, many other artists, Anne Bean worked with changes taking place over an entire year. It was staged in and around Southwark Park, London, between September 2004 and September 2005 and included venues such as Café Gallery Projects, Dilston Grove (former Clare College Mission Church) and the Coleman Project Space (as well as an abandoned garden of extraordinary spookiness secreted in the middle of the park). At one end of Dilston Church Anne Bean installed a vast square of massed apples on the floor. This work became a sort of comparative history of rotting. As the year wore on some apples reduced themselves to dust, while others remained almost pristine: it was hard to know why the differences were so great. A first impulse to congratulate the rosy apples for keeping their complexion over 12 long months gave way, on reflection, to valuing the brown shrivelled husks just as highly. Some lines from TS Eliot's poem 'Ash Wednesday' (1930) painted on the wall of the church read:

> Because I know that time is always time
> And place is always and only place
> And what is actual is actual only for one time
> And only for one place
> I rejoice that things are as they are…[5]

Later, I learned of the process behind the work, and of some things that I had missed at my own viewing. The 5,000 apples had been

gathered together after initial research with Brogdale Apple Research Centre at Imperial College London, where Anne Bean had learned about preservation by various techniques from waxing to Genetic Modification (waning): 'I wanted some apples in the piece to sustain their youth whilst those around crinkled and rotted, but a crucial part for me was that in these "youthful" apples I wanted a sentence to emerge.' The initial apples were totally indistinguishable from each other, then as colours changed to dark brown and decomposition began, certain apples emerged to reveal the words, also from T S Eliot, a line from 'Burnt Norton' (1936),

Neither from nor towards; at the still point, there the dance is[6]

In the final rotting the sentence submerged again.

At the other end of the chapel, the equally large installation started off as a delicate construction of spiral incense coils supported with turquoise thread. When it was lit, the process began of exchanging its physical substance for smell, creating a perfumed space: a year of scent, the conversion in infinite slowness of a visual into an olfactory phenomenon. In both works it was a question of the exit of objects, the entrance of dust.

Anne Bean buried a teddy bear in the grounds of Southwark Park and it was exhumed a year later with all the rigours of an archaeological excavation. As part of her involvement with the idea of change, she had wanted 'many identical and pristine objects to "travel" through a year together in wildly varying situations, with their very different experiences reflected by their physical state at the end: I wanted people all around the world to be involved.' After wondering and discussing with other artists what that object could be (a book? shoes? pot plants? photos? various toys?), 'we kept coming back to the notion of a teddy bear ... I started speaking to people about the teddies and the idea sparked such enthusiastic speculation and a keenness to be involved that it stuck'.[7] It was a stroke of genius as a device to spark collaboration and collective invention because it

revealed, quite unexpectedly, how much people invest in teddies;
72 teddies, 72 artists and others became involved, generating
72 stories of complete individuality and imagination as 'Teddy',
a kind of innocent, was thrust out into the world.

The results were shown at the Coleman Project Space. Among
them: teddy included in every wash cycle for a year; teddy lying
among ivy and toadstools in a Czech village; turbine teddy on a
tiny swing in the midst of Borlin Valley hydro-electric system, Eire;
sleeping teddy, eyes closed; a sooty teddy with a brush placed above
a chimney in Hull; teddy sitting beside a large rock-drawing at an
ancient Aboriginal [Indigenous Australian] sacred site in Australia;
teddy dwarfed by the seeweedy hulk of Richard Wilson's sculpture
A Slice of Reality (2000); iced-up teddy in New York; mummified teddy;
petrified teddy, after a year in the hot springs of Western Bohemia.[8]
The scenarios, trials and joys that teddy went through were actually
very adult, but his/her presence there emblematised each author's
link with childhood, providing an original route to an unusual
and touching exhibition, which in the process gently mocked the
official seriousness of most art events.

Sometimes the fast and slow time come together in a single
work. In 1992, Anne Bean initiated, with Paul Burwell and Richard
Wilson at the Serpentine Gallery, London, a memorial to Stephen
Cripps. Stephen Cripps was an artist of great energy, inventiveness
and audacity who died in 1982 at the age of 30. Pyrotechnics was his
metier and he had been involved with Anne in events which led to
the formation of the group that became Bow Gamelan Ensemble.
The Serpentine Gallery event, A Slow Event, both mourned his loss
and celebrated the publication of a book on his work by David Toop.[9]
Slow time was encapsulated in a 'melting monument', a stepped
structure of blocks of ice in each of which was sealed a floral tribute
from an artist or friend (these were as diverse and personal as the
later teddies). The slow melt of the ice during the long June day,
leaving only the scantiest debris of petals behind, was followed at

dusk by the instantaneous: the 'launch' of the Stephen Cripps book into the sky as an explosion of paper with the aid of a mortar.

The Whitechapel Art Gallery's A History of Performance, the present show Autobituary at Matt's Gallery, and last year's Reap in Southwark are pertinently, if unintentionally, linked by another of Anne Bean's experiments with time. At the beginning of the year at Southwark, at the Scout Hut, Jamaica Road, Bermondsey, she did a performance in front of an audience of five women, of which no records were made. On the same night in the same place a year later, she asked each of them to re-perform the piece for her according to their memories of it. They did so in turn, without seeing each other's versions. Yearnings, as the piece was called, was re-made as a public performance which Anne Bean herself took part in and performed her own memory of the original. 'I asked for absolutely no documentation so there are no images at all of this work which, in the fevered recording of today, really gave it its own "actuality".' Not only were all their memories of what happened very individual and different, but sometimes the five witnesses remembered things Anne Bean had done that even she had forgotten, or given little importance to. Possible conclusions to be drawn from the experiment? That there is no remembering without forgetting, that there is no single truth, and that we need the Other!

On reflection, I have the feeling that Anne Bean's treatment of time in her works parallels closely her treatment of time in her creative life. The instantaneous and the long-drawn-out are both measures which are foreign, in excess of, or outside the rationalised time which the institution of art increasingly imposes on the production of artists, and which it demands in exchange for fame and power. A crucial difference exists between the time of creation and the time of the market. Anne Bean has questioned this notion of fame and career and has even said she would prefer to remain anonymous, not through any saintly abnegation of the self, but from a desire for freedom, not to be tidied-up or narrowed down. This is expressed in

her rolling experimental and collaborative practice over the years and her responsiveness to place and time and to other people. This has its own rhythm, and along the way has allowed for the redefinition, or playful expansion, of genres such as drawing or sculpture, and has extended to ways of referring to art work of the past, not only her own past and art work, which keep its spirit alive, as when, in *Shadow Deeds*, a liberal white monochrome comes raining down on the fingers and keyboard of a pianist (the artist) playing Erik Satie's *Vexations* (1893).

Autobituary: Shadow Deeds, Matt's Gallery, Artsadmin and Firstsite, London and Colchester, 2006

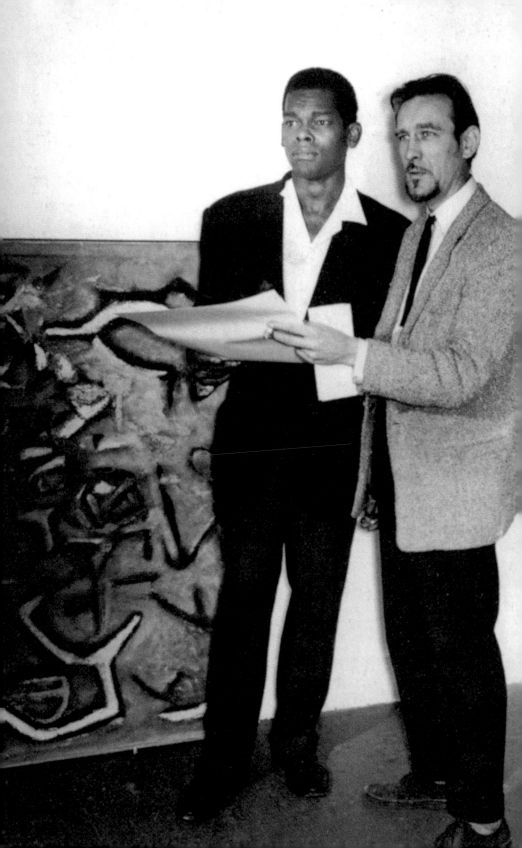

Aubrey Williams
A Tragic Excitement

Aubrey Williams hated to explain his paintings. The few writings of this kind, which he felt obliged to produce, usually included some disclaimer or complaint. Thus, in a short text accompanying an exhibition of his Shostakovich series (1969–81), he said:

> This TRACT, EXPLANATION, PROLOGUE or whatever one might care to call it is against all that I hold sacred in ART, and is done out of a sense of duty to the public.[1]

In his view 'people should have a visceral response to painting', and he didn't mind if they liked or disliked his work so long as there was a genuine reaction to the object itself. In this way he joined those many artists who have said in one way or another, 'If I could explain it in words I would not need to do it.' One would at least like to respect this before embarking on one's own torrent of words: to testify to the visual grandeur of a work like *Symphony no.5, opus 47* (1981), which seems to me among the most powerful abstract paintings to have been produced in Britain. Appropriately this work is inspired by music: a tour de force of multiple meanings and formal suggestiveness.

Yet at the same time, *Symphony no.5, opus 47*, like most of Williams's other work, gives a sense of being encoded, of containing intelligible signs which beg to be interpreted. As strong as the invitation to cast oneself adrift in the turmoil of colour and light is the desire to trace the facts of Williams's career, his 'journey', and to draw out its particular significance for the history of culture here in Britain, and beyond. His work still has to be given its significance

155

Aubrey Williams and Denis Bowen at the New Vision Centre Gallery, with Williams's painting *El Dorado* (1958). Photo: Anne Bolt

in words, in art historical discourse, in a milieu which has not been aware of it, which has reserved its sense of importance and nuance for other matters. What does it mean that Aubrey Williams lived in Britain almost continuously since arriving here from Guyana in 1952 until his death in 1990, and exhibited his work here, but was never considered part of British art? He was not included in any of the surveys mounted by such bodies as the Tate Gallery, Arts Council or British Council. The first time his work was shown at an important mainstream public gallery was in *The Other Story* at the Hayward Gallery in 1989, an exhibition tracing the work of 'Afro-Asian artists in postwar Britain', which Rasheed Araeen, the organiser, had campaigned for ten years to put on.[2]

Of course, the subtlety of the matter – the complexity of the history that has yet to be written – is that Aubrey Williams's work would have to be considered in three different contexts: that of Guyana, that of the Guyanese and West Indian 'diaspora' in Britain, and that of British society. These contexts would have to be considered to a degree separately, and in their complicated interrelationships, affected by the realities of power. And all would have to be adjusted in relation to Williams's own desire to be simply a modern, contemporary artist, the equal of any other. This was the context in which he saw himself. At one moment he could say: 'I haven't wasted a lot of energy on this roots business ... I've paid attention to a hundred different things ... why must I isolate one philosophy?';[3] at another: 'The crux of the matter inherent in my work since I was a boy has been the human predicament, specifically with regard to the Guyanese situation.'[4]

A further gloss on these complexities is given by the fact that Williams's painting fluctuates between representational references and abstraction. We cannot be so simplistic as to identify Williams's pre-Columbian motifs solely with the 'local' and his abstraction solely with the 'universal'.

When Aubrey Williams was born during 1926, Guyana was still a British colony. The whole economy was dominated by the sugar

industry and one company – Booker McConnell & Co – owned everything, effectively running the country as an extension of the British government. There was no visual art in Guyana in the contemporary sense when Williams was growing up. He 'found himself drawing'[5] at any early age and later he took lessons with a Dutchman, Mr de Winter, a restorer working on religious paintings in Guyanese churches (this was at his father's instigation). Then he studied with artist and teacher ER Burrowes, who started the Working People's Art Class. Burrowes was a tailor by profession, and gave drawing and painting lessons out of an innate belief in the importance of art and beauty. Anyone interested could join his classes. Williams credited Burrowes with 'opening the Guyanese eyes to art'.[6] But in general, middle-class Georgetown society was marked by respectability and 'hand-me-down Colonial values', Williams remembers.[7] He has left a telling description of the denials this entailed:

> I early discovered that nearly every dynamic environmental aspect to which I was naturally attracted was culturally forbidden or had a taboo subtly attached … As a child in Guyana I was mesmerised by the Santapee Band during the Christmas season. These bands made up of from 2 to 6 drums, 2 or 3 flutes (fifes in most cases) and from 6 to 12 dancers, colourfully attired in Equatorial African regalia, would roam the city performing for hand-outs of coin or kind. I remember that they were always forbidden by law the best residential section of the city … I would be screamed at and thumped for running out when these bands came around, and invariably accused of harbouring rotten appetites … My parents were black and I am black, but I could hear the slamming down of windows and jalousies of the houses in the neighbourhood whenever the bands came around. Only the children of the slums could really experience the Santapee bands.[8]

Geographically, the narrow, flat, well-populated coastlands of Guyana, which include the urban area of Georgetown, contrasted with the vast hinterland of savannah and jungle, parts of which were still inhabited by indigenous peoples. Williams trained as an agronomist and worked as an agricultural officer for the government. So successful was he at encouraging the exploited small farmers to claim their rights against the British-owned sugar plantations that the colonial authorities took alarm and banished him to a remote agricultural station in the north-west of the country. What he took as a personal tragedy became in fact one of the great formative influences of his life, because he came to know there an indigenous tribe, the Warrau. In later life Williams often mentioned the Warrau and the impact they had on him. He learned their language, observed their customs and listened to their stories. Despite conversion to Catholicism, the Warrau still secretly made their ancestral artefacts and practised their rituals. As he listened to the Indians talking about colour and form, he says, 'I started to understand what art really is.' Among the things which impressed him was 'how man makes things according to his own image … at once the creation of something that has never been in the world before – and yet nothing really new, just a re-arrangement'; and 'how easy [the Warrau] found it to be surrealistic'.[9]

After two years in the north-west, Williams returned to Georgetown. He found it in a political ferment. All his intellectual friends had joined the People's Progressive Party (PPP), which was in the forefront of the struggle for Guyana's independence. It was a dangerous time. Unknown to Williams, the government had him down as a political activist and opened a dossier on him. When the political tension climaxed in a shooting incident on a sugar estate in which 11 people died, a friend advised Williams to leave the country as soon as possible. 'You are a painter, you will never be a politician and you should study painting in Europe', was the gist of his friend's advice.[10] Three months later the entire leadership of the PPP was in

jail. So when Aubrey Williams originally left his country in 1952 at
the age of 26, it was for an inseparable combination of artistic and
political reasons.

He arrived in London as a young artist with a unique combination
of experiences: an agronomist's knowledge of the flora and fauna of
his country, political experience of a moment of profound historical
change, a deep curiosity about the pre-Columbian culture of Central
and South America, and memories – human, affective ones – of a
people for whom 'life' and 'art' were interconnected. With these
memories he began working in the 'mainstream of modern art',
influenced by American and Latin American painting: Jackson Pollock,
Franz Kline and especially Arshile Gorky, as well as Diego Rivera,
José Clemente Orozco, Rufino Tamayo and Roberto Matta (the North
and South American artistic vanguards had a connection, especially
in the 1930s and 1940s, which they have never had before or since).
Williams was less impressed by British work he saw around him.[11]
Since he was technically on leave and still receiving his government
stipend from Guyana, he had for a while the means to support himself
and he travelled widely in Europe, looking at art in France, Germany
and Italy. His interests continually broadened, taking in archaeology,
astronomy, ornithology, ecology, mythology and music.

It is because he was an independent figure, with the strength of
character to go his own way, that Williams's relationship to several
different contexts becomes so fascinating. He was part of all of them
without exclusivity. If a writer such as myself claims his work as
part of the British art scene, in the face of official neglect, and of
Williams's own feeling of being an 'internal exile' in this country,[12] it
is not to promote national chauvinism, but on the contrary to show
that reality here is much richer, more paradoxical, mobile and elastic
than our reigning national paradigms allow. Equally, if Williams is
claimed for Guyana, it is in defiance of the kind of attitude which
would blind people there to the 'dynamic phenomena', both
indigenous and international. Perhaps our attempt to do justice

to Williams's art depends on the degree of refinement with which we can describe his multivalent position.

In London, Caribbean intellectuals' awareness of common experiences and problems gradually coalesced into the formation of the Caribbean Artists Movement (CAM, 1966–72), of which Williams was a founding member. (Again, I had never read of CAM in histories of postwar art in Britain and only became aware of it with the publication of Anne Walmsley's meticulous book on the subject in 1992.[13]) Although the intention of most participants was eventually to 'go back' ('We always meant to go back and contribute … go back and build a nation, there, not here'[14]), in the meantime CAM allowed a freedom and range of discussion not possible at home. CAM wrestled with the problem of defining the nature of Caribbean culture, the legacy that could be built on by the newly independent nations.

In early and symptomatic debates that CAM organised, the arguments tended to polarise. One position, held by the sociologist Orlando Patterson, was that there was no West Indian cultural tradition, only the experience of colonialism.[15] His opinion was echoed by the literary critic Louis James, who described West Indian culture as one 'built up by the destruction of a succession of civilisations, including indigenous cultures'.[16] Others, notably the poet Edward (now Kamau) Brathwaite, CAM's guiding spirit, took a more positive view. In his opinion, contemporary Caribbean culture had a 'jazz aesthetic'. The essential element in jazz is improvisation, which Brathwaite found in the 'oral tradition of West Indian folk literature, in Calypso, in Anancy stories, in speeches at "tea meetings"', and so on. He urged Caribbean writers to make more use of these possibilities.[17] It would be possible to find suggestions of both these interpretations in the paintings of Aubrey Williams, both destruction and transmutation. At a CAM symposium on contemporary West Indian art in 1967 (which was illustrated by means of slides), Williams claimed to find, in other artists' work as well as his own, 'claw-like forms':

You will find this strange, very tense, slightly violent shape
coming in somewhere. It has haunted me all my life and
I don't understand it. A subconscious thing coming out.[18]

For the novelist Andrew Salkey, speaking later, the claw was not
'a total image of violence', but looked like 'something left after
a destruction'.[19]

Although CAM discussions were necessarily concerned with
Caribbean identity, the artistic productions of many CAM members
were broader and reflected dilemmas of existing *between* different
realities. Kamau Brathwaite's interpretation of Aubrey Williams's
paintings in Jamaica in 1970 was made in almost exclusively
Caribbean, local, and as he said himself, 'primordial' terms (being
abstract, Williams's pictures invited the spectators to project what
they liked into the suggestive forms). Brathwaite likened Williams's
paintbrush to 'the door, the *porte cabesse* or central pole, down which
the gods often descend into the *tonnelle* during *Vodun* worship'.[20] Yet
the gestures of the brush could equally have been read in terms of an
urban existential angst, and many of Williams's 'marks' could be seen
as evoking geological and astronomical phenomena without being
culturally specific. In the 1960s novelists and poets associated with
CAM published their work with leading British houses (for example,
Wilson Harris with Faber, Brathwaite with Oxford University Press,
Andrew Salkey with Penguin). They were an important part of the
British intellectual scene. But the tendency to impose narrow readings
cuts both ways. Reviewing the long-term relations of the British
establishment with the Caribbean Artists Movement, Aubrey Williams
gave a damaging assessment: 'Since it was predominantly of Caribbean
people it was categorised, isolated and eventually destroyed. And it
was the BBC which played a major role in its destruction, by isolating
black intellectuals and giving them separate exposure.'[21]

Williams himself, after initial success and critical praise, found
his exhibitions ignored. Early on, he had been supported by gallerists

of a genuinely international and experimental outlook, such as Denis Bowen at the New Vision Centre Gallery, and Kenneth Coutts-Smith, writer, co-director of the New Vision Centre and organiser of the Commonwealth Biennales of Abstract Art at the Commonwealth Institute in the early 1960s. But with the growth of intense and highly specialised commercial speculation in contemporary art, attuned to the hierarchies of economic power, the New Vision Centre was increasingly marginalised and the Commonwealth Institute became a backwater. Although, socially, Williams mixed with the London intellectual and artistic scene (he remembered going to pubs after openings with people like Dylan Thomas and John Minton[22]), artistically his work was rarely exhibited with or compared with his 'British' peers.

I have remarked in previous writing on the isolation of Williams from his British counterparts, and the immense loss it entailed to our understanding and experience of the modern world, in its process of change. There was the opportunity to compare both common projects and cultural difference to the greatest refinement of nuance in the non-verbal language of painting, a kind of painting that was abstract and therefore not impeded by single meanings and the tyranny of images. It would have been an initiative worthy of the actual richness of the London art scene, not its pseudo-reflection in the myth of 'British art'. To a great extent its outcome would have been unknown, depending on the individual's visceral (to borrow Williams's term) response to – for example – seeing Williams's 'tropical' colours alongside the wan blue and muddy green of Peter Lanyon's Cornish abstracts. This is only a tiny indication of a complex web of similarities and differences transmitted through abstraction's distillation of emotions and sensory memories.

On an external level one can point to several intriguing connections between Williams's work and that of, for example, Peter Lanyon and Alan Davie. These go beyond the obvious fact that they all practised a type of large-scale gestural painting, and in Williams's and Davie's

case were drawn to symbolic forms. All three had a connection with music. Davie is a jazz enthusiast and even played in a jazz orchestra in his early years. Jazz improvisation was cited in CAM meetings as an analogy for Caribbean literary and artistic creation (see above). Williams spent ten years painting a series inspired by Shostakovich's music. He also played the violin and sang – as did his paternal grandfather, the dominant influence in his childhood. Lanyon, too, came from a musical family (his father was a composer and pianist as well as an amateur photographer). All three artists had an emotional-spiritual affinity with flight. Davie and Lanyon were both gliding enthusiasts (Lanyon died in a gliding accident), and both identified with birds ('How much more important than Art, just to be a bird' – Davie;[23] '[my pictures] are concerned with birds describing the invisible, their flight across cliff faces and their soaring activity' – Lanyon[24]). Throughout his career, Williams added to a series of 'bird portraits'. Furthermore, all three identified strongly with an ancient cultural or environmental heritage: Davie has claimed that the roots of his symbolism are 'in my Celtic heritage'[25] (he was born at Grangemouth, Scotland, in 1920), Lanyon stressed an ancestral link with the Cornish landscape, and pre-Columbian culture was Williams's lifelong preoccupation.

Of course these common enthusiasms can be related to desires which inspired the kind of painting all three artists practised: spontaneous improvisation, freeing oneself in the act of painting, tapping the unconscious, etc. But the ways in which this phenomenon is 'all of a piece' only sensitises one all the more to differences. One has a certain feeling at an intuitive level that the British artists' notion of freedom entailed an escape from self-control, whereas, for Williams, with his equal and opposite attraction to artists like Orozco, Wilfredo Lam and Matta, the same freedom was associated with containing chaos. Looking at Aubrey Williams's *Guyana* (1965), compared with Davie and Lanyon paintings of roughly the same date, we might recall the artist's own words (addressed to a meeting on Caribbean art):

163

We are still in a position to contemplate terrestrial reality. Ours is a beautiful landscape, unbelievably beautiful in some cases; but, as compared to the ordered landscapes in the countries that have been over-lived-in, [ours is] bizarre, unreal, incongruous.[26]

Similarly, symbols in Alan Davie's paintings have the appearance of brightly coloured games, a sort of entertainment, if compared to Williams's, which are marked by cataclysmic destructions and transformations. Davie borrowed symbols freely from ancient Egypt, Syria, Mexico, Hopi Indians, etc., as well as those he defined as Celtic. Williams, too, admitted to many influences, but a word like 'borrowing' hardly describes the intensity of his identification with Carib and Mayan symbols. They seem to stand for his conviction that a vital element in his environment, and therefore in himself, had been suppressed, denied or merely mummified, and needed to be recognised, freed. This was true for him despite the fact that he was dependent for his knowledge on archaeology, museums and books, like anyone else (aside from what he learned directly from the Warrau). What precisely was Williams's relationship to the pre-Columbian motifs and symbols that run through all his work, even those paintings inspired by the music of Shostakovich? In the excellent interview which he conducted with Williams in 1987 (from which I have already quoted repeatedly), Rasheed Araeen pursued this as a key question of Williams's painting.

A typology of these motifs in Williams's painting would range from an almost literal transcription to extreme generality and suggestiveness, where they become fused with many other references. The most literal depictions probably occur in the Olmec-Maya series (1981–85), and the most diffused in the Shostakovich series, and in abstracts from the late 1950s and early 1960s. However, there is rarely a complete separation. In the Olmec-Maya series the hieratic heads are half consumed by painterly turmoil. In the triptych of murals which

Williams painted for Dalhousie University, in Nova Scotia, Canada, in 1978, the configurations of 'abstract' signs follow an elaborate explication of Carib, Warrau and Arawak mythology. Williams described these murals as composed of 'dismembered and re-arranged Totems'.[27]

This phrase seems a perfect description of his method – although a matter-of-fact one compared with what was, in painterly terms, a passionate and searching process. His work appears as a kind of investigation of the pre-Columbian legacy that a painter, not a scientist, could make: a deconstruction refusing to take the given as fixed and final, dismembering and re-assembling the components. There is the continuous sense of meltdown, of chaotic turmoil, but also of germination, growth and construction. In Mayan culture, 'painting' and 'writing' were close together in their systems. Mayan glyphs were small compressed conglomerates of pictorial elements. They often surrounded the main figurative images with a close stylistic concordance, and Mayan writing is said to have given scribes some latitude for 'virtuosity and playful invention'.[28] In Aubrey Williams's paintings the particulars of this cultural artefact mix and merge with the cosmic: electrical energy, cells, molecules, stars. The borderline between nature and culture, or universe and mind, is consciously explored and played with. This is made explicit in drawings left in the artist's notebooks, graphic 'clusters' recorded by the painter's improvising hand which seeks to define or divine life. It is fascinating the way the 'linguistic' signs, with their borders and signifying elements, bear a resemblance to the biological cell with its walls and nucleus. Both are melting into one another. Some signs could equally be the whorls, scales and excrescences round a fish's mouth, or the lines round a bird's eye.

Therefore, Williams's paintings strike one as much as a quest for knowledge as expression, an approach to the unknown that combined the objective and subjective, the historical and contemporary, and validate an artist's intuitive methods. After all, Mayan civilisation

Pages from Aubrey Williams's
notebooks, 1970s

remains semi-mysterious and opinions about its character have changed, even among scholars. 'In my little way I'm trying to go as far back as possible in order to really understand that part of my own history.'[29] Part of the 'mystery' was the unanswered question as to what caused the sudden and catastrophic collapse of the Mayan state. Part of the 'understanding', for Williams, was the conviction that this collapse was due to a runaway technology, and that the Mayan predicament had close parallels with our own in the modern world. The destruction wrought by colonial conquest was another phase in this process and the present ecological crisis was essentially a continuation of colonialist greed ('Now the faults are with us, with humanity'[30]). It would be hard to exaggerate how deeply Williams felt about the desecration of our global environment, and the acuteness of his anxiety.

Can this be 'read' from his paintings? Anxiety can, certainly, but as Rasheed Araeen pointed out, Williams's paintings give as much a sense of celebration as of gloom. Williams called it 'a tragic excitement'. In the end it is hard to say what works of art really mean, and in Williams's case I feel that multiple meanings are necessary to his paintings' innermost energies. When he embarked on his Olmec-Maya series, and introduced figurative imagery into his abstract paintings late in his career (he had always painted figurative pictures in parallel with his abstract works), Williams gave as one of his reasons the feeling that his abstraction had become a habit, almost a trademark, and that he was glossing over his real convictions, hiding something. By re-introducing recognisable pre-Columbian iconography he was, he felt, able to '[tell] the real story', to 'have the best of both worlds'.[31] It sounds convincing, but in my view he was not able to resolve this dilemma in artistic terms. The Mayan and Olmec heads remain some-what illustrative and extraneous to the real substance of the painting. Paradoxically it was in abstraction that Williams communicated most directly, perhaps for the very reason that it is there that the various dualisms he wrestled with (specificity/generality, spontaneous

gesture/iconographic symbol, natural/artificial, past/ present, Guyana/Europe, etc.) are most energetic and most fused.

In the final analysis, abstraction attempted a description of the world and experience which went beyond anthropocentrism. A new model of the interaction of forces, energies and qualities was proposed. In doing so, artists often returned to reconsider systems where drawing and writing were closely related: ideograms, calligrams, calligraphy, so-called 'decorative' systems, and in Williams's case Mayan glyphs and pre-Columbian geometric symbolic orders. Therefore in one sense the wheel came full circle. Perhaps this suggests why, as we noted at the beginning, Aubrey Williams was not fond of explaining in words a painting which was itself a form of explanation.

Aubrey Williams, Institute of International Visual Arts
(Iniva) and Whitechapel Art Gallery, London, 1998.
Republished in *Third Text*, vol.13, issue 48, no.48,
including a new introduction, 1999

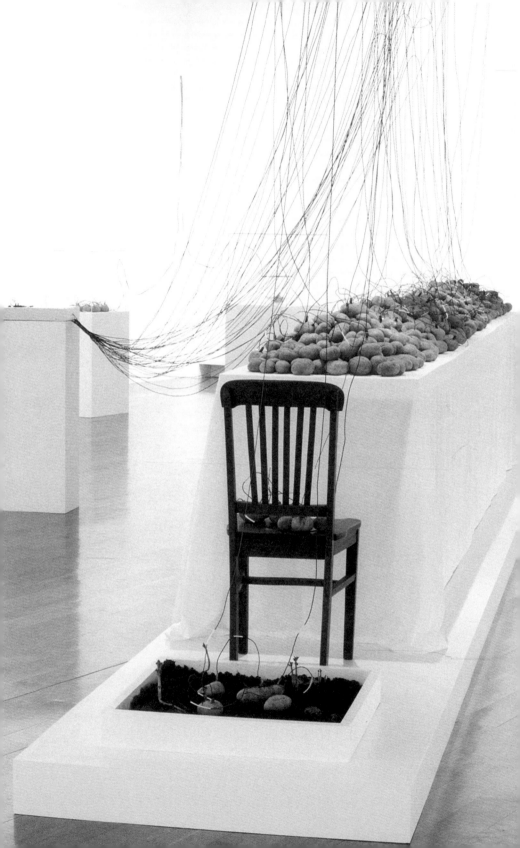

Victor Grippo
Material and Consciousness

I met Victor Grippo in 1973 in Buenos Aires. I liked him immediately and I felt a strong empathy with his work and ideas. What was this empathy based on? Partly it was the combination in his work of what I would call an outlook on the universe – in the broadest possible terms, beyond all nationalisms and ethnicities – combined with his humane attitude, his immersion in his immediate surroundings, in the nitty-gritty both of sociopolitical realities and material specificity and nuance. Partly also it was the quietness of his work, its lack of ego and rhetoric, the audacity of its simple demonstration of things.

Underlying all this, it was Grippo's constant attention to the clash of opposites – whether it was art and science, light and dark, the defined and the nebulous (the list is endless) – and his search for a unity between them, a future where 'the word divide will have been forgotten'. That attracted me deeply.

In 1973 I had been working as a journalistic art critic for nine years on *The Times* newspaper – I was getting restless and I took six months off to travel in Latin America.

Already I knew the Brazilians Lygia Clark, Hélio Oiticica, Mira Schendel and Sérgio de Camargo (who much admired Victor Grippo), and also the Venezuelans Jesús Rafael Soto, Alejandro Otero, Carlos Cruz-Diez. All these artists had exhibited at Paul Keeler and David Medalla's Signals Gallery in London in the mid 1960s, or had their work featured in *Signals* magazine.

Since I was in no hurry I took a ship, the *Augustus*, which came from Genoa and which I caught in Lisbon. I arrived at the port of

173

Victor Grippo, *Naturalizar al hombre, humanizar a la naturaleza o Energía vegetal* (Naturalize Man, Humanize Nature or Vegetable Energy), 1977

Buenos Aires with just one telephone number: that of Jorge Glusberg, who ran an experimental art space in the city – the CAYC (Centro de Arte y Comunicación). He kindly invited me to stay in his house and to give a lecture at CAYC. My real intention was to head towards [Salvador] Allende's Chile to meet the Brazilian critic and writer Mário Pedrosa, who had taken refuge in Santiago from the military dictatorship in Brazil and was planning an art conference to take place on Easter Island. But it was a time of excitement and intellectual ferment in Buenos Aires and I dallied there for two months. Bookshops were open till midnight, buses ran all night, food shops were never closed. There was a popular search for knowledge. Many serial magazines dealing with history, science or art could be bought in the street kiosks. But then Chile fell victim to a military coup, the borders were closed, a brutal repression started and I never reached my destination. Argentina too was soon to suffer an extreme right-wing regime.

A year or two before I met him, Grippo had actually exhibited in London with Glusberg's *Arte de sistemas* exhibition at the Institute of Contemporary Arts (probably in 1971). Then the artists associated with CAYC formed themselves into the Grupo de los Trece (inspired by a lecture they had heard in Buenos Aires by Jerzy Grotowski, the Polish theatre director); Jorge Glusberg explained their aims:

> The essential premise of the group […] was not to compete against art dealers or galleries but to favour the process of communication between creators and their audience, between the spectators and the makers. That is the reason we decided to promote an art linked to life that we understood as a process of teaching and humanisation. Not only did we oppose artistic conservatism, but also a fake avant-garde.[1]

CAYC was by no means the only vital artistic phenomenon in Buenos Aires at that time, or the only subscriber to these ideas. Several years earlier, in 1969, artist Lea Lublin had built hugely elaborate sensory

and philosophical labyrinths for participation by the spectators. Later she moved to live and work in Paris.

Grippo had made the first of his Analogías (Analogies), a 'potato battery', in 1970. I loved the work. It was a startling material metaphor for human consciousness. We had long conversations accompanied by glasses of wine. Recently I found my old notebooks of that time. These are some of the things Grippo talked about:

> The feeling that 'here in Argentina knowledge is untapped. Many pictographs around Mendoza have never been studied. Thousands of items in the Museo de La Plata have not been studied.'
>
> He was especially excited by the struggle of the North Vietnamese, and their courageous and ingenious improvisations against the might of the American army. For example, 'The use by the Vietnamese of a specially sensitive person to act as a radar in forward positions to tell of approaching planes.'
>
> 'A British military secret after the war: a biological battery, giving electricity from the movement of micro-organisms.'
>
> 'A small amount of Material/a great amount of Imagination: this is the real "poor means": not the aesthetic Arte Povera!'
>
> He had the idea of taking a lorry around the edges of the city – the poor areas – and exploring with people some simple things – electric installation, a tap, refrigeration without a refrigerator. To establish the principles, and proceed from there to thinking of ways of using what there is…

A year or so later Grippo passed through London and together with my friend Teodoro Maler, who worked for the BBC Latin American Service, we took Victor on walks around the city. A long interval followed during which the vitality of the work of contemporary Latin American artists gradually began to be recognised in Europe. In 1990,

thanks to the interest of curators Antonia Payne, Angela Kingston and Elizabeth Ann Macgregor it became possible to mount a substantial showing of nine artists from Brazil, Chile and Argentina at the Ikon Gallery, Birmingham, and the Cornerhouse, Manchester. This was *Transcontinental*, an exhibition that included work by Cildo Meireles, Tunga, Waltércio Caldas, Regina Vater, Roberto Evangelista, Jac Leirner, Eugenio Dittborn, Juan Davila, as well as Victor Grippo. The show was not intended as a 'regional survey', nor did it present an 'essentialist' view of Latin American art. The exhibition's subtitle described it in the broadest terms as 'an investigation of reality'.[2]

Making the show happen within its budget raised fascinating logistical questions. For his participation, Grippo needed only to bring a few electrical components with him from Argentina. The hundreds of potatoes he needed for his installation were easily obtained locally.

Five years later Catherine de Zegher, Elizabeth Ann Macgregor and Piet Coessens mounted a full-scale individual show of Grippo's work at the Ikon and at the Palais des Beaux-Arts in Brussels, with a substantial catalogue. But while his reputation grew outside his own country, within it Grippo was living through the ghastly years of military dictatorship that decisively marked his work. As part of the preparations for the Birmingham/Brussels show I returned to Buenos Aires – to find Victor quietly living in the same house. I quote a description of it by writer and photographer Jorge di Paola:

> The house where he lives has a certain mystery to it. There are interior patios with plants, a diffuse, soft light, and silence. There is a hallway which leads to his apartment [...] Victor Grippo occupies one of those roomy apartments, somewhat dark, with a touch of De Chirico outside and something more reminiscent of quieter times inside [...]. Victor Grippo is someone who is continuously at work and not merely a visual artist who produces objects that are worthy of mention in catalogues and prizes [...] The author

of *Mesas* (Tables) works on the same table as he eats, he
shoves a number of tools off to one side, books and objects
that appear to be incongruous, and that stimulate one's
capacity to associate.[3]

Grippo came once more to Britain – to St Ives – in 1997, as one of
a group of artists invited by Iniva (Institute of International Visual
Arts) to contribute a work concerned in some way with the 'quality
of light' in that seaside town associated with generations of visual
artists. Grippo responded in unique fashion by staging two rooms –
allegories of the workshop – to which daylight was only partially
admitted and therefore all the more intensely and intimately felt.
I chaired a discussion in which Victor participated. It was the last
time I saw him.

After these personal notes, I would like to offer some scattered
thoughts on his work in general, as a modest addition to the
testimonies collected in the recent posthumous catalogue
published by MALBA (Museo de Arte Latinoamericano de Buenos
Aires) in Buenos Aires: excellent writings most of them – consisting
of Grippo's own, the insights of his close friends and interlocutors
(his circle, remarkable in itself, people such as Elias Piterbarg,
Ricardo Martin-Crosa, Gabriel Levinas, Jorge di Paola), and the
interpretations of art historians, notably Mercedes Casanegra,
Elsa Flores Ballesteros and Ana Longoni.

Grippo was a thinker among artists. A man of great conceptual
lucidity. The fascinating thing is that, with all his conceptualism,
Grippo remained so deeply attached to the manual, the material,
the artisanal. His wife Nidia mentions his 'profound knowledge of
materials and their reactions'.[4] We know this from his own descriptions
of the importance of his training in chemistry and childhood experi-
ences growing up in a family of immigrants in the small town of
Junín. The link of these experiences with his later work as an artist
he has described as a 'thread':

177

'I would have liked this show', he wrote referring to an
exhibition of 1988 at the Fundación San Telmo in Buenos
Aires, 'to be like a distinct thread, rising from the tripod
my father used in his Sunday tasks, and descending
below to the pot where my mother stirred up our meals
(both operators with fire and nutrition, which has to be
observed, transformed, stored or distributed).'[5]

The light of thought, spirituality or enlightenment is always
matched in Grippo's work by the darkness and material mess of
the workshop. I think this 'dialectic' of opposites was of profound
value to him. And this was in a way confirmed by an email I received
recently from the Argentinian artist Patricio Forrester, who lives
and works in London. He told me that his teacher in Buenos Aires
had told him that Grippo had told her that he, Grippo, liked to 'hang
out in the dark', as Patricio put it. He used to say 'la oscuridad me
cura', 'I am healed by darkness'.

Grippo conjured with this dialectic reverentially, but also with
irony, in his late work at St Ives in England. This was the result
of a commission to make a work concerned with light, and it
eventually took the form of two 'workshops', one in the town (his
transformation of a studio that had once belonged to the painter
Ben Nicholson), and the other a specially built cabin interpolated
in the architecture of Tate St Ives. Both interiors were painted
a neutral flat white. In the studio the windows were barricaded
to let an intense single shaft of light play on the six somewhat
precarious worktables that were strewn with what seemed to be
the tools and ingredients of works in progress; and in the little
cell in the museum a very faint light filtered in from the ceiling so
that one could just discern a seventh table bearing some plaster
fragments, a stone from the beach, a tool or two, and a quotation
of author Piterbarg's: 'I believe in the stone, elemental individual,
mute form of life.'

The depiction of workshops is a distinct theme in the history of Western art and one is struck by the darkness, untidiness and visual density of many of these images: from blacksmiths' shops to alchemists' laboratories, from David Smith's steel sculpture of his own workbench to probably the most famous smithy in European art, Velázquez's *Apollo in the Forge of Vulcan*, painted in 1630. This painting must gain its power from all the tensions involved as Velázquez sets a mythological scene within a real one. Velázquez 'seeks the root of every myth in what we might call the logarithm of reality', according to philosopher and writer José Ortega y Gasset: 'Thus it is no jest or parody, but the myth turned inside out; instead of letting it carry him off towards an imaginary world, he compels it to move back towards verisimilitude.'[6]

Recently I came across a small painting by Antoine Watteau in a museum in Strasbourg. It is hard to believe, but it was a picture of a copper cleaning workshop (painted in 1710): a poor environment, ugly and dilapidated, with dull pewter plates strewn around, so totally foreign to Watteau's idyllic scenes of dalliance and musical picnic. In one corner of the picture there was a viola, apparently forgotten. The workshop, the incongruous viola, in a way it led me back to Grippo. In his work *Vida, Muerte, Resurrección* (Life, Death, Resurrection, 1980), basic forms familiar in visual art – cones, cubes, cylinders, pyramids – and a symbol of music, a violin, are opened up from within by forces of nature. In a traditional technique used by artisans, the violin is filled with moist maize corn which swells slowly and evenly enough to prise open a damaged violin without breaking it.

For all the superbly rendered bodies in the Velázquez painting and the nimbus of light around the youthful and angelic head of Apollo, for me the most beautiful passage in this work is the rendering of the anvil, a chord of dull, dark tones set against an earthen or stone base. And a most striking part of the composition is the disposition of the tools around the anvil, arranged by nothing more elevated

than the demands of work. Now, since the anvil is a kind of table, it can lead us round again to consider one of the most persistent and remarked-on features of Grippo's art: his love of tables.

Painting can also be brought into the discussion here because a table, like the canvas, is a support. In his early days Grippo made paintings that hang vertically on walls, but it was the horizontal plane of the table that became his means of fusing his art with life, as he did with typical simple directness in his *Tabla* (Board, 1978), inscribed with its modest testimony. I described this work in a previous essay:

> *Tabla* is homophonous to tablet in English. What we see is a 'written table', or 'tabled writing', in which the text describes its own 'support' in terms of life experience. Characterising the table as a 'sister' to countless others, the words on its surface range over the ways in which this table has been a passive witness, or active nucleus, of diverse human activities. The text ends in mid-sentence with the words 'transubstantiation of…' Just before, there is the mention of some artistic activity. The table may have seen the composition of 'some drawings, a few poems, a metaphysical adventure that complements reality'. By means of these words the table is transposed into the discourse of art while remaining a table, anchored in reality.[7]

And transposed into science too. Grippo once sent me an image he had copied from a book of a meeting between Thomas Edison and Charles P Steinmetz in which the two scientists excitedly examine Steinmetz's device for investigating artificial rays, both leaning on a prominent workbench.

With his typical dialectic, Grippo questioned the table's role of passive support and made it an equal protagonist in life's events and the creative process. In the blacksmith's shop, the hammer blows raining down would be futile without the anvil to receive them and

make them work. On a visit to Grippo in his Buenos Aires apartment I asked him if he had any examples of his writings beyond the ones we already knew and he fished out a copy of a short review he had written in 1983. It was about an exhibition of Latin American silver-work, mainly of the eighteenth and nineteenth centuries. The cups, ewers, spurs and bells had profoundly moved Grippo. 'One only has to point out', he wrote, 'the unconventionality of the way they developed certain forms – in the morphology, for example, of a strange drinking straw (*bombilla*) which is actually two straws and two mouthpieces with their stems entwined together like a Caduceus.' For Grippo a conflict, or interdependence of opposites, lay behind all the silver objects in the exhibition. He referred to 'the sustained struggle between the muteness of the original silver and the steel of the tool, which, in an infinite number of meaningful actions, reached its limits in the piece achieved'.[8] This directly corresponds to Grippo's belief that 'there are perfect moments in work when it is impossible to discern whether the hand guides the tool or the tool is guiding the hand.'[9]

Given Grippo's retiring nature and his pottering about in the same house for years on end there were two things that surprised me about him. First, his personal knowledge of other Latin American artists: when we made the *Transcontinental* exhibition, we found that the Brazilian artists did not know the Chileans, for example, but Victor was the one who knew most artists, from most countries. Second, his sense of scale. He could work on a very modest scale and with very succinct expression: a single potato next to a lump of coal on a plinth (remember that he made a living as a jeweller for periods of his life). He could also rise magnificently to the occasion of a large space, as with his banquet tables laden with potatoes and their tangle of energy-bearing wires, 'like a nervous system', as he said. His long series of boxes strike me as intimate private works, condensed works to be taken home, even if their themes may be public (for example, a protest against military government – I will return to this).

His boxes compare interestingly with those of American artist Joseph Cornell, and it is noteworthy that both artists worked 'on the kitchen table'. There is a sense in both of a cosmic vastness, a universal energy within the box's strict limits. Cornell, however, could not manage, or did not attempt, the grand scale.

In art-historical terms, an insight into the nature of Grippo's work is given by a consideration of the key moment at which it first appeared, just as the decade of the 1960s turned to the 1970s. He was grounded in certain aspects of Kinetic art: his interest in material transformation, for example, and his apparent 'anti-aesthetic' by which phenomena were allowed to present themselves as they are, seemingly without aesthetic considerations. He incorporated material processes in his work with the equipment and mode of presentation directly derived from his training in chemistry. While still painting on canvas, he made an unashamed (and convincing) link between electric circuitry and abstract form. There is a parallel with the Greek artist Takis's incorporation of electricity and magnetism in his work, or Jesús Rafael Soto's dissolution of pictorial form into optical vibration. In the 1960s the French critic Jean Clay wrote of Takis's work, that it 'makes direct use of the force of nature. For him, it's about capturing reality itself and no longer about transcribing onto a two- or three-dimensional support a symbolic representation of that reality.'[10]

This 'directness' was an illusion, of course, since the aesthetic was never absent from Takis's sculpture, and in fact the tenuous borderline between 'force of nature' and 'aesthetic choice' was a great source of its artistic vitality. This basic attitude can be traced all the way back to László Moholy-Nagy and the origins of abstract art. For Moholy-Nagy abstract art was felt as a liberation precisely because of the way in which it cleared away 'the welter of traditional symbolism', and 'all loosely trailing connotative associations'.[11]

The fascinating thing is that at the turn of the 1970s, Grippo, along with other artists connected with Kineticism, such as David

Medalla and Hans Haacke, carried over their pursuit of movement and energy – imagined in terms of processes of nature – to the workings of society, to society as process and energy system. One can only think that these changes came about under the pressure of political events, both global and local. In Grippo's case they led to a kind of re-symbolisation by which he began to confront, in his own very personal way, the predicament of Latin America.

Generally speaking, rather than 'symbol', Grippo preferred the term 'analogy'. Perhaps 'allegory' could also be used. The process of this analogy or allegory was to pursue energy in the guise of some of the most basic requirements of human life, true 'poor means', in particular three forms of alimentation: bread, maize/beans and potatoes.

I have already referred to the action of moist beans and maize in gradually breaking out of lead containers/geometrical solids in Grippo's allegory of *Vida, Muerte, Resurrección*. In 1972 he and the artist Jorge Gamarra staged a public event in a square in central Buenos Aires. This consisted of inviting a rural worker, A Rossi, to build a traditional rustic clay oven on the street and bake bread for passers-by (a shift of an object's context that dramatised the polarised relationship between city and countryside in Argentina). As for potatoes, they have become the emblem of Grippo's art (still incongruous enough in an art context to incite the philistine ridicule of certain Birmingham councillors during Grippo's exhibition at the Ikon Gallery in 1995).

In his exhibitions Grippo presented potatoes, both en masse and individually, as generators of an electrical current which could be read off a voltameter – a poetic analogy between energy and consciousness pitched at the level of common humanity. In this world 'there isn't a single day without potatoes'.[12] Indeed potatoes have entered into language to express a whole range of emotions, from the celebratory to the disparaging. In an early essay on Grippo, Jorge Glusberg conjured some of the Buenos Aires slang idioms featuring potatoes. It can define an object of high quality: 'este traje

es una papa – 'this suit is a potato'; or a job easily carried out: 'Qué papa hacer esos informes' – 'what a potato it is to do these reports' (in English we would say 'a piece of cake'); or an item of journalistic news of importance that implies a revelation: 'tengo la papa' – 'I have the potato' (we would say 'a hot potato'); a beautiful woman – 'Fulana es una papa' – 'Fulana is a potato' (we might say 'a dish'), etc.[13] It seems left to North America to supply an idiom of contempt: '"small potatoes" – coll., chiefly US, a person, people or thing(s) of no great importance or worth'![14]

For all their material directness, Victor Grippo's Analogías were in another way secretive – especially in making allusions to transformation, liberation and a better future within a repressive and murderous political climate. That the potato, a tuber which originates in Bolivia, Peru, could stand for raising consciousness, and empowerment of the downtrodden of the continent, is already coded with a poetic wit equally subversive of the protocols of political discourse and of art exhibitions. His series of boxes, which appeared steadily during Argentina's military dictatorship, were discreet forms of resistance for those who could read the signs. In particular, Grippo adapted the alchemical procedures and precepts of material transformation to depict the struggle of opposed forces: lead standing for the military (in Brazil, which also endured military rule, beginning a little earlier, the worst period, 1969–1974, was known as 'the leaden years') and the rose standing for life and its transience. Which would succeed in transforming the other? 'To rosify lead, or to leadify roses', Grippo wrote in a cryptic fragment found among his papers.[15]

(By the way, Victor's mother was called Rose and he told me that she sang the Internationale with a red rose in her hand.)

Cildo Meireles once described the tactics employed by artists in opposition to the dictatorship in Brazil – and he used the word in a positive sense – as 'nebulous'. An unusual and ironic sculpture of Grippo's, which is not much discussed I think in studies of his work, and which I interpret as an act of defiance in Meireles's sense,

is *Homenaje a los constructores* (Homage to the Constructors, 1978).
I quote from a previous description of mine:

> This was made as a public sculpture for a temporary outdoor
> exhibition in the Calle Florida in central Buenos Aires in
> 1978 and presented the appearance of an amorphous pillar,
> standing 3.5 metres high. The object consisted of a mixture
> of Portland cement, sand and an aggregate of various
> sulphates, forming a kind of 'dough' and undergoing a slow
> chemical change which would eventually transform the
> material internally and stabilise itself. Bricklayers' tools
> were enfolded in this matrix at various points. A curious
> object in the downtown elegance of Buenos Aires! One
> could see *Homage* as an affirmation of the pleasures of the
> amorphous and undefined.
>
> But at another level the irony of an inchoate lump of
> unstable matter forming a 'homage to constructors' could be
> read as an acid comment on the perversion of construction
> and order by fascist regimes. *Homage* was only exhibited in
> public with considerable difficulty. A candid eye may unite
> these two interpretations. As Grippo was passing in the
> street one day near his sculpture he heard a child say to its
> mother: 'It's the caca of King Kong!'[16]

I never saw the posthumous exhibition of Grippo when it was
shown at MALBA in Buenos Aires in 2004. But I did receive the great
retrospective catalogue through the mail, and when I opened it and
fanned through the pages I was astonished to come across the works
called Anónimos (Anonymous, 1998–2001). They sort of burned into
my consciousness from the page. Eight pages are filled with them,
superbly photographed. They were made at the turn of the millennium.
If these human figurines are a kind of swansong, I feel that Grippo
was issuing us with a warning. Once, when he was asked if there were
other Argentinian artists who had inspired him, Grippo mentioned,

Victor Grippo, *Homenaje a los constructores*
(Homage to the Constructors), 1978

without hesitation, Antonio Berni. Stylistically they seem poles apart – Berni worked in a Socialist Realist style tinged with the surreal and later developed his unique assemblage and collage cycles of the life of the slum-boy Juanito Laguna and the prostitute Ramona. What linked them, Grippo felt, was their 'humanist content'. Grippo saw in Berni a quest parallel to his own. They shared, he wrote:

> The attempt to express ourselves through transformations, through the religious sense of the trade, in the search for an analogy between consciousness and energy, in mankind's heraldry and the soul's metabolism.[17]

By the time he made Anónimos such vibrant hopes seem to have been dashed or seriously damaged. In an interview of 1997, looking back at the dictatorship and everything that went with it, he saw:

> Argentina taken over by a dreadful attitude of negation and suppression […] Young people have received the worst mutilation. They don't possess memory because the connections have been suppressed. The coup was carried out against those who could have transmitted something to them.

Slightly later in the interview he added, 'I think that power is the enemy of the body and the soul.'[18] The Anónimos must be these lost, disoriented people; but they could also intimate a broader human condition, a degradation of awareness generated by global consumerist capitalism, whether promoted – and this is a very disturbing aspect – by dictatorship or by democracy. In poetic notes attached to the Anónimos series, Grippo writes:

> We watch, engrossed, our landscape / filled with almost shapeless beings, / impassive, soulless presences / supported by neither roots nor soil. / Clones from the very nothingness.

187

In this ghostly image of a sort of 'virtual citizen' we can certainly see the antithesis of Grippo's sense of values. In his vision the alchemist's or the artisan's understanding of materials (artisans of every trade) joins with that of the scientist/inventor and the artist as a way of being in the world, of interaction with it. For him a material process is also a poetic process. His vision is based too on a certain understanding of time. Time in relation to these delicate processes. The time needed for ripening, transformation, efficacy. 'A new violin doesn't sound good. A new table has no memory' was his way of putting it, once, when we met in his studio before the Birmingham and Brussels show. He also spoke of his desire to 'extend things' time', and said that 'what time has consumed must be renewed'.[19]

Perhaps one of the greatest problems facing artists today is the disparity between creative time and the time of the market. Artists come under tremendous pressure to produce works, not for a distinct patron as in the past but for an abstract set of institutional and commercial forces in which each demand is heedless of all the others. It is not a new situation, and it applies equally whether one thinks of time in terms of duration or of the instantaneous. When he began work on his *Large Glass* in the early twentieth century, Marcel Duchamp spoke of a work that would 'occupy me for a long time [...] which I knew was going to be a long term project. I had no intention of having shows', he went on, 'or creating an oeuvre, or living a painter's life'.[20] And in the 1960s Robert Smithson made this remarkable statement:

> A great artist can make art by simply casting a glance.
> A set of glances can be as solid as any thing or place, but the society continues to cheat the artist out of his 'act of looking', by only valuing 'art objects'. The existence of the artist in time is worth as much as the finished product. Any critic who devalues the time of the artist is the enemy of art and the artist.[21]

Victor Grippo, Anónimos (Anonymous), 1998–2001

It is difficult not to see the artist's experience as one vivid instance of a colonisation of time that increasingly affects all of us. This was brought home to me recently when I read an anecdote about the artist Cildo Meireles. Meireles was in New York where he was preparing an exhibition of his work at the New Museum in 1999 and he was in his hotel room late at night half-watching a television programme that featured the Ku Klux Klan. Suddenly a Klan leader started to speak and Cildo turned up the volume. He was struck by something the Wizard said about the Klan's enemies: 'We want to steal their time. We want to steal their space. We want to steal their mind.' Meireles felt this was a horribly direct description of authoritarianism in general, which could be extended to an authoritarianism in the field of art and culture. Very soon after he made a new installation, *Strictu* (1999), which incorporates the overheard Ku Klux Klan statement in a work intended to, in the artist's words, 'take a position against such a perverse and absurd illusion'.[22]

Grippo's Anónimos may be the pessimistic product of the awareness of such a dehumanising process. Yet it is hard to accuse someone like Victor Grippo of losing hope. Perhaps I am projecting my own wishes, but in the abstract ambivalence of these gesso humanoid presences I see a faint possibility of germination and growth. After all, 'nothingness' – the void – as well as being a frightening abyss is, in metaphysical terms, a space of inexhaustible potential.

This essay is based on a lecture given at Miami Art Central on 18 May 2006, and was also, with some additions, given as a talk at Camden Arts Centre, London, on 10 December 2006. It was published in *Victor Grippo, Transformación*, exhibition catalogue, Centro Galego de Arte Contemporanea (CGAC), Santiago de Compostela, 2013. An earlier version of this essay was published in *Third Text*, vol.21, issue 4, no.87, 2007

Lygia Pape
The Logic of the Web

As you can see, all is connected.
The artwork does not exist as a finished and resolved object,
but as something that is always present,
permanent within people.
LYGIA PAPE[1]

If one were to place side by side images of two works by Lygia Pape –
Ttéia Quadrada (first version 1976) and *New House* (2000), one of her last
installations – the contrast between them would be almost shocking.
On the one hand, an ethereal beauty of the utmost delicacy, a kind
of late flowering of the orderly system of constructivism, filled with
light; and on the other hand a scene of complete ruin and visceral
chaos incongruously mounted as a house amidst the lush vegetation
of Rio de Janeiro's Tijuca forest.[2]

Both scenes carry a powerful conviction, and each is as typical of
the artist as the other. Construction vies with destruction. Interpreted
more broadly, there is in Pape's work an equal identification and
simultaneous immersion in cosmic reality, the universe, infinity and
in the low-down, nitty-gritty of human social and material life on
earth. It is remarkable how pervasive this theme – this contradiction
or interaction of apparent opposites – has been throughout the
twentieth century in the art and the literature of Latin Americans.
In that sense, Lygia Pape's twin consciousness can be seen as a recent
extension, expressed in new forms, of a tradition that stretches back
at least to the 1930s.

193

Lygia Pape, *Divisor* (Divider) (detail), 1968/2010 (reenaction)
Digital video (colour, sound), 4:52min
Performance at Museu de Arte Moderna, Rio de Janeiro, 2010

In her perceptive overview *Latin American Vanguards: The Art of Contentious Encounters* (1994), the North American scholar Vicky Unruh has shown that this theme can be traced as a continuing thread across the gaps and discontinuities that have characterised artistic production in Latin American countries. She deals mainly with literary avant gardes in the 1920s and 1930s, focusing on such figures as Roberto Arlt (Argentina), Miguel Ángel Asturias (Guatemala), Alejo Carpentier (Cuba), Oswald de Andrade and Mário de Andrade (Brazil), and Vicente Huidobro (Chile). Looking for common features among them, Unruh finds that 'A combative … interaction between "celestial poetics" and a concern with the contingent world, permeates vanguardist concerns all along.' A frequent feature of the Latin American avant-garde novel, she continues, is 'the artist's lament, calling to mind once again the stresses between cosmic aspirations and the pulls of a contingent world'.[3]

A continual switching between these worlds characterises Lygia Pape's entire oeuvre and is linked with her insistence on the freedom to experiment, driven by her rebellious spirit. The neo-Concrete movement in Brazilian art was for her as a young artist something defining and unprecedented:

> When the Neo-Concrete group was formed, there was none more constructive. We began inventing new languages, but without stringency, without systematising. Freedom was absolute. That is what my work always pursued.[4]

If this new language was based in geometric abstraction, it was not the result of:

> deforming anything gleaned from the real world. Our objective was to create from three basic forms: the circle, the square and the triangle.[5]

This economy of form and semantic compression was then applied by Pape to subject matter of vast proportions: the origins of the universe and the evolution of human life on earth, which is the subject of her *Livro da criação* (Book of Creation, 1959), and of time, in her *Livro do tempo* (Book of Time, 1961–63).

All the more remarkable, then, that Pape could move to an apparently opposite pole in her following series of works, the Caixas (Boxes), towards the end of the 1960s. When the neo-Concrete group began to break up in 1961, Pape had turned her attention to film. She worked for several years as a visual designer with the leading figures of the Cinema Novo. As a neo-Concretist she found most Cinema Novo films old-fashioned in their visual language.[6]

Pape returned to the world of visual art with the Caixas, a series of objects deliberately intended to shock and to confront the 'shut away, dead art of museums'[7] with raw life itself. Even in the avant-garde context of the epochal *Nova Objetividade Brasileira* (New Brazilian Objectivity) exhibition at the Museu de Arte Moderna in Rio de Janeiro in 1967 her Caixas caused puzzlement. Sometimes called the 'black humour boxes', these works kept the formal compression associated with neo-Concretism but aimed to provoke a physical reflex of repugnance, even abhorrence in the viewer. Looking into the *Caixa das formigas* (Box of Ants, 1967), a mirror at the base reflects back one's face, surrounded by the detested insects. In *Caixa das formigas*, massive Brazilian ants gorged themselves on a piece of red meat mounted at the centre, 'in an action full of eroticism and lust'.[8] *Caixa Brasil* (1968) is a box painted blue with a sumptuous red-felt lining; you open the lid to see the word 'Brasil' in silver along with hanks of hair from the three 'races' forming the multiracial Brazilian people – indigenous Indian, African, and European – in the order in which they arrived in the country.[9]

Particularly important to Pape in these new works was that they would communicate ideas 'through the skin, in an essentially sensorial way … and not by formal discourse'.[10] She called it an *epidermizacão* ('epidermisation') of an idea, an extraordinarily succinct way of summing up what may be seen as a characteristically Brazilian take on the relationship between mind and body. In his brilliant text on Pape, the artist Hélio Oiticica, who movingly described her as a 'permanently open seed', went on to assert that the 'living act of having an idea' did not abandon the sensual for the cerebral. On the contrary, it constituted 'a search for the direct sensorial consciousness for the act of seeing and feeling by touch – intellect defying itself.'[11]

It is extremely revealing of the artistic climate that linked neo-Concretism and Pape's experience with cinema to discover that Glauber Rocha's remarkable first film, the 11-minute *O pátio* (Terrace, 1959), was first screened in Pape's house. The film is a lyrical and almost abstract observation of two bodies, a woman's and a man's, lying on and moving sensuously around a floor of regularly spaced black and white tiles. The film poses the geometric rigour of the floor against the organic intimacy of the two bodies as a sort of endless conundrum.

Later, and especially in her work with the cineaste Paula Gaitán, Pape was to use film to expand our perception of the 'object' conventionally associated with the plastic arts. By slowing time down, through extreme close-up and the introduction of a drawn-out or pulsating soundtrack, she gives the full sensuousness of the process that is encapsulated in the object. The cloacal mouth in *Eat Me* (1975), the very gradual birth of the body from the *Ovo* (*O ovo*, The Egg, 1967), the billowing sheet of *Divisor* (Divider, 1968), at first seen without the presence of people, produce an opening beyond the constraints of the material thing – something equivalent to the subjective charge that we all bring to the experience of art.

Three artists emerged from neo-Concretism with radically new ideas: Lygia Clark, Lygia Pape and Hélio Oiticica. They looked beyond

the conventional categories of painting and sculpture and they opened the artistic process to the active participation of the spectator. Their questioning was not only radical but also profound, since they made a conscious link between the transformation of the nature of the work of art and the great changes taking place in our perception of the universe. It was a vision both kinetic and dialogic. The three artists had distinct trajectories, but for a period their experiments intertwined.[12]

For example, Pape's *Ovo* and Clark's *A casa é o corpo* (The House is the Body, 1968) are linked by metaphors of birth. In the latter, participants struggle through a dark room packed with balloons to emerge into the light-filled transparency of the central tent. Pape's *Ovos* are fabric-sided boxes in which a person is enclosed and can break out through the thin material. 'You are enclosed in there, enveloped in a sort of skin, or membrane; and then you stick your hand out like this – the membrane starts to give: suddenly it breaks and you are "born"; you put your head through the hole and roll out.'[13]

DIVIDING IS UNITING

The tension between the organic and the rectilinear in Pape's *Ovo* is clear – after all, the *Ovos* are not ovoid in shape but cubic. There are similar tensions in her celebrated *Divisor*, a work providing one of the most memorable poetic-political images of the 1960s. A great piece of cloth, 30 × 30 metres, holds together, yet apart, a crowd of people whose heads protrude through the evenly spaced holes. It was an ambivalent metaphor: either referring to an atomisation, the 'massing together of man, each inside his own pigeon-hole',[14] or to an ethic of community, since each individual's movements have a direct effect on those of others, on the whole group. The dividing-uniting dialectic extended down to each individual's body, since the huge cloth separated the head from arms, legs and trunk, an effect that Pape would have enhanced, if she had possessed sufficient

Lygia Pape, *Livro do tempo* (Book of Time), 1961–63
Automotive paint, tempera, acrylic and latex on wood

resources at the time, by causing a freezing stream of air to blow across the upper part and a draught of hot air across the nether regions. 'You feel your body without a head, or without arms and legs', she wrote.[15] *Divisor* focuses on people as individually and socially constituted, through the experimental creation of what Lygia Clark would later call a 'collective body'.

Despite their convergence over the invention of forms of public participation, and the general challenge to the notion of unique authorship, Clark's and Oiticica's bodies of work remain very different from Pape's. Clark went deeper and deeper into the implications of a dialogic relationship between the creative energies of 'artist' and 'other'. The progress of her work has an incredible internal logic, even if Clark herself experienced the stages as profound dislocations accompanied by psychological crises. For us, now, the unity between her reliefs of the 1950s and her *Therapy with Relational Objects* of the last ten years of her life is clear to see. The pattern is similar with Oiticica. Although Oiticica's main, or ostensible, link was with the exterior world, and Clark's with the interior – Clark herself made this comparison – his work has the same sequential drive as hers. Each stage leads to the next as a result of a powerful self-critique of previous work combined with the approach to a state where 'the work is born from merely a touch upon matter … nothing more than a breath: interior breath, of cosmic plenitude'.[16] Every stage, every work of both artists, is of equal interest.

Pape's work, by comparison, is diverse. Over the years she embraced many enquiries and enthusiasms, forms and formats. While this may mean that some groups of works or episodes strike us as less successful or less central than others – the literal figuration of the Amazoninos sculpture series for example – for the artist herself diversity is connected with creative freedom, a need to rebel, and has a rationale of its own. She saw everything she had done as essentially simultaneous: 'I've never liked dates';[17] 'My process of creating is circular. I've never had phases',[18] she told the newspapers. And it is

interesting that the critic Mário Pedrosa, in the brief preface he wrote for Pape's monograph published by Edições Funarte in 1983, alluded to a 'cycle of creativity' and 'an endless circuit'.[19] This movement can be traced all the way back to the *Livro da criação*, whose operation Pape described as a cycle. The pages are flat planes; when you take one out and open it up you realise it is a construction, a three-dimensional object in space, charging that space. You then press it flat and it returns to being a plane. In this action she sensed a nascent eroticism.

Later, she expanded her notion of the eroticisation of space to take in the entire city, whose system of forces, pulling this way and that, building up and dissipating, attracting and repelling, could be followed all the way down to the street vendor in the city centre:

> He comes to his corner and opens up his little case
> and starts his sales pitch, suddenly creating a kind of
> magnetisation. People flock around him, identifying with
> that irregular, sometimes brief, sometimes long-winded
> patter. And then, all of a sudden, he shuts his mouth,
> closes his case and the space dwindles into nothingness.[20]

CHRISTO AND JEANNE-CLAUDE, SERRA, AND PAPE

Expanding again to the large-scale we could ask ourselves if there is a Brazilian, or more specifically a *carioca*,[21] ethos or sensibility in Pape's work, a quality that asserts itself in relation to recent art internationally, in particular to European and North American art. This is not an appeal to 'the sad anachronism of nationalism', as Brazilian composer and musician Caetano Veloso called it;[22] nor is it an attempt to establish a hierarchy of aesthetic values, nor even to reverse a historical injustice. What we are seeking is in fact an aspect of diversity, which does imply an assertion of particular values.

Pape's *Divisor* has interesting points in common, and in contrast, with another membranous structure made six years later, and

201

presumably without knowledge of the Brazilian's work: Christo and Jeanne-Claude's *Ocean Front, Newport, Rhode Island* (1974).[23] *Ocean Front* was one of the artists' technical and logistical tours de force, by which they extended the strange visual assuaging effect of Christo and Jeanne-Claude's packaging principle over the vicissitudes of the landscape. This was a tethered white sheet of polypropylene that covered over a vast area where the sea meets the shore at King's Beach, Newport, United States of America, for eight days. The 'natural' energies of Christo's work compare very strikingly with the 'human' ones of Pape's. People are present in photos of *Ocean Front*, but only as skilled professionals or helpers whose role is to implant the artificial surface in the flux of nature. Associations of nature – sea waves and light – are present in photos of *Divisor*, but they arise spontaneously out of a work that is essentially about the body, anybody. Revealingly, Christo and Jeanne Claude emphasise the professional nature of their projects, stressing an almost puritan concept of 'work'. Christo writes: 'If 300 people are used it is not because we might want 300 people to play roles, but because we have work for them.'[24] Pape's *Divisor*, on the other hand, fits within an ethos of leisure, of play, of festivity you could say, an ethos with deep roots in Brazil.

There are differences, too, between Brazilian scale and North American scale. Both are big countries, but Brazil reacts differently to space and the body: it always joins the vast with the intimate. From the point of view of the public's experience, a work like *Divisor* can be compared with Richard Serra's big walk-in sculptures, such as have recently been shown at the Guggenheim Museum in Bilbao. Serra's steel sculpture imposes itself as an indestructible monument beside the soft materials and collapsible flexibility of *Divisor*. Both works set up a relationship between inside and outside. In the Serra the final inside arena is reached by a winding path that stretches the time taken to penetrate the labyrinth, not knowing what the end will be. 'Outside' and 'inside' are absolute states, whereas in the Pape they are fluid and interwoven states: the heads are apparently

outside and the rest of the body inside, but with the movement of participants the reverse can become true. In the Serra, the visitor confronts the work as an individual and is heedless of others. In the Pape, it is impossible for an individual to avoid an interaction with others because the movement and even the stasis of one affects all the others. 'You have to find a chink for yourself', Pape mused, 'can you imagine all those disembodied heads talking to one another against the white cloth?'[25] The work is paradoxical: it unites by dividing. Yet *Divisor* does not obliterate the individual in the collective: it envelops all in a particular state of creative energy, just as carnival does in its true nature.

MANTO TUPINAMBÁ

The two sides of Pape's art, her two 'lives' as she called them – pure abstraction and immersion in the pressing problems of contemporary Brazil – continued. For a long time she had supported the struggle of the indigenous population in Brazil. There is little information about her precise role in these affairs, but as long ago as 1988 she wrote to me in London:

> I am working very hard with the movement to defend the Amazonian Indians and those of the north and border with Venezuela (Ianomami, Macuxi, Maiongong, etc.). They live in the most dangerous part of our country: there are cruel farms, gold mines, big fires [destroying] the forest, and the Indians are being killed … My friend Gilberto Macusi is the representative of 400 chiefs at Roraima who have made a foundation for themselves, safe from Government and Church.[26]

These concerns coalesce in her multi-format work *Manto Tupinambá* (Feather Mantle), which occupied her in the second half of the 1990s. The Tupinambá lived along the coast of what is now Brazil before the

203

Overleaf: Lygia Pape, *Divisor* (Divider), 1968/2010

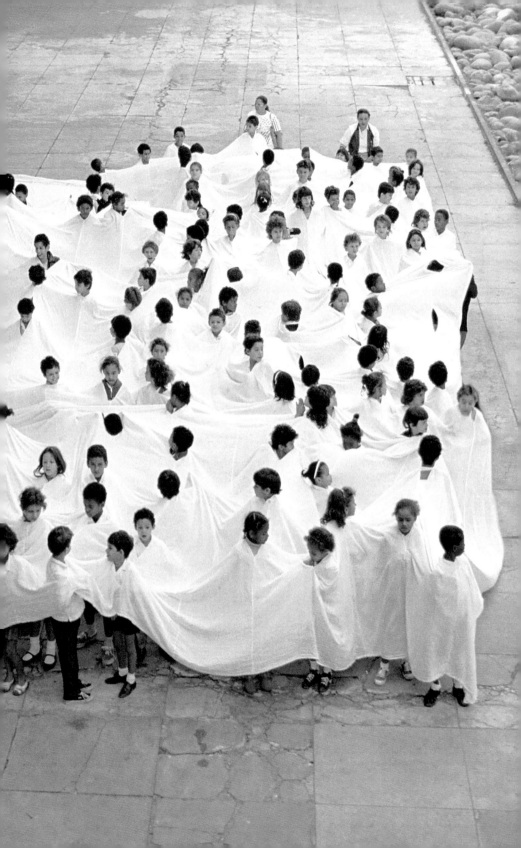

Europeans arrived, and the feather mantle was their symbol of power. They practised anthropophagy, which Pape is at pains to distinguish from cannibalism: 'The Tupinambá devoured their prisoners, their enemy, not from hunger, as in cannibalism, but to swallow and assimilate the spiritual capacities of the other.'[27] The Tupinambá provided, therefore, the key concept that, in metaphorical form, was taken in the modern period, originally by the poet Oswald de Andrade, to define Brazil's unique cultural assimilation of the 'spiritual capacities' of other peoples: *anthropophagia*. But in a kind of defiant irony, Pape's work points to the Tupinambá's absence, not their presence (among other matters, surviving feather mantles can be found in Denmark, Germany and Belgium but not in Brazil). In one of its guises,[28] Pape's *Manto Tupinambá* is materialised as a vast red fabric field/cape, reminiscent of *Divisor* but tethered to the ground, with, instead of heads, disquieting balls of red feathers, each with a protruding limb streaked with red paint. Or the Mantle could be evoked in a dematerialised, digitalised, virtual form as a red cloud hovering over the city of Rio, or covering the artist's shoulders like a cape as she waits at a bus stop (impossible in this last image not to see a passing tribute to Oiticica's *Parangolé*). In another culture that has valued the mantle above all other fabricated objects – the New Zealand Maori – to throw one's own cloak over the shoulders of another is a gesture of peaceable welcome.

PARADOX OF CONSTRUCTION

Right at the end of her life Pape knew a period of intense creativity. Although physically weak, she was mentally very strong and was able to produce a number of large-scale and ambitious installations. Though thin and fragile, she maintained her youthful and mischievous dress sense. Her clothes had always made her seem one step ahead of others, on the move, impossible to pin down. But now, allied to her playful side, in works like *Carandiru* (2001) and *New House* there is

anger. *New House*, particularly, represents an extraordinary departure in Pape's work. In both venues where it has been shown – the gallery of the Centro de Arte Hélio Oiticica in Rio de Janeiro and a neglected spot in Tijuca forest – the impact has been immediate and extremely disturbing. This scene of ruin, with its rubble, its jagged hanging fragments of plasterboard and clotted strings, is, as we noted at the beginning, visceral in its material presence. Both the white cube of the gallery and the 'constructive will' that had marked Pape's motivation from the Grupo Frente days, seem to be shattered in chaos and mess. The spectacle is made all the more powerful by being sealed off from the spectator. In the Centro Oiticica exhibition it was an unreachable, no-go area in the centre of the gallery, visible only through gaps in the walls. And in the Tijuca forest it was estranged by its lack of any organic relationship to the nature surrounding it. Its removed quality seems to refer in equal measure both to the artwork sealed off in museums and to the daily disasters safely distanced from us in newspaper and TV images from across the world.

Pape stresses the poetic rather than didactic nature of these installations, and, despite its closures, *New House* is certainly a work open to interpretation. It is ambivalent in its affirmations and negations. At the same time, it is a strictly architectural allegory. There are no agonised human references.

Brazilian cities are in a constant state of construction – of two kinds: on the one side the high-rise apartment blocks and corporate offices produced by the great construction companies, gleaming, distant, mechanical and impersonal, and on the other side the hands-on, improvised and personal house construction of the favelas and squatter settlements. Here, construction is part of a struggle for survival in which everyone is continuously involved. Pape had a long-term admiration for the way in which favela dwellers improvise structures starting from nothing. As part of the architecture courses she gave at the Universidade Santa Úrsula in the 1980s, she took hundreds of photographs of what people could do just with

lashed-together sticks and mud. When Pape interprets *New House* in a positive spirit, it may be to pay a tribute to the favela builders: 'A *New House* comes from debris.'[29]

New House, however, does not evoke favela housing so much as the cheap, capitalist mass production of homes 'which do not serve the occupant, a minimum schematic dwelling of which he/she becomes a mere "prop" (*adereço*)'.[30] An element in the formation of the work is Pape's disgust with a cycle of destruction in Brazil, as persistent as her cycle of creativity, whose two sides could be seen in the wanton destruction of precious environments in the name of 'progress', and the lethal entombment of favela dwellings in floods and landslides. 'When something grows', she wrote:

> it becomes bothersome and is knocked down … the University of Brasília, which was truly a marvel, was demolished and turned into something completely mediocre. Penelope weaves, and someone is undoing it. We are always blundering, by choice.
>
> […] That does not mean I'm an unhappy person or pessimistic at all. I think, rather, that art has such vitality, it is so powerful that it overcomes all. I say this not as an idealisation, or utopia. It is a creative energy that every person has within themselves. And I think we have to use it very well.[31]

In a brief tribute elicited by a newspaper on Pape's death, the artist Amélia Toledo described Pape as close to the Brazilian populace, the multitude, 'living together' (*conviver*) with it in a way that is 'not common among artists'.[32] Even given the generous scope and scholarly precision of the exhibition at the Reina Sofia, I believe we still have more to learn about the way Lygia Pape's work and life were intertwined.

Lygia Pape, Magnetized Space, Museo Nacional Centro de Arte Reina Sofia and Projecto Lygia Pape, Madrid, 2011

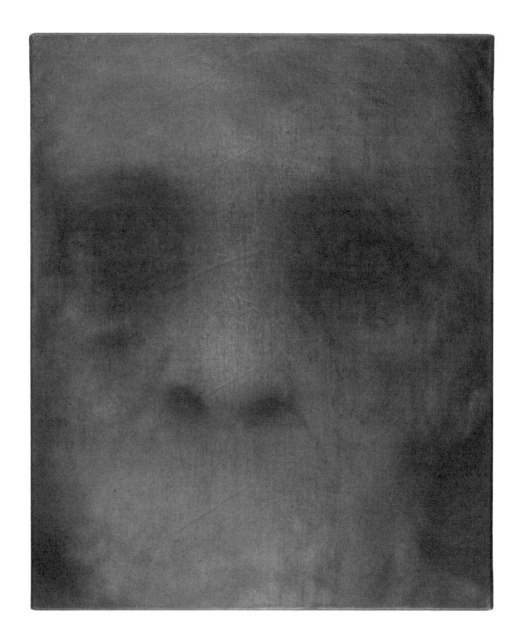

Peter Kennard
face

One first of all notices the extreme minimalism of the set-up.
A number of small canvases of equal size, equidistant from one
another, parade around the walls of the gallery. They are so dark as to
appear almost black in the all-white atmosphere, which is accentuated
by the four white columns which divide the interior. A discreet beige
parquet floor completes the scene. In fact, a quick glance from the
street by the average punter would probably put this exhibition
down as a piece of conceptualist déjà vu.

To approach close is to have this first impression, this assumption
of a slick coolness, completely contradicted. Each small canvas
renders a human face. With varying degrees of distinctness an eye,
or a nose, or part of a face emerges from the overall dark grey of the
oil paint. The faces are anonymous, of a certain age, life-worn. They
are painted with a delicate realism and an empathy which is quite
unexpected within the minimalist ethos which has been set up.
Since the features are life-size, and since we can't easily seize the
image visually, it is as if we ourselves are looking into a dark mirror.

I found this exhibition a triumph for Peter Kennard. It marks a
qualitative leap, bringing to a new stage the themes he has treated
with such consistency for the past 35 years. The writer and curator
John Roberts has said of Kennard that he is 'one of the very few
artists – the only one, it might be said – who has had a direct effect
on recent British politics'. Kennard's chief medium for doing this has
been the photomontage work published from the 1980s onwards in
The Guardian and other newspapers, his magazine covers and posters.

211

Peter Kennard, *face* 4, 1992
Oil and silver gelatin on canvas, 55.8 × 45.7cm

Like a latter-day John Heartfield, he has taken the everyday traffic of an image-saturated society, deconstructing and reconstructing it to expose the murderous drives of corporate capitalism. In the early 1980s his main targets were the arms industry, nuclear weapons and war (some of his best-remembered images were made for the Campaign for Nuclear Disarmament and were regularly carried as placards on demonstrations). In the mid 1990s he adopted a more general and at the same time more intimate metaphor, pictured as a clash between human flesh and newsprint. The financial pages of newspapers were the common pictorial surface. Sometimes a face would establish itself through the columns of stocks and shares; sometimes two finely rendered hands would tear at the newspaper pages, 'as if grasping for air', in the artist's words. Because of the positioning of the hands and arms in relation to the viewer, the viewer could feel that these hands were actually his own.

In 1998 Kennard widened his practice with a street-level intervention. Whenever there was a 'shudder on the stock market', he would push his 'News Truck' into the City of London, unload his work and display it in giant newspaper vendor's frames along the wall of the Stock Exchange or the Bank of England.

As well as – or beside, or within – all his work for specific causes, something very personal has run through Kennard's work from the beginning, a certain material sensibility. There has always been a strong material correspondence between the ink of the printing process, the dust and dirt of the world, and the warmth of human flesh. It was the mess of the blots and stains of the ink, as much as the imagery, which stood out in his first London show, *Generation Newspeak*, which I remember seeing at Zees Arts, a short-lived basement gallery near Baker Street in 1970. The Newspaper series is in a mixed media of carbon toner, charcoal and pastel on newsprint. His installations of ruined pallets and torn placards (shown in past exhibitions at Gimpel Fils) use dust, oil, acrylic and photography on wood. Never losing sight of the material basis of the image: this

is always a way to challenge the falsehoods of the media without taking an idealistic position.

It is this close relationship of materiality to meaning which comes to the fore in his latest exhibition, even though, surprisingly, Kennard is here working in oils. In fact, there is a startling correspondence between the face series of paintings and some of Kennard's earliest works, such as his Giacometti-like portrait *Mother* (1966), made when he was 17, and a *Head* of the same year, made in the 'coal-hole at the back of the flats' in Maida Vale that he used as a studio.

As you move from one painting to the next, at the Gimpel exhibition, the faces seem to shift. They shift in and out of definition, and they shift within the rectangle of visibility which constitutes the canvas, making its limits even more implacable, making the drama between life and representation poignant and intense. It is as if the faces are being lost and forgotten as much as they are being brought to mind. Our experience of these paintings as a dark mirror leads us to examine our own roles as viewers of artworks and as citizens.

It gradually becomes clear that Peter Kennard has painted these faces without mouths. It is not an aggressive silencing, a gagging, but a sort of atrophying, as if the faculty of speech was un-used, forgotten, withered. It is the eyes that communicate, merging individual stories into one great common story. Kennard's endeavour in Face is to establish a physiognomy for those millions who are on the receiving end of global economic policies. Like the image itself, the ways of designating this multitude of human beings constantly shifts: homeless, unemployed, refugee, asylum seeker, the bulldozed of Gaza, the bombed-out of Baghdad… In contrast to some artists' recent efforts to disquieten gallery-goers with images of the poor, such as Andres Serrano's large, high-focus, full-colour prints of New York homeless men, Kennard adopts a different strategy. His people are very much present but they are not to be quickly typecast or objectified as 'other', and this is bound up in the way they face us and we face them.

213

Is it only they who are silent, or is it also we? These works insist on dialogue. At the time of his exhibition *Welcome to Britain* at the Royal Festival Hall in 1994, Kennard and the poet Peter Reading worked together for a week with people who had lived on the streets in the surrounding area. People who came to work with them were provided with free materials and meals. At the end of the week a photocopied book was produced of all their work, and they, as the authors, decided to call it *Voice of the Unheard*.

In terms curiously similar to the procedures of his own paintings, Peter Kennard has said of himself, 'I like the sense that (my work) can't be catalogued; that I'm a nebulous figure who turns up in funny places'.

This essay is part of an article published in
Third Text, vol.17, issue 2, no.63, 2003

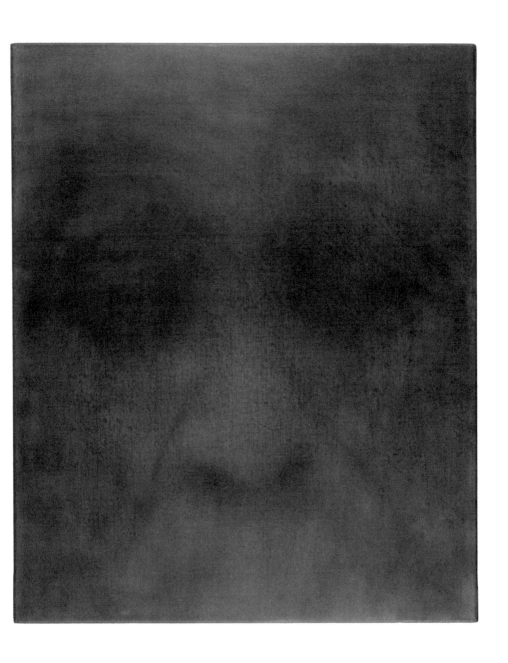

Peter Kennard, *face* 6, 1992
Oil and silver gelatin on canvas, 55.8 × 45.7cm

Notes

Preface

1 Len Lye, the first notebook, quoted in Roger Horrocks, *Len Lye: A Biography*, Auckland University Press, Auckland, 2001, p.19.

2 Julia Prewitt Brown, *Cosmopolitan Criticism: Oscar Wilde's Philosophy of Art*, University of Virginia Press, Charlottesville, VA and London, 1997, p.xv.

3 *Ibid*., p.50.

4 *Ibid*., p.49.

5 Carl Hill, *The Soul of Wit, Joke Theory from Grimm to Freud*, University of Nebraska Press, Lincoln and London, 1993, inside sleeve. Jean Paul was a German writer of the eighteenth and nineteenth centuries. He was one of the first who approached humour from a theoretical standpoint and his writing was known for its structural complexity. Arriving at the view that the philosophies of the Enlightenment and Metaphysics had failed, he recommended adopting a perspective of 'humorous resignation'.

Ana Mendieta: One Energy

All quotes by Ana Mendieta in this essay ©The Estate of Ana Mendieta Collection, LLC. Courtesy Galerie Lelong & Co.

1 Ana Mendieta, quoted in Judith Wilson, 'Ana Mendieta plants her garden', *The Village Voice*, 13–18 August 1980, p.71.

2 Ana Mendieta, quoted in Petra Barreras del Rio, 'Ana Mendieta, An Historical Overview', Petra Barreras del Rio and John Perreault (eds), *Ana Mendieta: A Retrospective*, exhibition catalogue, New Museum, New York, NY, 1987, p.31.

3 Ana Mendieta, *The Village Voice, op.cit.*

4 Ana Mendieta, excerpt from an unpublished note, undated. Quoted in Charles Merewether, 'From Inscription to Dissolution: An Essay on Expenditure in the Work of Ana Mendieta', *Ana Mendieta*, exhibition catalogue, Fundació Antoni Tàpies, Barcelona, 1996, p.101.

5 Ana Mendieta, lecture with slides, Alfred State University, Alfred, NY, 1981.

6 Octavio Paz, *The Labyrinth of Solitude: Life and Thought in Mexico*, Lysander Kemp (trans), Grove Press, New York, NY, 1961, pp.47–64.

7 In fact, it is uncertain whether these were ever intended as titles. They may indicate a reluctance to name, and therefore to contain or distance, such a raw experience. Whatever the case, their starkness remains and they chime with the ethos of Minimalism.

8 Ana Mendieta, quoted in Marlene J Perrin, 'Ana Mendieta works with nature to produce her art', *Iowa City Press Citizen*, 2 December 1977.

9 Lucy Lippard, 'The Pains and Pleasures of Rebirth: Women's Body Art', *Art in America*, vol.64, no.3, May 1976, pp.75, 79.

10 Lucy Lippard, 'Ana Mendieta 1948–1985' obituary, *Art in America*, vol.73, no.11, November 1985, p.190.

11 Ana Mendieta, *The Village Voice*, *op.cit.*

12 Juan Sanchez, speaking in Nereyda Garcia-Ferraz, Kate Horsfield and Branda Miller (dirs), *Ana Mendieta: Fuego de Tierra*, 1987 [film].

13 Lucy Lippard, untitled article in 'Earth from Cuba, Sand from Varadero: A Tribute to Ana Mendieta', Clayton and Caryl Eshleman (eds), *Sulfur*, vol.22, Eastern Michigan University, MI, Spring 1988, p.77. I am aware that behind Lippard's reasonable phrase lie powerful contradictions. Ana Mendieta was marginalised in the art world for years, not only as a woman (known as Carl André's wife), but also as a Latin American. During her lifetime most of the exhibitions in which she was included were women's, or Latin American, exhibitions. Her sister Raquelín, who inherited her estate, consciously decided to deny Ana's work to Latin American exhibitions until such time as Ana was recognised as an artist first, not by her gender or where she came from.

14 John Perreault, 'Earth and Fire: Mendieta's Body of Work', Barreras del Rio and Perreault, *op.cit.*

15 Gaston Bachelard, *The Flame of a Candle*, The Dallas Institute of Humanities and Culture, Dallas, TX, 1988, p.2.

16 Leopoldo Maler, letter to the author, 23 July 2000. Maler's exhibition *Mortal Issues: A Sanctuary with Flames & Figures* was held at the Whitechapel Art Gallery, London, in 1976.

17 Marta Minujin, interviewed in Richard Squires, 'Eat Me, Read me, Burn Me: The Ephemeral Art of Marta Minujin', *Performance*, no.64, Summer 1991, p.24.

18 *Ibid.*

19 Is it too fanciful to connect the fire metaphors in Latin American art with memories of the emotions surrounding 'the world's first fires'? In Aztec society, every cycle of 52 years was marked by the New Fire Ceremony, a time of great anxiety in which all fires were extinguished and replaced with a new fire ceremonially kindled using a fire drill and board.

20 Hélio Oiticica, quoted in *Hélio Oiticica*, exhibition catalogue, Whitechapel Art Gallery, London, 1969.

21 Gerardo Mosquera, introduction, *Rupestrian Sculptures/Esculturas Rupestres*, exhibition catalogue, AIR Gallery, New York, NY, 1981.

22 Nancy Spero, 'Tracing Ana Mendieta', *Artforum*, vol.30, no.8, April 1992, p.77.

23 See Miwon Kwon, 'Bloody Valentines: Afterimages by Ana Mendieta', *Inside the Visible: An Elliptical Traverse of 20th Century Art in, of, and from the Feminine*, MIT Press, Cambridge, MA, 1996, p. 171, note 13.

24 Robert Smithson, 'Untitled, 1972', in Nancy Holt (ed), *The Writings of Robert Smithson*, New York University Press, New York, NY, 1979, p.220.

25 Information about one such scheme can be found at www.boggscenter.org, accessed 7 April 2017.

26 The movement's full name is Movimento dos Trabalhadores Rurais Sem Terra (MST), www.mst.org.br

27 Of course, large-scale, un-ecological and corrupt corporate exploitation also exists in Brazil.

28 Quoted from the flyer for the event which took place on the 9 December 1989 in La Plata, Argentina, involving some 500 artists.

29 Ana Mendieta, interviewed by Linda Montana, *Sulfur*, *op.cit.*, p.67.

30 Spero, *op.cit.*, p.77.

31 Gerardo Mosquera, 'Ana Mendieta: Art, Religion and Cultural Difference', Alessandro Angelini (trans), *ArtLies*, vol.28, autumn 2000, pp.22–25.

32 Lucy Lippard, *Overlay: Contemporary Art and the Art of Prehistory*, Pantheon, New York, NY, 1983, pp.45–51.

33 Ana Mendieta, lecture with slides at Alfred State University, 1981.

34 Lygia Clark, letter to Hélio Oiticica,
 31 March 1971, quoted in *Lygia Clark*,
 exhibition catalogue, Fundació Antoni
 Tàpies, Barcelona, 1997, pp.276–77.

35 Ana Mendieta in Barreras del Rio and
 Perreault, *op.cit.*, p.216.

36 Lygia Clark, 'On the Act' (1965), *Lygia
 Clark*, *op.cit.*, p.164.

37 Lygia Clark, 'The Death of the Plane'
 (1960), p.117.

38 Hélio Oiticica, from New York notebooks
 (unpublished), quoted in Guy Brett,
 'The Experimental Exercise of Liberty',
 Hélio Oiticica, exhibition catalogue,
 Witte de With and Jeu de Paume,
 Rotterdam and Paris, 1992, p.237.

39 Lygia Clark, quoted in Guy Brett, 'Lygia
 Clark: The Borderline between Art and
 Life', *Third Text*, no.1, autumn 1987, p.87.

40 Lygia Clark, letter to Hélio Oiticica,
 6 July 1974, *Lygia Clark*, *op.cit.*, p.288.

41 Lygia Clark, *Third Text*, *op.cit.*, p.87.

42 Suely Rolnik, 'Um Singular Estado de
 Arte', *Folha de São Paulo*, 4 December
 1994, no.6, p.16.

43 Gerardo Mosquera, 'Ana Mendieta y el
 Arte de las Islas' (unpublished) date
 unknown.

44 Sudhir Kakar, *Shamans, Mystics and
 Doctors: A Psychological Enquiry into India
 and its Healing Traditions*, Oxford
 University Press, Delhi, 1990, p.233.

Dias & Riedweg:
The Expanding Conversation

1 Maurício Dias & Walter Riedweg,
 Dias & Riedweg, exhibition catalogue,
 Museu d'Art Contemporani (MACBA),
 Barcelona, 2003, p.140.

2 *Ibid.*, p.78.

3 *Ibid.*, p.79.

4 Marita Muukkonen, *Ehkä Puhumme
 Samasta/Possibly Talking About the Same*,
 Kiasma, Helsinki, 2004, p.21.

5 Maurício Dias speaking in Fabiana
 Werneck and Marco del Fiol (dirs),
 *Mau Wal: Encontros Traduzidos/Translated
 Meetings*, Associação Cultural
 Videobrasil, 2002 [video].

6 Walter Riedweg, *ibid.*

7 *Ibid.*

8 Dias & Riedweg, *Dias & Riedweg*, p.102.

9 *Ibid.*, p.104.

10 *Ibid.*, p.60.

11 *Ibid.*, p.61.

12 *Ibid.* p.65.

13 *Ibid.* p.90.

14 *Ibid.*, p.91.

15 Maurício Dias, *ibid.*, p.247.

16 Walter Riedweg, *ibid.*

17 As quoted by Lygia Clark.

18 Hélio Oiticica, quoted in Guy Brett,
 'The Experimental Exercise of Liberty', in
 Hélio Oiticica, Witte de With, Rotterdam,
 1992, p.234.

19 *Ibid.*, p.233.

20 Dias & Riedweg, *Dias & Riedweg*,
 op.cit., p.168.

21 Nikos Papastergiadis, *The Turbulence of
 Migration: Globilisation, Deterritorialisation
 and Hybridity*, Polity Press, Cambridge,
 2000, p.50.

22 *Ibid.*, p.57.

23 *Ibid.*, p.50.

24 *The Independent*, 25 March 2002.

25 Lee Ufan, *Selected Writings by Lee Ufan
 1970–96*, Jean Fisher (ed), Lisson Gallery,
 London, 1996, p.130.

26 Hélio Oiticica, 'A dança na minha
 experiencia', in *Aspiro ao Grande Labirinto*,
 Rocco, Rio de Janeiro, 1986, p.258.

27 Papastergiadis, *op.cit.*, p.11.

28 Rabindranath Tagore, writing in the
 1920s, quoted in Ashis Nandy, *Bonfire of
 Creeds: The Essential Ashis Nandy*, Oxford
 University Press, Delhi, 2004, p.471.

29 Part of the soundtrack from *Sugar
 Seekers*, Dias & Riedweg, 2004.

30 Susan Hiller, interviewed in *Fuse*,
 November/December 1981.

31 Maurício Dias, email with the author,
 14 February 2005.

Javier Téllez:
Worlds Real and Imagined

1 Raul Zamudio, 'Javier Téllez:
Institutionalised Aesthetics', *Flash Art*,
July–September 2002, p.96.
2 Javier Téllez interviewed by Euridice
Arratia, *Tema Celeste*, summer 2001.
3 *Ibid.*
4 Michèle Faguet and Cristóbal Lehyt,
'Madness is the Language of the
Excluded: An Interview with Javier
Téllez', *C Magazine*, no.92, winter
2006, p.27.
5 Zamudio, *op.cit.*, p.96.
6 Erving Goffman, *Asylums: Essays on the
Social Situation of Mental Patients and Other
Inmates*, Pelican Books, London, 1968.
7 Rubén Gallo, 'Javier Téllez', *Poliester*,
vol.6, no.20, autumn 1997, p.16.
8 Carmen Hernández, *La Extracción de la
Piedra de la Loeuvra (The Extraction of the
Stone of Madness), An Installation by Javier
Téllez*, Museo de Bellas Artes, Caracas,
1996, p.36.
9 *Ibid.*, p.20.
10 Mikhail Bakhtin, *Rabelais and His World*
(trans Hélène Iswolsky), University
of Indiana Press, Bloomington, IN,
1984, p.7.
11 Roberto DaMatta, in Claudio Edinger,
Carnaval, Dewi Lewis Publishing,
Manchester, 1996, p.10.
12 Marina Warner, *Joan of Arc: The Image of
Female Heroism*, Penguin Books, London,
1983, p.34.
13 Marina Warner, 'Introduction', *The Trial
of Joan of Arc*, Arthur James Publishers,
Evesham, 1996, p.26.
14 Warner, *Joan of Arc, op.cit.*, p.157.
15 Warner, *The Trial of Joan of Arc, op.cit.*, p.33.
16 *Ibid.*, p.133.
17 Goffman, *op.cit.*, p.35.
18 Warner, *The Trial of Joan of Arc, op.cit.*, p.11.
19 Lilly Wei, review of the 2004 Sydney
Biennale, *Art in America*, December
2004, p.65.
20 Javier Téllez, email to the author,
31 January 2008.
21 *Ibid.*
22 David Macey, *Penguin Dictionary of Critical
Theory*, Penguin Books, London, 2000,
p.229.
23 *Ibid.*
24 Goffman, *op.cit.*, p.45.
25 Michael Kustow, *Peter Brook, A Biography*,
Bloomsbury, London, 2005, p.147.
26 AS Byatt, *Babel Tower*, Random House,
New York, NY, 1996, p.169.
27 Osvaldo Sanchez, *Javier Téllez*, in *100 Latin
American Artists*, Exit Publications,
Madrid, 2007, p.410.
28 Quoted in Guy Brett and Paulo Venancio
Filho, *Fatos: Antonio Manuel*, Centro
Cultural Banco do Brasil, São Paulo,
2007, p.136.
29 Okwui Enwezor, 'On the Politics of
Disaggregation: Notes on Cildo
Meireles' Insertions into Ideological
Circuits', *Cildo Meireles*, Tate Publishing,
London, 2008.
30 Giorgio Agamben, 'No to Biometrics',
Le Monde, 5 December 2005.
31 Javier Téllez, in conversation with
Monserrat Albores, *Sitac V: Insolent
Dialogues*, PAC Patronato de Arte
Contemporáneo, Mexico City, 2007.

Jimmie Durham:
The Questioner, Material
and Verbal Wit

1 Chris Baldick, *The Concise Oxford Dictionary
of Literary Terms*, Oxford University Press,
Oxford, 1990.
2 *Cassell's New French Dictionary*, Cassell &
Co., London, 1962.
3 Quoted in Richard Ellmann, *Oscar Wilde*,
Penguin Books, Harmondsworth,
1988, p.349.
4 Jimmie Durham, 'A Friend of Mine said
that Art is a European Invention', in
Saskia Bos and Johannes Schlebrügge

(eds), *Jetztzeit*, Cantz, Amsterdam, 1994, p.36.

5 Jimmie Durham, 'Eurasia', in Virginia Garreta (ed), *Pour une nouvelle géographie artistique des anneés 90*, CAPC Musée d'art contemporain de Bordeaux, Bordeaux, 2002, p.119.

6 Jimmie Durham, 'Waiting to be Interrupted', *[UP]Arte*, no.2, 1996, p.61.

7 Jimmie Durham, 'Author's Note', in Jean Fisher (ed) *Jimmie Durham: A Certain Lack of Coherence*, Kala Press, London, 1993, p.VII.

8 Lu Xun, 'Silent China', a talk given at the Hong Kong YMCA, 16 February 1927, in *Silent China: Selected Writings of Lu Xun*, Gladys Yang (trans), Oxford University Press, Oxford, 1973, p.163. Sardonically, Lu Xun said of his countrymen: 'By temperament the Chinese love compromise and a happy mean. For instance, if you say this room is too dark and a window should be made, everyone is sure to disagree. But if you propose taking off the roof, they will compromise and be glad to make a window. In the absence of more drastic proposals, they will never agree to the most inoffensive reforms.'

9 Jimmie Durham, *My Book, The East London Coelacanth, Sometimes Called, Troubled Waters; The Story of British Sea-Power*, Institute of Contemporary Arts and Book Works, London, 1993, p.21.

10 Jimmie Durham, 'A Brief Letter of Introduction, or Apology', in *Between the Furniture and the Building (Between a Rock and Hard Place)*, Kunstverein München, Munich, 1998, p.9.

11 Jimmie Durham, 'A Kind of Upright Gravestone; Hence, also a Pillar', in *Between the Furniture and the Building*, op.cit., p.17.

12 Jimmie Durham, 'The Story of Tobacco in Germany (a Commercial Break)', in *Between the Furniture and the Building*, op.cit., p.75.

13 Nikos Papastergiadis and Laura Turney, *Jimmie Durham: On Becoming Authentic*, Prickly Pear Press, Cambridge, 1996, p.10.

14 Vine Deloria Jr, *Custer Died for Your Sins: An Indian Manifesto*, Macmillan, London, 1979, p.146.

15 Durham, *A Certain Lack of Coherence*, op.cit., p.191.

16 Gates, a missionary quoted in *Columbus Day: A Play Compiled by Natasha Drootin and Jimmie Durham*, 1988.

17 Jimmie Durham, interviewed by Mark Gisbourne, *Art Monthly*, no.173, February 1994, p.9.

18 Jimmie Durham, interviewed in *Art Journal*, vol.51, no.2, 1992, p.16.

19 Jimmie Durham, interviewed by Nicola Barker, *The Observer*, 19 December 1993, p.8.

20 Charles H Kahn, *The Art and Thought of Heraclitus*, Cambridge University Press, Cambridge, 1979, p.85.

21 Mikhail Bakhtin, *Rabelais and His World*, Hélène Iswolsky (trans), Indiana University Press, Bloomington, IN, 1984, p.380.

22 Jimmie Durham, *A Matter of Life and Death and Singing*, exhibition booklet, Alternative Museum, New York, NY, 1985.

23 Durham, *Nature in the City: A Diary*, entry of 2 May 2001, Büro Friedrich, Berlin, 2001, n.p.

24 Jimmie Durham, untitled text in Robert Pinto (ed), *Facts and Fiction: Arte e Narrazione*, Comune di Milano/Triennale di Milano, Milan, 1998, p.57.

25 Durham, *Nature in the City*, op.cit.

26 Jimmie Durham, '(The Direction of My Thought)', in *Strangers in the Arctic: 'Ultima Thule' and Modernity*, The Finnish Fund for Art Exchange and Museum of Contemporary Art, Helsinki and Pori Art Museum, Pori, 1996, p.147.

27 *The Guardian*, 6 December 2007.

28 Durham, *Nature in the City*, op.cit.

29 Jimmie Durham, untitled text in Agnaldo Farias and Moacir dos Anjos

(eds), *29th Bienal Catalogue*, Bienal de São Paulo, São Paulo, 2010, p.394.

30 Durham, *My Book*, *op.cit.*, p.4.

31 Jimmie Durham, in *Universal Cosmic Murmur*, FISC 8° Festival Internazionale Sullo Spettacolo Conemtporaneo, Bologna, 2008.

Monika Weiss:
Time Being

1 Monika Weiss in conversation with Aneta Szylak, WYSPA Institute of Art, Gdansk, Poland, 23 March 2005.

2 David Coxhead and Susan Hiller, *Dreams: Visions of the Night*, Thames & Hudson, London, 1976, p.44.

3 Monika Weiss, letter to the author, 2 July 2005.

4 In conversation with Aneta Szylak, *op.cit.*

5 Marta Minujín, quoted in Richard Squires, 'Eat Me, Read Me, Burn Me: the Ephemeral Art of Marta Minujín', *Performance*, no.64, summer 1991, p.20.

6 Monika Weiss, email to the author, 24 September 2005.

7 Monika Weiss, in conversation with William Anastasi, *Monika Weiss: Vessels*, Chelsea Art Museum, New York, NY, 2004, p.14.

8 Monika Weiss, email to the author, 26 September 2005.

9 Monika Weiss, letter to the author, *op.cit.*

10 Jerzy Grotowski in Zbigniew Osinski, *Jerzy Grotowski. Zrodla, inspiracje, konteksty* (slowo/obraz terytoria, Gdansk, 1998.

11 Diamela Eltit, quoted in 'Nelly Richard, Margins and Institutions: Art in Chile Since 1973', *Art & Text*, no.21, special issue, May–July 1986.

12 In conversation with William Anastasi, *op.cit.*, p.19.

Len Lye:
Force Field and Sonic Wave

1 Len Lye quoted in Wystan Curnow, 'Len Lye's Sculpture and the Body of his Work', *Art New Zealand*, no.17, spring 1980, p.35.

2 Roger Horrocks, 'Len Lye: Origins of his Art', in Jean-Michel Bouhours and Roger Horrocks (eds) *Len Lye*, exhibition catalogue, Centre Pompidou, Paris, 2000, p.11 (French), p.178 (English).

3 Ibid., p.15/p.179.

4 Roger Horrocks, *Len Lye: A Biography*, Auckland University Press, Auckland, 2001, p.19.

5 Alastair Reid quoted *ibid.*, p.107.

6 Jesús Rafael Soto quoted in Jean Clay, 'Soto', *Signals*, vol.1, no.10, Nov–Dec 1965, p.6.

7 Barbara Rose, 'Len Lye: Shaman, Artist, Prophet' in Bouhours and Horrocks, *op.cit.*, p.134/p.220.

8 Len Lye quoted *ibid.*, p.134/p.221.

9 Georges Vantongerloo, 'To Perceive', in Anthony Hill, *Data: Directions in Art, Theory and Aesthetics*, Faber & Faber, London, 1968, p.23.

10 Ana Mendieta quoted in *Ana Mendieta*, exhibition catalogue, Fundació Antoni Tàpies, Barcelona, 1996, p.216.

11 Roger Horrocks, quoted in Bourhours and Horrocks, *op.cit.*, p.18/p.181.

12 Len Lye, 'The Body English of Myth Art and the Genes: Somewhat Autobiographically', unpublished MSS, Len Lye Foundation Archive, Govett-Brewster Art Gallery, New Plymouth, New Zealand.

13 Jean Tinguely quoted in *Jean Tinguely*, exhibition catalogue, Centre Pompidou, Paris, 1996.

Gianni Colombo:
The Eye and the Body

1 Pontus Hultén, *Museum Jean Tinguely Basel – The Collection*, Museum Jean Tinguely, Basel, 1996, p.156.

2 Quoted in José Balza, *Alejandro Otero*, Edizioni di Comunitá, Rome 1977, p.48.

3 Lygia Clark, 'The Death of the Plane' (1960). Reprinted in *Lygia Clark*, Fundació Antoni Tàpies, Barcelona, 1997, p.117.

4 Jesús Rafael Soto, 'Interview with Guy Brett', *Signals*, November–December 1965, p.13.

5 Guy Brett, 'Introduction', *Soto*, exhibition catalogue, Marlborough Fine Art, London, 1969, p.16.

6 Lucio Fontana (1955) quoted in Mario Pedrosa, 'Da dissolução do objeto ao vanguardismo brasileiro'. Reprinted in Mario Pedrosa, *Mundo, homen, arte em crise*, Editora Perspectiva, São Paulo, 1975, p.165.

7 Gianni Colombo, 'Statement' (1963–65), quoted in Guy Brett, *In Motion: An Arts Council Exhibition of Kinetic Art*, exhibition catalogue, Arts Council of Great Britain, London, 1966.

8 Gianni Colombo, 'After-Structures', projects, 1964.

9 François Morellet, quoted in Lynn Zelevansky, 'Grids: François Morellet at the crossroads' in *François Morellet: 60 Random Years of Systems*, exhibition catalogue, Annely Juda Fine Art, London, 2008.

10 Soto, *op.cit.*

11 Jesús Rafael Soto, in Marcel Joray and Jesús Rafael Soto (eds), *Solo*, Editions du Griffon, Neuchâtel, 1984, p.46.

12 William M. Ivins Jr (1938), *On the Rationalisation of Sight: With an Examination of Three Renaissance Texts on Perspective*, Da Capo Press, New York, NY, 1973. Theodor Schwenk, *Sensitive Chaos: The Creation of Flowing Forms in Water and Air*, Rudolf Steiner Press, London, 1965.

Liliane Lijn:
Wavering Line of Light

1 Louis Khan quoted in Louis I Kahn and John Lobell, *Between Silence and Light: Spirit in the Architecture of Louis I. Kahn*, Shambhala Publications, Boulder, CO, 1979, p.4.

Gego:
Art, Design and
the Poetic Field

1 Luis Pérez-Oramas, email letter to the author, 4 January 2006. Quoted with the writer's kind permission.

2 Luis Pérez-Oramas, 'La colección Cisneros: del paisaje al lugar', in *Abstracción Geométrica: Arte Latinoamericano en la colección Patricia Phelps de Cisneros*, Harvard Art Museums and Fundación Cisneros, Yale University Press, New Haven, CT and London, p.56.

3 Jesús Rafael Soto, quoted in Jean Clay, 'Soto', *Signals*, London, vol.1, no.10, November–December 1965, p.9.

4 Alfredo Boulton, *Art in Guri*, CVG Electrificación del Caroní, CA (EDELCA), 1988, pp.58–60.

5 Marta Traba, quoted in Iris Peruga, 'El prodigioso juego de crear', in *Gego. Obra Completa 1955–1990*, Fundación Cisneros, Fundación Gego and Fundación Museo de Bellas Artes, Caracas, 2003, p.379, note 13.

6 I am grateful to the artist Jaime Gili for this information. Jaime Gili created a work on this theme which was exhibited in his exhibition at Riflemaker, London, February–March 2006.

7 Gego, quoted in Maria Elena Huizi and Josefina Manrique (eds), *Sabiduras and Other Texts: Writings by Gego*, International Center for the Arts of the Americas, Museum of Fine Arts Houston and Fundación Gego, Houston, TX and Caracas, 2005, p.234.

8 Peruga, *op.cit.*, p.379.

9 Huizi and Manrique, 'Introduction', *op.cit.*, p.22.
10 Gego, quoted in Guadalupe Montenegro, 'Chronology', in Peruga, *op.cit.*, p.416.
11 Peruga, *op.cit.*, p.385.
12 Hans M Wingler, *La Bauhaus*, Editorial Gustavo Gili, Barcelona, 1962, p.614, quoted in Ruth Auerbach, 'Gego: Constructing a Didactics', in Peruga, *op.cit.*, p.407.
13 *Ibid.*, p.406.
14 *Ibid.*
15 *Ibid.*
16 *Ibid.*, p.410.
17 *Ibid.*
18 Hanni Ossott, *Gego*, Museo de Arte Contemporaneo de Caracas, Caracas, 1977.
19 Luis Pérez-Oramas (text), Alvaro Sotillo (design), Gabriela Fontanillas (photographs), *Gego: Anudamientos*, Telcel, Caracas, 2004.
20 Paolo Gasparini, *Retromundo*, Grupo Editor Atter Ego, Caracas, 1986.
21 Bruno Munari, quoted in Claude Lichtenstein and Alfredo W Haberli (eds), *Air Made Visible*, Verlag Lars Müller, Zurich, 2000, pp.42–43.
22 Umberto Eco, quoted on the cover of *Air Made Visible*, *op.cit.*
23 Victoria de Stefano, 'Un oasis de civilidad', *El Nacional*, Caracas, 28 April 2000.
24 Luis Pérez-Oramas, email letter to the author, 4 January 2006. With Gego and Leufert it may have been a case of reciprocal modesty. Gego said of Leufert: 'He taught me how to see and discover, something you cannot learn by studying engineering or architecture.' Quoted by Peruga, *op.cit.*, p.379.
25 Gego, quoted in Huizi and Manrique, *op.cit.*, p.171.
26 Umberto Eco, *The Open Work*, Anna Cancogni (trans), Harvard University Press, Cambridge, MA, 1986, p.88.
27 Gego, quoted in Huizi and Manrique, *op.cit.*, p.99.
28 Lygia Clark, quoted in *Veja* magazine, December 1986.
29 Georges Vantongerloo, 'Conception of Space – 1' (1958), reprinted in Anthony Hill (ed), *Directions in Art History and Aesthetics*, Faber & Faber, London, 1968, p.27.
30 Max Bill, quoted in Angela Thomas Schmid, 'Georges Vantongerloo (1886–1965)', in *Georges Vantongerloo, A Retrospective*, Annely Juda Fine Art, London, 2006.
31 Jane Livingston, 'Introduction', in *Georges Vantongerloo*, Corcoran Gallery of Art, Washington, DC, 1980, p.13.
32 Gego, quoted in Huizi and Manrique, *op.cit.*, p.163.
33 *Ibid.*
34 Rina Carvajal, 'Gego: Weaving the Margins' in Catherine de Zegher (ed), *Inside the Visible: An Elliptical Traverse of 20th Century Art in, of, and from the Feminine*, MIT Press, Cambridge MA and London, 1996, p.345 and p.342.
35 Luis Pérez-Oramas, 'Gego: laocoonte, las redes, y la indecisión de las cosas', in Peruga, *op.cit.*, p.397.
36 Alois Riegl, *Problems of Style: Foundations for a History of Ornament*, Princeton University Press, Princeton, 1992, p.238.
37 Peruga, *op.cit.*, p.389.
38 Luis Pérez-Oramas, *La invención de la continuidad*, Galeria de Arte Nacional, Caracas, 1997, p.19.
39 Luis Pérez-Oramas, *Abstracción Geométrica*, *op.cit.*, p.41.

Anne Bean:
Within Living Memory

Remarks by Anne Bean that are not foot-
noted were made in conversation with
the author.

1 Jean Fisher, 'Introduction', *Electronic
Shadows: The Art of Tina Keane*, Black Dog
Publishing, London, 2004, p6.
2 All artist quotes in conversation with
the author.
3 See the artist's statement in *Autobituary*.
4 Rabindranath Tagore, *Our Universe*, Indu
Dutt (trans), Jaico Publishing House,
Dehli, 1969, p68.
5 TS Eliot, 'Ash Wednesday' (1930)
Collected Poems 1909–1962, Faber & Faber,
London, 1963.
6 TS Eliot, 'Burnt Norton' (1936), from
Four Quartets (1943) Faber & Faber,
London, 2001.
7 Artist's statement in *Today's The Day*, a
calendar published to accompany *Reap*.
Profits from the sale of this calendar
go to Mwandi Community School,
Livingstone, Zambia.
8 Contributions, respectively, of Sean
Dower, Zuzana Rousova, Harris Bean,
Jo Stockham, Paul Burwell, Cliff Kelsall,
Richard Wilson, Martin von Haselberg,
Sally Wallace-Jones, Tomas Vylita and
Karlovy Vary.
9 See David Toop, 'Aftershock' in Jonathan
Harvey (ed), *Stephen Cripps: Pyrotechnic
Sculptor*, ACME in association with
Stephen Cripps Trust, London, 1992.

Aubrey Williams:
A Tragic Excitement

1 Aubrey Williams, 'The Symphonies
and Quartets of Dmitri Shostakovich –
Paintings', in *Shostakovich: An Exhibition
of New Paintings by Aubrey Williams*,
exhibition catalogue, Commonwealth
Institute, London, 1981. Reprinted in
Anne Walmsley (ed), *Guyana Dreaming:
The Art of Aubrey Williams*, Dangaroo
Press, Aarhus, 1990, p.32.
2 Despite writing regular criticism since
the 1960s, I myself was not aware of
Aubrey Williams's work until 1981, when
it was pointed out to me by Rasheed
Araeen. Williams had received a certain
attention in his early years from British
and Caribbean critics. Then, after a gap,
recent appreciations of Williams's
oeuvre have included Imruh Bakari's
film profile, *The Mark of the Hand*, Arts
Council/Kuumba Productions, 1986;
Rasheed Araeen's long interview with
the artist in *Third Text*, no.2, winter
1987/88; the publication of a monograph
Guyana Dreaming, Anne Walmsley, *ibid.*;
and Stephanie Harvie's unpublished
MPhil thesis, *The Search for a Guyanese
Identity: The Evolution of the Fine Art in
Guyana with Specific Reference to the Works
of Aubrey Williams*, 1993.
3 Guy Brett, *Interview with Aubrey Williams*,
October 1981. Extracts published in Guy
Brett, 'A World Aesthetic', *City Limits*,
20 October 1981.
4 Rasheed Araeen, 'Conversation with
Aubrey Williams', *Third Text*, *op.cit.*, p.49.
5 *Ibid.*, p.26.
6 *Ibid.*, p.27.
7 Aubrey Williams, 'Caribbean Visual
Art: A Framework for Further Inquiry',
Literary Half Yearly, vol.11, no.2, July
1970, p.144. Reprinted in Walmsley,
op.cit., p.24.
8 *Ibid.*, p.36.
9 Aubrey Williams, talking to Anne
Walmsley, London, 28 March 1972
(unpublished typescript).
10 Araeen, *op.cit.*, p.31.
11 *Ibid.*, p.36.
12 Brett, *op.cit.*
13 Anne Walmsley, *The Caribbean Artists
Movement, 1966–1972: A Literary and
Cultural History*, New Beacon Books,
London and Port of Spain, 1992.
14 *Ibid.*, p.36.

15 *Ibid.*, p.52.
16 *Ibid.*, p.66.
17 *Ibid.*, p.56.
18 *Ibid.*, p.82.
19 *Ibid.*, p.83.
20 Edward Kamau Brathwaite, 'Timehri', talk at the opening of Aubrey Williams exhibition, John Peartree Gallery, Kingston, Jamaica, March 1970. Reprinted in Walmsley, *Guyana Dreaming*, *op.cit.*, p.84.
21 Araeen, *op.cit.*, p.35.
22 *Ibid.*, p.33. Williams did not say if Herbert Read, Henry Moore and John Rothenstein also came to the pub, but we know from photographs that these luminaries attended his private views.
23 Alan Bowness, *Alan Davie*, Lund Humphries, London, 1967, p.19.
24 Andrew Causey, *Peter Lanyon*, Aiden Ellis, Henley-on-Thames, 1971, p.25.
25 Bowness, *op.cit.*, p.174.
26 Aubrey Williams, 'The Predicament of the Artist in the Caribbean', 1967. Reprinted in Walmsley, *Guyana Dreaming*, *op.cit.*, p.19.
27 Aubrey Williams, 'Dalhousie Murals', 1978. Reprinted in *ibid.*, p.29.
28 SD Houston, *Reading the Past: Maya Glyphs*, British Museum Publications, London, 1989, p.25.
29 Araeen, *op.cit.*, p.38.
30 *Ibid.*, p.50.
31 *Ibid.*, pp.50–51.

Victor Grippo: Material and Consciousness

1 Jorge Glusberg, 'Origen del Grupo CAYC', *Grupo CAYC Patagonia*, exhibition catalogue, Ruth Benzacar Art Gallery, Buenos Aires, 1968. Reprinted in *Grippo, una Retrospectiva. Obras 1971–2001*, MALBA, Colección Costantini, Buenos Aires, 2004, p.346.
2 Guy Brett (ed), *Transcontinental: Nine Latin American Artists*, Verso, London, in association with Ikon Gallery, Birmingham and Cornerhouse, Manchester, 1990.
3 Jorge di Paola, 'Victor Grippo: cambiar los habitos, modifica la conciencia', *El Porteño*, April 1982. Reprinted in *Grippo, op.cit.*, p.320.
4 Nidia Olmos de Grippo in conversation with the author.
5 Victor Grippo, in *Victor Grippo. Obras de 1965 a 1987*, Fundación San Telmo, Buenos Aires, 1988. Reprinted in *Grippo, op.cit.*, p.317.
6 José Ortega y Gasset, *Velázquez, Goya and the Dehumanization of Art*, Alexis Brown (trans), Studio Vista, London, 1972, p.102.
7 Guy Brett, 'Equilibrium and Polarity', in *Victor Grippo*, exhibition catalogue, Ikon Gallery, Birmingham and Palais des Beaux-Arts, Brussels, in collaboration with Kanaal Art Foundation Kortrijk, 1995, p.12.
8 Victor Grippo, 'Tesoros de América', *Arte Informa*, no.42, July–August 1983.
9 Victor Grippo, *Algunos ofidos*, exhibition catalogue, Galeria Artemúltiple, Buenos Aires, 1976. Reprinted in *Grippo, op.cit.*, p.315.
10 Jean Clay, 'Introduction' in *Takis*, exhibition catalogue, Alexander Iolas Gallery, Paris, 1966.
11 László Moholy-Nagy, 'In Defence of Abstract Art' (1945), reprinted in Richard Kostelanetz (ed), *Moholy-Nagy*, Allen Lane, London, 1974, p.44.
12 Victor Grippo, quoted in Di Paola, *op.cit.*, p.322.
13 Jorge Glusberg, *Victor Grippo, Art Criticism Briefs*, International Association of Art Critics, Argentina Branch, Buenos Aires, undated (1970s), p.11.
14 *Longman Dictionary of English Idioms*, Longman, London, 1979, p.261.
15 Victor Grippo, note written in May 1979. Reprinted in *Grippo, op.cit.*, p.338.
16 Brett, 'Equilibrium and Polarity', *op.cit.*, pp.13–14.

17 Victor Grippo, 'Some time ago when Isabel Zuccheri asked me...', in *Encuentros entre un pintor y su memoria: Victor Grippo, Berni Castagnino, Union Carbide*, Buenos Aires, 1982. Reprinted in *Grippo, op.cit.*, p.314.

18 María Helguera, 'Conversaciones en el taller; Victor Grippo', in *Un altre mirar. Art contemporani argenti*, Centre d'Art Santa Monica, Generalitat de Catalunya, Barcelona, 1997. Reprinted in *Grippo, op.cit.*, p.336.

19 Victor Grippo, quoting a traditional Tatar invocation for the New Year; in *Victor Grippo*, Galeria Artemúltiple, Buenos Aires, 1980. Reprinted in *Grippo, op.cit.*, p.316.

20 Marcel Duchamp, referring to his *Large Glass* (*The Bride Stripped Bare by Her Bachelors, Even*, 1915–23). Quoted in Linda Dalrymple Henderson, *Duchamp in Context: Science and Technology in the Large Glass and Related Works*, Princeton University Press, Princeton, NJ, 2005.

21 Robert Smithson, 'A Sedimentation of the Mind: Earth Projects', in *Robert Smithson: The Collected Writings* (1968), Jack Flam (ed), University of California Press, Berkeley, CA, 1996, p.112.

22 Cildo Meireles, quoted in Cheryl Hartup, 'Introduction' in *New Work: Cildo Meireles*, Miami Art Museum, Miami, FL, 2003.

Lygia Pape: The Logic of the Web

1 'Como você vê, está tudo ligado. /Não existe obra como um objeto acabado e resolvido, mas alguma coisa sempre presente, /permanente no interior das pessoas.' Quoted in Denise Mattar, *Lygia Pape: Intrinsecamente Anarquista*, Relume Dumará, Perfis do Rio series, Rio de Janeiro, 2003, p.86.

2 *Ttéia Quadrada*, virtually unknown in Europe, was a revelation when installed in the first room of the Arsenale at the 53rd Venice Biennale of 2009. *New House* was first shown in 2002 as part of Lygia Pape's solo exhibition at the Centro de Arte Hélio Oiticica in Rio de Janeiro, curated by Paulo Sérgio Duarte. The following year it was remodelled by the artist and built as a permanent installation in the Tijuca forest for a project curated by Márcio Doctors. Three artists, Pape, José Resende and Nuno Ramos, were invited to make new work as part of a programme of commissions for the forest initiated by the Museu du Açude, part of the Museus Castro Maya.

3 Vicky Unruh, *Latin American Vanguards: The Art of Contentious Encounters*, University of California Press, Berkeley, CA, 1994, pp.74, 87.

4 'Quando o grupo neoconcreto se forma, ninguém é mais construtivo. Passamos a inventar linguagens novas, mas sem a necessidade daquele rigour, daquela sistematicão. Era a liberdade absoluta. Minha obra sempre perseguiu isso.' Mattar, *op.cit.*, p.65.

5 'uma deformacão de algo recolhido do mundo real. Nosso objetivo era criar a partir das três formas básicas: o círculo, o quadrado e o triângulo.' Lygia Pape, interview with Angélica de Moraes, o *Estado de São Paulo*, 22 April 1995, p.D4.

6 Lygia Pape went on to make 15 or 16 films of her own. About her cinema, see Ivana Bentes essay in *Lygia Pape Magnetised Space*, Museo Nacional Centro de Arte Reina Sofia, Madrid, 2011, pp.333–48.

7 Lúcia Carneiro and Ileana Pradilla, *Lygia Pape: Entrevista*, Lacerda Editores and Centro de Arte Hélio Oiticica, palavra do artista series, Rio de Janeiro, 1998, p.29.

8 *Lygia Pape*, Edições Funarte, Rio de Janeiro, 1983, with texts by Lygia Pape, Mário Pedrosa, Luis Otavio Pimentel and Afonso Henriques Neto, p.45.

9 This earthy strain, invading the museum with assemblies of everyday

objects, set at a basic level of eroticism and hunger, and including sound and smell, continues with *Objetos de sedução: The Loss* (Seduction Objects: The Loss, 1976), *Eat Me: a gula ou a luxúria?* (Eat Me: Gluttony or Lust?, 1976), *Narizes e línguas* (Noses and Tongues, 1995) and *Eu Como Eu* (I Eat Myself, 1999), etc.

10 Mattar, *op.cit.*, p.71.

11 The quotes are from a text written by Oiticica in English, 'Tropicália Times Series 2. Lygia Pape', London and Paris, May 1969. A version in Portuguese was published in *Lygia Pape: Obras*, Galeria Arte Global, São Paulo, 1976. This publication also included a facsimile of three hand-written fragments by Oiticica in Portuguese, written in New York in 1973, which discusses Pape's *Ovo*. A complete version of both texts is included in *Lygia Pape Magnetised Space*, *op.cit.*, pp.245–47 and 249–52 respectively.

12 Pape and Clark had mutual respect but the relationship was not warm. Oiticica maintained a close friendship with both Clark and Pape.

13 Lygia Pape, Edições Funarte, *op.cit.*, p.46.

14 'Você fica trancado ali dentro, envolto por uma espécie de pele, de membrana, e então você enfia a mão assim, a membrana começa a ceder e de repente ela se rasga e você "nasce", bota a cabeça pelo buraco e rola pra fora', *ibid*.

15 Lygia Pape, letter to Guy Brett, September 1988.

16 Hélio Oiticica, diary entry 6 September 1960, in *Hélio Oiticica*, Witte de With Center for Contemporary Art and Galerie Nationale du Jeu de Paume, Rotterdam and Paris, 1992, p.32.

17 Lygia Pape, quoted in *O Estado de São Paulo*, 5 May 2004, *Caderno* (notebook) D6.

18 Lygia Pape, interview with Angélica de Moraes, *o Estado de São Paulo*, 5 August 1997, *Caderno* (notebook) D12.

19 Mário Pedrosa, Edições Funarte, *op.cit.*, p.1.

20 Lygia Pape, Edições Funarte, *op.cit.*, p.47.

21 Popular term for an inhabitant of Rio de Janeiro.

22 Caetano Veloso, *Verdade Tropical*, Companhia das Letras, São Paulo, 1997. Published in English as *Tropical Truth*, Isabel de Sena (trans), Bloomsbury, London, 2003, p.183.

23 Christo and Jeanne-Claude, *Ocean Front*. The making of this work was recorded in *Christo: Ocean Front*, Princeton University Press, Princeton, NJ, 1975, with text by Sally Yard and photographs by Gianfranco Gorgoni.

24 *Ibid.*

25 Lygia Pape, Edições Funarte monograph, *op.cit.*, p.46.

26 Lygia Pape, letter to Guy Brett, 31 December 1988, written in English.

27 Lygia Pape, interview with Óscar Faria, *Público*, 18 June 1999, p.5.

28 For further details about the versions of *Manto tupinambá*, see Bentes, *op.cit.*, p.347.

29 Lygia Pape, quoted in Mattar, *op.cit.*, p.95.

30 Lygia Pape, interview with Ethel de Paula, *o Povo*, 5 May 2002, p.5.

31 Carneiro and Pradilla, *op.cit.*, pp.80–81.

32 Amélia Toledo, quoted in *Folha de São Paulo*, 4 May 2004, p.C4.

Author Acknowledgements

This book is a tribute to the fourteen artists whose work is discussed in its chapters. It represents my gratitude for all I have learned from these and other artists.

I would like to give a special thanks to Karsten Schubert, founder of Ridinghouse, for valuing and respecting my work as a writer. I am deeply touched that he was prepared to support this book so generously. Of equal generosity and faith was the support from Nicholas Logsdail, founder of the Lisson Gallery, which has allowed this project to flourish.

A special thank you goes to Eileen Daly, who has been a driving force and backbone of this project, not only for her meticulous editorial work, but also in managing the project. The book could not have been made without her strength and tenacity.

A warm thank you to Philip Lewis, designer, for creating something beautiful, refined, and with heart.

Much gratitude is due to Doro Globus who was the former publisher at Ridinghouse, and to Louisa Green, both of whom warmly supported the idea of my book in the early stages.

I would like to thank Sophie Kullmann, publisher at Ridinghouse for her overall assistance in proofreading the final text, image-researching and production management in the final stages of this work.

I am deeply grateful to my wife Alejandra Altamirano Brett and my daughter Luciana Brett England for the unconditional support they have given me throughout this adventure.

Photographic Credits

Published in 2019 by Ridinghouse
46 Lexington Street
London W1P 0LP
United Kingdom

ridinghouse.co.uk

Distributed in the UK and Europe
by Cornerhouse Publications
c/o Home
2 Tony Wilson Place
Manchester M15 4FN
United Kingdom
cornerhousepublications.org

Distributed in rest of world by
ARTBOOK | DAP
75 Broad Street, Suite 630
New York, New York 10004
United States of America
artbook.com

Special thanks are due to
Alejandra Altamirano Brett and Nicholas Logsdail

Epigraph: Mário Pedrosa. Reprinted in Gloria
Ferreira and Paulo Herkenhoff (eds), *Mário Pedrosa
Primary Documents*, Stephen Berg (trans), Museum
of Modern Art, New York, NY, 2015, p.325.

British Library Cataloguing-in Publication Data
A full catalogue record of this book is available
from the British Library.

ISBN 978 1 909932 53 1

Ridinghouse Publisher: Sophie Kullmann

Edited by Eileen Daly

Designed by Philip Lewis
Set in Enigma

COVER Liliane Lijn, *Linear Light Column* (detail),
1969
FRONTISPIECE Gego, *Chorros* (detail), Museo de
Barquisimeto, 1985

Printed in Verona by Verona Libri

Ridinghouse